A PARTIAL TESTAMENT

HELEN LESSORE

A PARTIAL TESTAMENT

*Essays on Some Moderns in the
Great Tradition*

THE TATE GALLERY

ISBN 0 946590 50 8
Copyright © 1986 Helen Lessore & Tate Gallery Publications
All rights reserved Designed and published by
Tate Gallery Publications, Millbank, London SW1P 4RG
Photoset in Great Britain by
Rowland Phototypesetting Ltd, Bury St Edmunds, Suffolk
and printed by St Edmundsbury Press Ltd,
Bury St Edmunds, Suffolk

CONTENTS

FOREWORD [7]

1 THE GREAT TRADITION [9]

2 GIACOMETTI [14]

3 CRAIGIE AITCHISON [22]

4 MICHAEL ANDREWS [35]

5 FRANK AUERBACH [55]

6 FRANCIS BACON [73]

7 BALTHUS [97]

8 LUCIAN FREUD [122]

9 LEON KOSSOFF [144]

10 EVERT LUNDQUIST [155]

11 RAYMOND MASON [168]

12 EUAN UGLOW [184]

DEVELOPMENT OF THE THEME OF
THE GREAT TRADITION [199]

REFERENCES [218]

INDEX [219]

TO THE MEMORY OF
HENRY TONKS &
TANCRED BORENIUS

FOREWORD

This book does not pretend to offer anything approaching a complete view of the world of painting during my lifetime; therefore in that sense it is partial. But it is also partial because it embodies my very strong preferences.

Most of my life I have lived among paintings – and good paintings. At the Slade School I was trained in the craft, and in the history of art by Tancred Borenius; and in the running of a dealer's gallery by my husband, Frederick Lessore, for whom I began to work soon after leaving the Slade. After his death, in November 1951, I ran the Beaux Arts Gallery until March 1965, and during that time gave exhibitions to eight of the ten living artists discussed here. Francis Bacon was already known, and the Swedish painter Lundquist well established and famous in his own country, but not here. The other six were young and unknown. I often had the feeling of being as it were in the kitchen and seeing the stuff actually made.

Of the two remaining artists, Lucian Freud was a frequent visitor, and indeed a show had been agreed on, but he was fortunate in receiving an offer from a more businesslike gallery. I have written about Balthus from sheer admiration, and recognition of his unique importance.

Among the admirable painters about whom I have not written, there are two to whom I particularly want to pay tribute – both artists of rare integrity and great achievements – William Coldstream and Marie-Louise Motesiczky

The genesis of the book was this: one evening in 1963 I was sitting in the flat attached to the gallery and looking at the new paintings by Leon Kossoff, not yet hung. He was the artist whose work I had most difficulty in promoting, and it suddenly struck me that it was, after all, rooted in the great European Tradition, and that if only I could make this clear, people would accept it more easily. But I was too slow, since it was necessary first to try to elucidate and define the tradition itself. So, having missed that bus, I took another. Thus the work arrived at its present shape. It was all done intermittently, and took a long time, and naturally I left each artist's

development at the point it had reached when I finished writing about him, though sometimes later work is illustrated.

My choices – partialities – cannot be logically explained or justified. One does try, after the event, to analyse one's judgments, but in fact they rest on intuition. However, believing in my own as strongly as I do, I have written these essays, partly as a tribute to the artists, partly in the hope of their being useful, in the chaos of our time, especially to young people.

Helen Lessore
1985

ACKNOWLEDGMENT

The publishers are grateful to all those artists and galleries who helped to obtain the illustrations, particularly Marlborough Fine Art and Mr Raymond Mason.

I

THE GREAT TRADITION

After I had reflected for many years on the character, course, vicissitudes, and precarious survival of the Great Tradition of European Art, suddenly one night, just before I fell asleep, it all seemed to pass before me in the following extremely abbreviated form:

A fantasy before falling asleep
The Muse of Western Art speaks:

My father[1] was an extraordinarily handsome man of great authority, and retained the latter and something of his looks even into his old age, when he married my mother,[2] then a very young girl. My father died before I was born. The best years of my childhood were spent in Rome, where he was still remembered, but soon my mother took complete charge of me, and that was rather wretched at first, for she was not interested in physical or visual beauty, but only in moral virtue, in championing the poor and oppressed, and in the rewards of all this in a life after death. It is hard to say how it came about, but as I grew up a barbaric vitality began to surge through my veins, a kind of wildly luxuriant, if somewhat uncouth, springtime,[3] and though inferior to my father in the flower of his youth and prime of his manhood,[4] there was reason to hope that eventually I might develop a comparable beauty. While this was happening I was much in France, though travelling about considerably; and a little later, in Italy, finding a resurgence of interest in my father and his family, I became very excited, met and married one of his descendants, and during the period that followed, which was the most radiantly happy of my whole life, we produced a family of amazingly brilliant children. Nothing so miraculous has happened since. Dividing and subdividing as families do, we have had some illustrious descendants; but the only time a whole group of them distinguished themselves so splendidly that one

[1] Ancient Greek art. [2] Christianity. [3] Romanesque. [4] Sixth and fifth centuries BC.

was reminded of that glorious flowering in Italy, was not so very long ago, in France.

After that it seemed as if the line was in danger of becoming extinct. Here and there a spark still kindles into something not altogether unworthy of its ancient lineage. But I cannot tell . . . I am old; and perhaps I must soon die.

Whether indeed the Muse of Western Art is on her deathbed I do not know. But certainly, in the second decade of the twentieth century, for the first time in history, there occurred a complete break across the hitherto continuous, however fluctuating, line of this tradition: the break with representation.

Across this break a few artists have succeeded in establishing a connection, through which the life-blood of the Great Tradition has flowed into their own work and propelled it forward. But even if such individual repairs became more numerous, it is unlikely that they would ever again join together to make a clear road; it seems more probable that, from now on, every artist will have to find and make his own.

In this book I have written about some of those who have done so, beginning with Giacometti, who is a sort of precursor of the rest, and who died in January 1966, about two years after I started to write this. The others I have placed in alphabetical order, because the relation between them is not sequential but circular. They are only very loosely connected, like dancers round a maypole, who each hold a ribbon attached to it. The maypole here is the Great Tradition of European Art, about which it has therefore seemed necessary to write, though as briefly as possible, a few words.

From Ancient Greek times until shortly before the First World War all European painting and sculpture, and even up to the present day some of it, has retained a recognisable character. As opposed to the art of other civilisations, Western art is distinguished by a greater attention to and imitation of natural appearances. In ancient Egyptian sculpture there are some instances of very tender and moving portraiture which seem to foreshadow a more modern spirit, but still they appear fixed in eternal, motionless monumentality. Their descendants, the archaic Greek standing figures, at first advance one foot, and then rapidly acquire the whole range of movement and engage in all the activities of peace and war. Greek

painting, as we know from the story of Zeuxis and Parrhasius, was sometimes deliberately and successfully illusionistic; and though none of it survives, we can see, from copies or imitations done in Roman times, that it was concerned, as European painting has been ever since, until quite recently, with the representation on a flat surface of the three-dimensional world, of solid bodies set in a believable space, while the painting of other cultures has been content with flatness. Where there is no temptation to illusionism it is probably easier for art to keep its proper aims in view, for in the West, whenever a new degree of skill has been attained, it has been followed by some confusion of intentions and misuse of facility, as if imitation were more admirable than creation, and naturalism the very goal of art.

Nevertheless, the tensions between established principles and new artistic discoveries have produced an extraordinary excitement and vitality in the best European art, which I personally seldom find in any other.

Max Friedländer, writing of the early Flemish painters, says:

Actuality does not agree with appearance. Artistic style is basically determined by the painter's decision to devote himself either to the absolute idea which is independent of place and light, or to the appearance of form and colour in which the idea presents itself casually, modified by place and condition. The development of painting as a whole could well be taken as the road from the former to the latter way of viewing things.

This seems undeniable, and although Friedländer adds: 'Every great painter has gone a part of the way along this road', it really means that, on the whole, painting has taken a path away from the making of monumental images towards the recording of accidental appearances, a path beset with the dangers of triviality, superficiality, and disintegration. *Mutatis mutandis*, the same is true of sculpture.

Within the European Tradition, then, the course of art has taken a perceptible direction for more than 2,000 years, away from the absolute towards the accidental, and away from the public, the monumental, the heroic, towards the private, the domestic, the everyday. This has corresponded to a general, though not invariable, tendency towards democracy, and though this form of social organisation originated in Ancient Greece, the slow but insistent movement in favour of the value of the

individual human being, and the value, in art, of individual experience, has been greatly fostered by Christianity, with its teaching that the salvation of every human soul is of importance. This over-all movement has not been simple, steady, and uninterrupted, but subject to revolutions, reactions, and returns, and periods of liveliness and dulness. Art has continued to be the product, in varying proportions, of two main streams, Greek and Christian, distracted and refreshed by many foreign tributaries. The Greek influence has persisted chiefly in the countries bordering the Mediterranean, the Christian in the North.

In the more Northern and, on the whole, Protestant countries, the balance has been weighted in favour of those qualities leading to genre, while the Mediterranean qualities lead to the Grand Manner. One cannot say that either tendency alone is better than the other, for, clearly, art that leans to one side needs something from the other as a corrective.

One could make a list of qualities, under two headings, thus:

Mediterranean	Northern
typical	individual
general	particular
simplified	detailed
regular	accidental
ideal	actual
heroic	everyday
monumental	domestic
public	private
The Grand Manner	genre

And, if there were more agreement as to their meaning, one could place the terms Classic and Romantic under the headings Mediterranean and Northern respectively.

A contemplation of these pairs of opposed qualities leads to the thought that those classed as Mediterranean are connected with a sense of form and design and largeness of conception, in fact with a sense of craftsmanship and the desire to make something satisfying in itself – hence with the 'abstract' qualities necessary in all good art – and to some extent with stability, while those listed as Northern have more to do with an interest in discovering and noting specific facts, in description, recording, and representation.

The Northern characteristics are probably more responsible for the

ceaseless drive of civilisation in general, though their democratic directions alone, unchecked by their opposites and pursued to the bitter end, would lead to anarchy and disintegration. The Mediterranean qualities, though needing the piquancy of a leaven from the others, probably count for more in that mysterious part of civilisation called Art, and also contain those elements which can sometimes make us feel that we have a spark of divinity, and which cause the Great Tradition continually to reassert its supremacy, so that again and again artists are drawn back to explore the sources and earlier masterpieces, because it is there that they find examples, standards, and inspiration.

2

GIACOMETTI

The break across the continuity of the Great Tradition was more than a simple break with representation. It was, rather, a huge chasm into which all accepted ideas and beliefs fell, and from which nothing was rescued as its former self, but subjected to complete reappraisal.

Across this chasm the most serious artists of the generation that came to maturity in the last years before the Second World War, and onwards, began to look back for clues. Picasso and Matisse were too recent, and, besides, each seemed to have exhausted the possibilities of his own way – like Michelangelo. But by degrees it became clear that Cézanne more than anyone else opened new possibilities and inspired hope. His profound understanding of the true nature of painting, and of the need to start afresh from basic principles, could serve as a foundation on which others might build their own personal languages. In his own work he brought the art back to as pure an expression as can be found in modern times of 'the absolute idea', grand, heroic, massively monumental, and classical. And indeed, the time when he lived did seem full of promise and hope.

The gulf between that earlier, confident period and the present bleak one was spanned by the efforts of another very solitary figure: Giacometti's life and work are the bridge from Cézanne to contemporary art.

From the point of view of direct tradition, it is in his drawings that Giacometti most clearly follows Cézanne and forms a link between him and much of the best art of today. There is even a kind of family resemblance in the character of the forms perceived, say, in a head or a tree. But these pencil drawings present a world of dauntingly pure form, as if made of crystal, without colour, and without shadow except such as crystal itself might produce. Each solid object is firmly carved, in planes or curved surfaces, by means – as with Cézanne – of many corrections, many increasingly exact strokes, of which, however, not the last but the sum gives the final fullness and clarity of statement; and, in addition, the

whole field of three-dimensional space within the frame of his vision is created by a kind of web of eye-beams, leaving tracks from point to point – sometimes made by the pencil, sometimes by wiping out with an india rubber – establishing distances, spatial relations, and continuity, so that the space in a landscape or interior seems almost palpably filled with air.

He was as much concerned with understanding and creating form in space as Cézanne had been, but in a different way, for he was primarily a sculptor, not interested in colour, and not a painter in the same sense as Cézanne. And this is perhaps the reason for what appears to be his lack of interest in the paper or canvas as a flat surface. He was less preoccupied with ideas of *art* than Cézanne, but, like him, obsessed with *representation*, with expressing his 'sensation' or experience.

Of Cézanne's drawings, those to which Giacometti's bear the strongest resemblance are of single heads, or of sculpture, or some fragment – for instance, the study after Chardin, 'Still-life with Pitcher' – that is, pencil drawings concerned entirely with the exploration of the form and, so to speak, preliminary to translating it and using it in a *work of art*.

All Giacometti's drawings are studies in this sense – even when the scene fills the whole sheet of paper; that is to say, like those comparatively few pencil studies of Cézanne, they are really like the drawings of the great Renaissance masters – if they are landscapes or interiors, the distance is excavated realistically, they are frankly studies of form, done without any intention of their being *works of art in themselves*, and in both cases the beautiful effect is due to a sure, instinctive taste, a classical evenness and absence of accents. These drawings of Giacometti's are so exemplary in their sustained discipline and purity of concern with form and nothing but form, that they ought to be regarded as models for study, just as Masaccio's paintings were in their time. He is indeed known to have talked and made suggestions in a way that showed concern for the art of drawing, in a sense in which someone who believes he is on the right path, and has something to impart, likes to found a school.

But his painting and sculpture are more private. In these his entire aim was to make his images 'like' (or so he said), to make them give him back, absolutely, the feeling of reality, or of his memory of reality. In this there is an analogy with Cézanne's pursuit of his 'sensation', but a belief has arisen, from his way of speaking, that Giacometti's pursuit was more frantic, more desperate, because more crazily single, not balanced and steadied by

any ideal of art which might have offered a clue. The final appearance of the work, its extraordinary characteristics, have nothing to do with any such ideal, but result from his acute analysis of his perceptions and reactions, and eventual achievement of 'likeness'.

And yet – are we a little deceived? Is it accidental that, in the end, Giacometti's own works have strong affinities with 'the art of the museums' – his sculptures with ancient Egyptian art, his paintings with Byzantine mosaics and the paintings of Cimabue? At all of these, we are told, as well as at the architecture of Borromini and other baroque art, he looked with interest when he travelled in Italy as a very young man, before settling in Paris. And it is highly probable that those kinds of art powerfully influenced his way of seeing – perhaps especially that of Borromini, who actually incorporated the effects of perspective into his architecture, just as Giacometti was later to do in his sculpture; so that, while he said he was only trying to make his work 'like' what he saw, at a deeper level, whether conscious or not, he did after all have artistic ideals, and was taking as a standard those grand and mysterious images which had entered his imagination so early.

However, while his personal procedures in painting and sculpture appeared completely experimental, and in defiance of tradition, the results seemed equally in accord with modern intellectual attitudes, and there is no doubt that it was these two aspects which made a very strong appeal, and drew towards him some artists only slightly younger, and many of the next generation, besides fascinating a much wider public.

Giacometti's art could be as easily a thousand years as fifty distant from that of Cézanne. Looking at his figures, one does not feel that he had much confidence, or even interest, in communicating with the rest of humanity. One feels as if he scarcely believed in the possibility of communicating at all, on any important level. An extraordinary quality of silence seems to enwrap his figures, not merely negative, absence of sound, but an intense, positive silence, freezing expression. Everyone appears utterly isolated and unapproachable; even in a sculpture where several figures are placed as if walking across a city square, they go their separate ways and no one seems aware of any of the others. Each lives enclosed in his own solitude, as if abandoned by any higher power, not believing in any, not answerable to any, responsible only for his quite private life. One senses the desolation of unimaginable nothingness behind and under Giacometti's work.

Perverse as it may seem, this in itself inspired a kind of trust. That

someone could look so unblinkingly at what appeared to be the comfortless truth of the human situation – as indeed many poets were doing at the time – and still make art out of it, was felt to be encouraging. And so was the remaking, from bed-rock, of the languages of painting and sculpture to meet his personal requirements. For the noble and relatively selfless spirit of Cézanne, who served painting almost like a priest, believing that one should be 'workmanlike in art' and 'paint in accordance with the qualities of painting itself', had been unable to pave the way towards more than this: that art should survive through the efforts of individuals to make it serve their own needs.

Now, as to Giacometti's own needs: in the chapter from his still unpublished book, which was printed as an introduction to the catalogue of the 1965 Arts Council Retrospective Exhibition, David Sylvester says:

> Experiments in perception show that in normal vision the mind
> corrects the retinal image so that distant things are not perceived small
> but life-size and distant. Giacometti's peculiar tendency is to see in a
> way that is free of the normal conceptual adjustments and reacts to
> what is strictly visible.

But this is immediately preceded by a long quotation from Giacometti himself, in which he says that it was only when drawing that, to his astonishment, the thing became so small; that when he wasn't drawing he felt he saw things the size they really were; and that it was only gradually that the kind of vision he had when working became so ingrained that he had it even when not working.

As a matter of fact, to have this kind of vision when working is normal for a painter. What is unusual is to retain it in all circumstances, and this, as Giacometti said, was something that happened gradually; it was not always so. So it was not natural, but acquired. It may, possibly, have come about through looking very often, with an unusual degree of attention, *as if working*, and probably focusing at a considerable distance – in all, a painterly habit. In any case, it was something with which Giacometti became obsessed, and it came to be identified with his feeling of 'reality' or 'truth', and strongly affected the character of his sculpture. But this way of seeing was combined with an abnormally sharp sense of depth and distance, which, while it may have pushed him towards sculpture, certainly did something extraordinary to his paintings.

The results of Giacometti's peculiar perceptions and needs were two-

fold: his sculptures are a painter's sculptures; and his paintings are a sculptor's paintings.

To a degree which must be unique, he sculpted what he saw, what he could see without going near, and touching, without going round the model and discovering the form from different points of view. He sculpted a figure or group of figures as they appeared at a certain distance, set in the surrounding space, half-dissolved or eaten away by light and atmosphere, distorted by perspective. That is to say, he included in his rendering of form the effects of light, space, distance, vision itself, on his perception of that form. (And it is hard not to feel that this habit and practice grew from a seed received from Borromini.) As David Sylvester remarks in the catalogue already mentioned: 'The single figures of standing women almost invariably remain beyond one's reach whatever one's physical distance from them.' So they do, because they are sculpted as seen, not as known; and one cannot get nearer to see what they are like, any more than if they were in a painting; only, because they are 'free-standing' it is more teasing – one would expect, on a closer approach, to discover more definition, but it is not there. And so they remain, for ever unknown. The emphasis is on the mystery, the impossibility of knowing, the imprisonment of each one of us in the self. And finally, Sylvester also notes that when he saw Giacometti working on a figure (from memory, but it would almost certainly have been the same had it been from life) he 'was working on it from just two viewpoints – frontally and in profile'. For they are not true sculptures 'in the round' at all. And this is the truly extraordinary thing: evidently, Giacometti passionately wanted to make sculptures, though he had no genuinely sculptural responses or conceptions; so he did what primitive, archaic sculptors did: worked from the front, and from the side. His figures are only imagined, only made, from those two viewpoints. Hence their simplicity, their archaic force and solemnity. Those of his works which conform more to the real character of sculpture are less amazing. By the sheer intensity of his feelings and the persistence of his drive he succeeded, against all probability, in making his peculiarities, his very weaknesses, produce impressive works of art.

And *mutatis mutandis* the same is true of his paintings, in which the essential character of a painting as a flat surface is denied, and only recovered by the skin of its teeth.

Juan Gris said that the spaces between objects should be as charged with energy as the objects themselves, and even if one tried to interpret this as

referring to three dimensions, in practice it would still work out as meaning, in a painting, the *flat shapes* of the spaces between objects; and what he says is true of most good painting, in which all the flat shapes are interlocked in an even tension, maintaining the unity of the surface plane in spite of the representation of depth playing against it and enriching it with a different tension. But in Giacometti's paintings – above all in those of single figures, which constitute the majority – it is almost impossible, even with an effort, to read the spaces round the figure as flat at all. We simply feel the depth of air around and behind it. The painting meets the eye's demand for the repose of a flat surface by seeming like the front of a glass case, which slightly and mysteriously unifies the depths into which we look (because we seem to read the contents *on* the glass as well as through it), this effect being achieved by painting a frame, or frame-like marks, on the canvas. But within, all is treated as sculpture. If it is a street scene, a landscape, a group of trees, a still-life, or an interior, the effect is almost as if it were engraved on metal, the forms are so incisively drawn; but the air floats gently around them, filling the whole magically created space. The colour is tender, but almost monochrome, and as pervasive as the air. The drawing, though in paint, is, as they say, 'heightened with white', and in the case of the figures this makes them gleam like bronze, with an extraordinary hardness. In fact, these paintings of single figures, whether seated, standing, or busts, are more like sculpture than the sculptures themselves. Sometimes they are as if in reddish, coppery bronze, sometimes blue-grey, or grey-green – as from verdigris – but they always appear to be of an indestructible hardness, not of flesh.

The three-dimensional effect is intensified by the exaggerated perspective.

If you cover your face with your hands, spreading them so that the thumbs reach the back of the jaw, under the ears, and the little fingers meet over the projection of the nose, and then take them away, holding them in the same position, and look into the cavity they form, you will be surprised that it is so much sharper and narrower than you expected. Having realised how sharply the two sides of the face recede from the centre – which, after all, we should have known, because we all know what a profile looks like – we can then realise the extent to which the usual way of representing the 'full face' in painting – as it were, opening it out and bringing the receding planes up to the surface – is a convention, adopted *faute de mieux*.

But Giacometti did not accept it. On the contrary, he accentuated the recession, and so found a way of drawing and painting the head which implies the only two views – front and side – which he allowed in his sculptures.

Of course, the most obvious and striking peculiarity of his work, the extreme narrowness and elongation of the human form, both in sculpture and painting, was neither what he saw nor what he believed, but his equivalent of what he *felt*, of the feeling that stayed in his mind *from looking*, and in this sense 'like' and 'true'. And to get this likeness and truth, both in sculpture and painting, he found himself compelled, in a way, to do violence to the nature of both.

Here, then, are the reasons for the almost legendary force of Giacometti's impact and influence on his contemporaries: an Existentialist artist, he accepted hopelessness with a stoic dignity which enabled him to rejoin the artists of the antique world, to rediscover, as Paule-Marie Grand felicitously expresses it, 'the accent of the religions without hope†: the long-joined feet of Egypt, the immobility of the steles, the gaze of Roman paintings'. Metaphysically and technically exemplifying in an extreme degree the searching, enquiring, doubting, analytical tendencies of the modern Northern mind, he succeeded in creating images more monumental and, in effect, religious, than any others of his time. His sculptures reach back to a kinship with some of the Gothic cathedral-sculptures – the lifted heads, the upward-straining, hungrily elongated figures – and further still, past archaic Greek, to something even more ancient, to the art of Egypt, from which the Greek itself sprang; his paintings, partly also to Egyptian sculpture, especially to the regal and divine seated figures, and partly to the great Gothic paintings of seated figures – Cimabue's and Giotto's – and yet his are portraits, bitingly particular, and no whit diminished by their particularity. In short, he has demonstrated that, without violating the modern conscience, it is still possible, by the most unexpected paths, to arrive at the grandeur of the ancient Mediterranean tradition, to produce great classical works of art. And this, probably, is what every serious artist of today would like to do.

* * *

In spite of the achievements of Cézanne and Giacometti, it remains more

† Although the ancient Egyptian religion supposed eventual deification for the four great ones, for the masses there was no prospect but the eternal prolongation of their state here.

difficult than ever before for a young artist to find his way. There is not much in common, visibly, in the work of the best artists affected by these two. Their example is largely a moral one, of courage, of a way of life, of a scrupulous attitude towards the experience and the statement of the experience of the visible world; and it is also an affirmation that, today more than ever, art is a private matter, something pursued modestly, from a personal need and standpoint, and that it is, paradoxically, only by this private path, if at all, that it may eventually reach a level profound enough to have a universal meaning, to speak to a public.

Giacometti's habit of working long hours, day after day – or night after night – alone with the model in the studio; the way he seemed to find Reality become ever more mysterious, elusive, and baffling; his perpetual dissatisfaction with his efforts – all this continues to find echoes today in the practice of some of the most serious artists.

Beyond the basic elements of craftsmanship, there is little that can be honestly taught now, for it is characteristic of this age that no method really serves, except for the artist who has evolved it as the most apt means to solving his particular problems. Therefore, apart from, possibly, a few technical habits which may have been acquired at the same school in youth, all the best artists of our time are very different from each other.

Examining their work with hindsight, one can discover influences, and connections with the Great Tradition; but the direction that each artist's work takes, decided to a great extent by the circumstances of his early life and by natural affinities, though never predictable, formerly varied within narrower possibilities; today, the art of all times and places having become accessible, the possibilities are – or seem – infinite.

3

CRAIGIE AITCHISON

Of all the artists now living and working in Britain, there is none with such a naturally Mediterranean bent as Craigie Aitchison; and after all that has just been said about Cézanne and Giacometti, it must be admitted at once that he shows no trace of the influence of either.

He was born in Scotland, in 1926, and he often says that, in spite of its being so far north, there is something about the clear light and the beauty of the landscape there that is like Italy.

But he was trained at the Slade School, in London, where he now lives, and it is surprising that his art has matured in that physical and mental climate. But, intelligent and sophisticated as he is, he seems to have always known his direction, though exposed to the full battery of contemporary ideas. There is therefore very little in the way of a story of development, beyond the natural one from hesitation to confidence. His growth has been like that of a plant putting up a straight shoot with a sober-looking bud, visibly different, however, from the buds of all the neighbouring plants, and which gradually unfolds and finally opens into a flower of quite unexpected and exotic splendour.

From the first Aitchison was concerned with making a picture – decorating the plain surface with a clear image, and not an imitation of an accidental and transient appearance. That is to say, decoration and representation, each understood in its highest sense, were always equally balanced in him.

When working from a living model, for a long time he chose the profile view, both in heads and nudes, achieving a clear definition, as on old coins and medals, although the actual contour was always soft, subtle, and delicate. There has never been tone, in the sense of light and shade, in Aitchison's work; even these early paintings, though muted and low in key, work by colour. The flesh is very cool, like pale pink or lilac seen through gauze, the hair most often darkish brown, the background grey-green. Invented compositions were more adventurous, showing a preference for purple. In one very large picture, done while a student, a

white jug is fastidiously placed in an entirely purple space.

His paint has always been extremely thin, scrubbed into the canvas. Often the colour is used pure, but even when mixed it is usually transparent, and this technique gives density, rather than weight, to the solid bodies, and at the same time a luminous depth to the surrounding space.

About the end of his time at the Slade School Aitchison did a large dark green and brown painting of a moor, a Scottish landscape. The ground goes almost to the top of the picture, and although one believes sufficiently in its horizontality and recession, it also becomes vertical and clings to the surface like a Chinese painting, while one seems to feel, more than see, the dense growth of plants covering the ground, and the ground itself. In a similar but much smaller picture, also upright, a violet-coloured path runs slantingly across the dark brown moor. This is almost as abstract and simple as a Rothko, but unlike Rothko's work it gives a strong sense of a particular place. The horizontal picture 'Landscape with Telegraph Poles' in the National Gallery of Modern Art in Scotland also belongs to this series. These landscapes, or elements of them, can be recognised later in his religious pictures.

It is doubtful whether Aitchison learnt much at art school beyond the seemingly inescapable practice of measuring, but he became more accomplished through the opportunities for working, and made lasting friendships, involving mutual respect, with a few students, including Michael Andrews and Euan Uglow, who have since taken their place among the most distinguished painters of that generation.

From the Slade he won an Italian Government Scholarship, and besides travelling in Italy visited museums and galleries in many parts of Europe. But it was his Italian experience which liberated him – the light, the landscape, the country itself, as much as – possibly more than – the art. He saw his goal more clearly than before, and on his return produced a series of vivid pictures, each one having a predominant colour – scarlet, violet, yellow – as its principal theme. Several were of butterflies, hovering in brightly coloured, severely simplified settings. In one, yellow butterflies are vanishing into the subtly modulated yellow landscape, dissolving into the light of the summer morning. It is called simply 'Yellow Picture'.

In the next few years there followed a wide variety of still-lifes and landscapes, and religious compositions – one or two Nativities and Lamentations, but mostly Crucifixions.

These Crucifixions are a very important part of Aitchison's work. They have provoked a great deal of comment and curiosity, and also some attacks. Art, however, should be judged as art – and that includes the whole question of genuineness and depth of feeling; but to consider and examine it as if it were a detailed confession of faith is unsubtle. There is no doubt that Aitchison's religious feelings are genuine and profound, however far they may be from any orthodox belief, and seeing so many Gothic and Renaissance religious pictures in Italy, often still in the very churches for which they were done, made him realise that a whole world of feelings, with which hitherto he had not known how to deal, could be channelled into these subjects, above all that of the Crucifixion. This image, already loaded with associations, ideas, and meanings, could be recharged with his own deep and intense emotions, by means of shapes and colours – his natural language for everything – in a way for which no other subject provided the opportunity.

He has always done the figure of Christ from imagination, which, inevitably, means drawing from his whole store of memories, however unconscious and unspecific; and these echoes are bound to affect the spectator, whether through the always comforting authority of tradition, or by provoking a comparison, and often a reaction against the new treatment.

For Aitchison there is a sharper division than for us between his religious pictures – done 'out of the head' – and the others. For us there is less difference because his personality is whole, and the character of his vision pervades his direct physical observation as much as his imaginative faculty.

It is a peculiarity of his approach that, while shape and colour are of the utmost importance to him, substance is of none whatever. Simplicity and clearness are, however, vital. So his figures of Christ are unbroken by any marks. Yet they do not have the effect of silhouettes, for they are three-dimensionally conceived, and we feel how the brush made the form, with the slightest possible gradations, working outwards from the central axes of movement, and the dark element in which the figures hang comes up to them, meets and surrounds them, without any contour being drawn. And even though in a few cases the sense of the strained skeleton is more fully realised than usual, we always feel that the figure is of the same substance throughout – that we could pass a sword through it and no blood would flow, it would close up again unharmed, like a flame or a

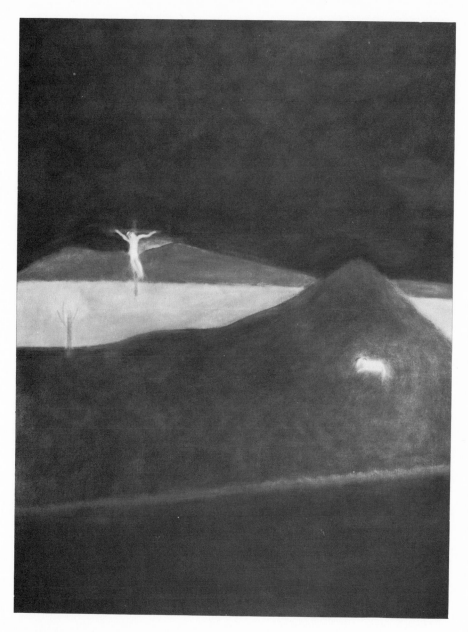

CRAIGIE AITCHISON
Crucifixion IV 1967
Oil on canvas, 51½ × 38½ in
Susannah York

sunbeam, composed of luminous particles cohering in some kind of dance. It is the same with many small landscapes and still-lifes painted during these years: a red rose against a green wall, a small dead bird, a tree and a garden gate, a cup or vase or candlestick, everything has this quality, as if it were the spiritual essence of the thing or person, its inmost identity, purified from all accidents of the flesh or material body, not more substantial than a mirage – an appearance, both less and more than physical reality.

This certainly contributes to the timeless, non-historical quality of the Crucifixions. They are both symbol and reality, in an eternal present.

The frequent use of the garden at Tulliallan (for long Aitchison's home in Scotland) or the country nearby, as a setting for them, is as natural to him as it was for the old Italian painters to use their local landscape.

Mostly they are night scenes, the sky varying from deep blue to strange purples and browns or greenish-blacks; sometimes small angels float between flowers and stars, and violet, orange, brown, blue and white interact between the flowers and the angels' robes and haloes; sometimes the treatment is more severe and bleak. In the Nativities the sky is a serene blue, and the landscape green, lit by the radiance from the Christ-child and from celestial sources.

There is one religious picture in a light key, a large triptych belonging to the Contemporary Art Society. In the left and narrowest panel, the cross is seen on a distant hill, and the right-hand panel shows the Nativity, and there is an effect as if these two duskier scenes formed a continuous landscape behind the wider central panel, which, however, is so dominant that in memory the whold triptych seems light as a summer day, or pale early evening. This central panel represents Adam and Eve in the Garden of Eden. With a Japanese spareness and exactness of placing, a zigzag rhythm floats gently down through the picture, marked by two trees, two stars, the figure of Eve, and finally, at the bottom, the leg of Adam. This rather shy, fragmentary, and tenderly painted Eve, so delicate yet with large, full breasts, is the only nude in all Aitchison's work that could be called voluptuous. Very simplified – with no face – she is slightly turned, in the pose of the Venus Pudica. The theme of seduction has surely never been more lightly touched upon. Below the lower hand she melts away completely – her legs are hidden by tall grass; for, although there is not a plant or flower to be seen, we feel, only through the modulations of colour, that the garden is full of lush vegetation. That isolated leg at the bottom of

the picture is all that is left of the once-reclining or half-seated figure of Adam; after the first astonishment, one willingly accepts it. It is an excellent example of Aitchison's way of settling any conflict between the claims of representation and abstract requirements. Something representational is bound to remain, for it was the beginning of the picture, its very subject; but beyond this essential residue, the abstract always wins.

After leaving the Slade in 1954, it was not until 1963 that Aitchison again worked from living models. His powers of observation are not less acute than those of his friends who were at the Slade with him, but there is a fundamental difference of approach. Those painters have all felt, in varying degrees, chiefly through Coldstream, the then Slade Professor, the influence of Giacometti and Cézanne, and with them there appears to be a sequence: observation, statement, further observation, correction, and so on, in a long process of gradual discovery of what they think of as truth about the model they are studying. Aitchison differs from all his contemporaries in that all his paintings are conceived from the first purely visually, as shape and colour. This preliminary flash of inspiration, or whatever one calls it, must, evidently, be of an appearance already filtered, for he can work a long time without noticing certain parts of the model at all. When he becomes aware of them later, he knows then that they are not required for that painting.

It should be noted that, whatever his abstract preoccupations, his portraits are always sharply characteristic likenesses.

In 1963 he painted two small pictures of female nudes – different models – seated in front of a dark, greenish-blue screen, in a carpeted room. They are strange pictures, and remind one that the idea of the nude, as Kenneth Clark points out, was for a long time something very difficult for the Northern artist to accept naturally; and perhaps it is in this field that Aitchison reveals the most Northern side of his character. These paintings have an atmosphere of unease, of tense, close privacy, oddly claustrophobic, as if he had once strayed into a harem and seen for an instant those extraordinary visions, which had continued to haunt him until he had exorcised them by painting them from memory. But in fact they were painted from life.

In the first picture the model is slender and graceful. She is seen in a full frontal view, as straight as if she were standing, for we look down upon her thighs and the pose is quite symmetrical except for the sideways droop of the head. She is very white, and the carpet is dark and merges into the dark

screen, which towers behind her like a wardrobe.

In the second, the model, seen exactly from the side, has a touchingly heavy figure and curiously small head, and in spite of the heaviness appears very young and vulnerable. She sits as rigidly as an ancient Egyptian statue, with an awkward stiffness, considered as a human being, but, considered as a solid shape, with a massive, almost geometrical beauty. Her white figure in front of the dark screen, above and behind which something – perhaps part of a picture – rises like a shallow dome, and the pale areas of wall and carpet, together form a simple, striking pattern, very monumental and rather oriental in character, but, if there was any pictorial precedent in the painter's mind, it was more probably the formal arrangement of some Gothic altarpiece.

These two paintings are important milestones, because, although the nude studies done at the Slade were quite personal, compared with these they included much more that was accidental, and in several ways came nearer to the generally accepted idea of what a nude looks like. Here we can sense a much clearer consciousness of Aitchison's goal, and the determination of an artist out of sympathy with the general development of painting since the fifteenth century, feeling his way back to a simpler presentation of the 'clear image' – one of his own favourite phrases.

A complete return is neither possible nor desirable, and inevitably Aitchison retains something, though far from all, that over the centuries has passed into educated ways of looking: for example, a perception of atmospherically modified colour relations. But he is quite free from any sentimental nostalgia for the past. From his point of view, these are very objective paintings of particular models in an actual room in his house, unidealised, and observed without prejudice; but they are so observed by somebody with an extremely idiosyncratic vision, itself Mediterranean in character.

It is the simple clarity of his vision, free from all the obscuring clutter of the centuries with which art talk and teaching have clouded our approach, that gives these paintings their strange, fresh, moving quality. Here in broad daylight, working from nature, he has presented something as he saw it, clearly and forcibly, and it appears to us as remote and surprising, as poetic and mysterious, as some fifteenth-century miniature in a Book of Hours of Bathsheba bathing her feet in a fountain, or as Thomas Mann's gothic, dreamlike short story 'The Wardrobe'.[1] It appears so to us, but not to him. When he looks at his subject, he is all concentrated in his visual

faculty – no romantic associations arise for him. He is hard and classical and down to earth.

With Aitchison's third painting of a female nude in 1963 there is a new development. The claustrophobia is gone, the atmosphere is free, spacious, and open, and all the colours light and springlike. There are pale blues in the background, where a large Crucifixion stands on the floor against the wall, and on the light green carpet the figure, pale as milk, stands easily, her arms hanging by her sides and head bent, one foot very slightly advanced, as if at the brink of water.

In this same year he did some paintings of coloured male nudes, still small, but seeming more solid and substantial than earlier figures. It may simply have been that the dark paint saturated the canvas more thoroughly than the light, but whatever the cause, he strengthened the effect by painting their cast shadows on the pale wall behind them. This was the beginning of a continuing predilection for coloured models. And, still in 1963, he did some profile portraits, larger than any he had done before, and more accomplished than any nudes of that year. Two are of a Greek girl, white-complexioned, with high-piled black hair, rather plump and heavy but with a small retroussé nose and fine sharp profile against a dark ground. Another, against dark green, is of a young woman with a skin that glows like a ripening apricot, a bright, sad, birdlike eye, and dark, waving hair from cheek to shoulder. These have an affinity with the work of Derain, whose influence Aitchison acknowledges. Then there is one of a coloured model, Mr Georgeous Macaulay. The background of this painting was once an intense raspberry-red, which unfortunately, owing to the use of a fugitive pigment, has faded to a sort of pale peach. Against this, however, the bronze-coloured head still stands massive and solid, as if in the round, with air freely circulating between it and the wall; and yet the unity of the surface is preserved. There is a grasp of the shape of the entire head, and a new feeling for varying textures – the close, fine black hair, the porcelain-white of the eye, the rubbery mushroom-grey of the lips, the

[1] In 'The Wardrobe' a traveller finds that the wardrobe in his hotel room, placed against the connecting door to the next room, has no back, only a piece of rough burlap tacked across. Returning after a walk and dinner, he prepares for bed, and opening the wardrobe sees there a young, slender, nude girl. She entertains him every night with sad stories, but if ever he stretches out his arms towards her, she stays away for several evenings.

firmness of the bone-supported flesh with its faint sheen as of bloom on grapes.

During all this time Aitchison never stopped painting small still-lifes and landscapes. The best of these express the quintessence of the subject by reducing the component elements to a minimum, faultlessly placed. To take one example, 'Candlestick Still-life': a few narcissus flowers, with orange centres and pale yellow petals unbroken by any mark, are set, with a few soft green leaves, against a deep cream wall. They stand in a white jug with a faint oval decoration, beside a brass candlestick, its tall white candle pure as the horn of a unicorn, on a table covered with a grass-green cloth. There is no drawn contour anywhere, simply colour against colour, and under this fragile-seeming beauty candlestick and jug stand so firmly on the table that one feels the disregard of conventional perspective to be a deliberate choice.

In landscape Aitchison has known with the same sureness which elements to select, and also – which was not necessary in the still-lifes – how to change the scale of some parts to get the right effect. Consider, for instance, two small pictures, only a few square inches in area, 'Garden at Tulliallan' and 'Poppies in Tulliallan Garden'. In the first, a circular flower-bed is summarised by painting only four flowers in it, but much larger than their actual size relative to the bed. By this device each area of colour becomes big enough to play its part abstractly, and the formal character of the different flowers does the same; in addition, there is the interest, and the lyrical quality, of the particularity of the flowers, instead of a generalised patch of colour in which all that would be lost. A detached spray of leaves suggests the garden beyond, without disturbing the self-sufficient unity of the picture. In 'Poppies in Tulliallan Garden' the same device by which the fullness of the circular flower-bed was represented is used again: two immense poppies slant up, almost floating, out of the grass against the grey wall, nearer to which two other flowers are seen. The white rectangle of the gate is echoed by a couple of barely indicated trees enclosing a rectangle of space above the wall: an exquisite and severe pictorial construction, summing up a sense of place and season.

Aitchison also did one very large landscape, 'Wall and Fields at Tulliallan', nearly 8 ft high and just over 7 ft wide. This is composed of astonishingly few elements, and was painted on the spot. It is a perfect example of the austere and economical architecture of composition which underlies the surface gentleness of his technique. In this large area, an inch

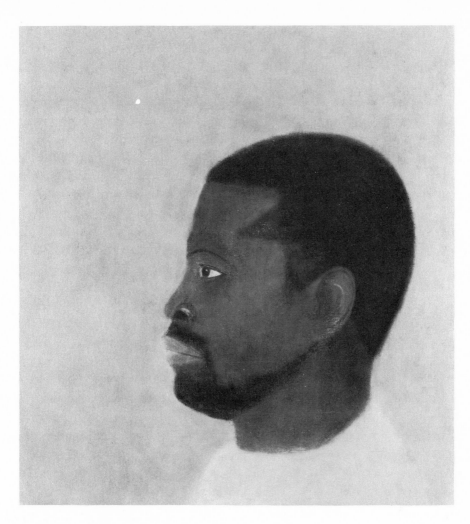

CRAIGIE AITCHISON
Mr Georgeous Macaulay 1963
Oil on canvas, 14 × 13 in
Private collection

or two this way or that from where they actually are, in the case of any of the four straight tree-trunks, the horizon, or the wall, would have destroyed the picture. The slim trees, three on the left, one on the right, with a few bare branches sloping up, rise like the calculated skeleton of an antique temple into the luminous blue sky; the fields are flat and blonde, the long low wall stone-colour; there is nothing else but three white rams sitting there, and a telegraph-pole. An audacious and successful picture.

Probably the experience of doing this combined with that of the 1963 heads to produce an urgent desire to paint more big pictures, with single figures on a larger scale. He had no suitable room to work in, but in 1965 he was lent one, and there he painted the first of a series, which is still continuing, of full-lengths, half-lengths, and busts, both nude and clothed. And just as, after his first visit to Italy, he suddenly began to use vivid colours in his butterfly pictures, still-lifes, and some landscapes, so now the new scale effected a second liberation, this time in the pictures of people, and partly because of the larger areas, sometimes the colours seem even brighter and stronger.

The first of this series was of a standing female nude, white as alabaster against the dark violet-blue of a section of the wall, on an Indian red floor. To the left, the rest of the wall is white, suggesting the freedom of infinite possibilities. On a small easel one of his own landscapes, with a purple path, breaks and unites the larger rectangles of the setting.

And now canvas follows canvas, with a new strength and sureness; sometimes a pale face or figure, clearly carved, glimmers against inky darkness; but more often the colours are brilliant.

It is as if one were led through a magician's palace, and as door after door is unlocked and flung open, from the separate, vivid world of each room a single person gazes out, quite unaware of being looked at. In the Arabian Nights occasionally a magician makes it possible to see someone in this way, while in fact he remains at a great distance. And these portraits, like apparitions, have that strange quality of distance, of reality without absolute illusion, of appearance without weight, of legible form that cannot be grasped, and seem on that account more poignantly beautiful.

Here we see Georgeous Macaulay again, in a blue-peaked cap and short-sleeved cherry-red pullover, sitting bright-eyed in a Mediterranean blaze of sunny golden-yellow.

And now a mysterious, black-walled chamber like a tomb; behind a table (and therefore half-length), resting one arm along it, a pale, nude

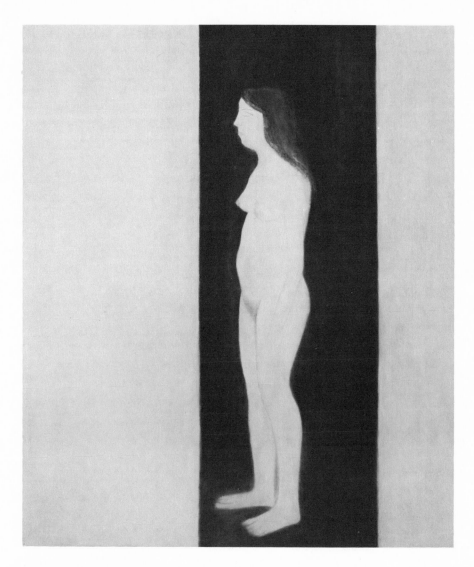

CRAIGIE AITCHISON
**Woman standing in front
of black background** 1966
Oil on canvas, 65¾ × 57 in
Jeremy Fry

woman faces us, wearing a necklace and head-ornament, regally straight, like an Egyptian queen.

Here, against a black panel, as of a doorway, stands a young nude woman, side-view, as if about to step out into the pale blue-grey room. Does she haunt it? She is not lovely enough for the story of 'The Wardrobe', but still unforgettable.

In this room, in spite of the brilliance, it seems to be night. We see a negro, a rather worldly character, in a smart grey suit, with white shirt, collar and tie, against a scarlet-vermilion wall.

Here a flawlessly groomed and made-up young woman in a pink dress and white shoes sits on a high chair against a yellow background, as if at a bar-counter in the sun.

Here she lies with closed eyes, nude, resting on a little rising ground covered with black drapery, and beyond stretches the flat landscape, in varied bands of wheat-colour and green, and the blue sky above; a haunting fusion of outdoors–indoors, of night and day, as in a dream.

And here is an American girl, aged about fifteen, with serious gaze and fair hair, wearing a crucifix in the wide opening of her dress. In spite of her massive breadth she has an aura of spirituality, and in spite of the red background and square-cut red dress, the whole picture has a luminous delicacy, and she looks as if she might have lived at the court of Mantua in the time of Isabella d'Este.

In the first portrait of Georgeous Macaulay, the accident of the faded background, though producing an effect not intended by the artist, brings out a similarity in the treatment of the head to some of the best paintings still surviving in Pompeii and in the museum at Naples, which, though only imitations, perhaps at several removes, of lost Greek masterpieces, still make the clear impact that we associate with the antique world, and show the unconfused power of selection which artists then possessed, and which has dwindled with the increase of realism. Over the centuries we see recurrent efforts to recapture that power – recently, for instance, in Gauguin and Matisse. In Aitchison's work we are witnessing one of the latest of such efforts.

4

MICHAEL ANDREWS

Michael Andrews was born in 1928, in Norwich. Trained at the Slade, he was strongly affected by Coldstream, and therefore at least indirectly by Giacometti and Cézanne. Both by this heritage and by his own temperament he is a typically Northern artist, enquiring, objective, infinitely fastidious and exact. There is very little Mediterranean idealism in him, but, on the contrary, sharp observation of individual peculiarities, almost to the degree of caricature. Against this he has the classical desire to make whole pictures, a natural gift for largeness of composition, and a kind of basic Grand Manner; and although at first he found great difficulty in finishing, he has in fact produced a succession of fairly complete big pictures.

His attention is largely directed outwards, on to the world in which he finds himself living – the world of today, and especially the man-made aspects of it; and he has perhaps the fullest acceptance of modernity among the better painters of his generation.

Having always been able to say what he wished, he has been exceptionally deliberate and given much thought to what exactly he wanted to say. He proceeds extremely slowly, almost like a chess-player, considering every move at great length, as if it were irrevocable. He says, in his 'Notes' in 'X' (March 1960): 'The activity [of painting] is for me the most marvellous, elaborate, complete way of making up my mind.'

His first important picture, done in 1951, before he was twenty-three, was his 'summer composition' at the Slade (which shared the first prize): 'August for the People'. It has an objective freshness of vision which just escapes cruelty, and the delicacy of execution is almost Chinese. The group of holidaying figures on the beach is dominated by the elephantine, shambling bulk of a middle-aged man in black, with pale, puffy head turned in melancholy profile above the frontal aspect of his enormous figure, and with tiny, ineffectual hands; this dark mass is chiefly balanced by the dark hair of a very plain girl lying on her front and resting her head sideways on her folded arms. They are linked by an intricate arrangement

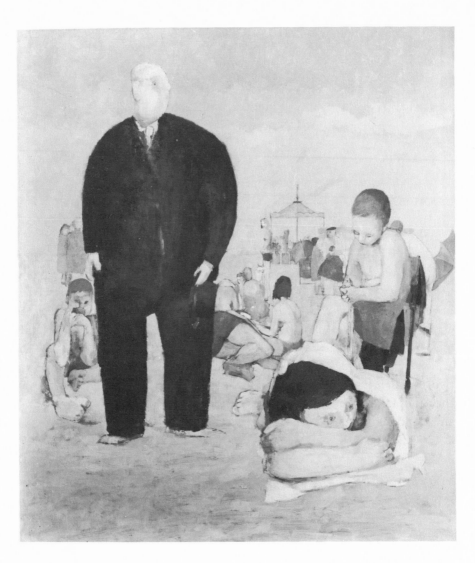

MICHAEL ANDREWS
August for the People 1951
Oil on board, 56½ × 48 in
Slade School of Fine Art,
University College, London

of other figures gradually receding towards a delicate little pavilion in the distance.

The subject was inspired by the opening line of a poem by Auden: 'August for the people and their favourite islands'.

At the first shock it seems almost as grotesque as Ensor. But there is no savagery. It is pure observation, and everything is built up into a composition of remarkable monumentality – very static. The colours are blonde, creamy, sandy, with pale blues and greys, cool as the painter's attitude.

The next memorable picture, 'A man who suddenly fell over' (now in the Tate Gallery), was done the following year. Here perhaps are the first signs of the influence of Bacon (never very strong, but in a limited way often present) on Andrews' work. It depicts a moment of horror, and also movement. It is almost entirely in tones of grey, white, and black, as if it were a photograph – a snapshot catching the instant of falling. The man is large and heavy, like the one in the beach scene, but appears more urbane, and was probably, up to this moment, a figure of some dignity. The massive face, bleached ivory, is still not entirely without dignity, in spite of a look of astonished fright. But now his helpless bulk stretches across two-thirds of the width of the picture, like a stranded whale; he is still in the act of falling, one leg in the air, and the free hand (again the hands are small and ineffectual) seems to seek something to break the fall; but there is nothing. And on the left, just beside his head, stands a little woman, extraordinarily diminished in scale, hunched, cowering, lifting her curled hands towards her ears, her eyes closed, her face screwed up into an anguished grimace like Giotto's wailing angels.

Both these pictures show an awareness of some of the preoccupations of contemporary art, poetry, and cinema. And, in the course of a year, his rendering of the human form has become more personal – both the actual shapes, and the way they are made: the brush-strokes.

After this, the work seems to become more autobiographical, but not as if from any conscious decision – rather, probably, because Andrews himself was becoming more drawn into living.

When he was quite young he seemed to stand on the brink of life, eagerly scanning the prospect as far as he could see, and confident, in a strange way, of victory – as long as he could remain unconfused – confident, rather like Michelangelo's David, the young hero, with his sling over his shoulder. And with his first notable picture, 'August for the People', he

remained quite detached, not even getting his feet wet. With 'A man who suddenly fell over' he seemed to give concrete expression to his own fear of taking a false step. One does not know whether the man will get up again: it is an expression of alarm, not tragedy – quite different from Munch's 'Cry' and from the screaming Popes which Bacon was painting at that time.

Very often the genesis of a picture is a phrase Andrews has read or heard, which has struck him as a very rich, concentrated image, crystallising matters that have lain a long time in his own mind, and suggesting possibilities of visual treatment. Then, over a long period, he makes sketches and collects a mass of relevant material, photographs, cuttings from newspapers and a great variety of magazines, and gradually it all seems to simmer down and clarify. If one sees him during this brooding period, one is struck by the strenuousness of his efforts to arrive at decisions; for although he directs his attention outward upon the world, he is also acutely aware of what it all means to him and of his own situation in it, and is unwilling to say a word, or make a mark, before he is sure of it. He dislikes the mess of having to make corrections, and guards a space round himself to try to exclude, as far as possible, distractions. Also in those 'Notes' he says: 'I am more afraid of becoming confused than of anything else.'

In the twenty years since 'A man who suddenly fell over', apart from studies and small incidental paintings, Andrews has produced barely twenty pictures – but each one memorable.

From the Slade he won the Rome Scholarship, but only stayed in Rome a few months, feeling too uneasy there to remain longer. But while there he painted one extraordinary picture: 'Lorenza Mazzetti in Italy'.

By now he was, to a considerable extent, master of his craft, and could draw and paint, in the traditional sense, with delicacy, firmness and economy, figures in their setting. And, whether from knowledge or instinct – probably both – he could achieve a unified and monumental composition. In the first two important pictures, all this was placed at the service of the Northern point of view, with its quirky particularity and tendency to genre, to the everyday – though in the second there is an element of the heroic, or anti-heroic, for it is almost the same thing: it is elevated to a symbolic level.

But the picture done in Rome is different, and unique in Andrews' output.

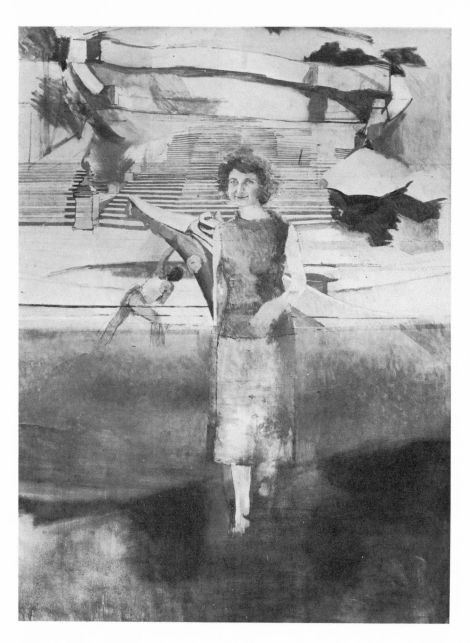

MICHAEL ANDREWS
**Lorenza Mazzetti in front
of the Spanish Steps** 1954
Oil on canvas, 77¼ × 57¼ in
Private collection

It was done from a photograph, of this almost lovely, very bright and intelligent-looking girl, standing in front of the Bernini boat-fountain at the bottom of the Spanish Steps. No doubt her smile was copied exactly from the photograph, yet one cannot help feeling that memories of Leonardo (even if unconscious) constituted a part of its appeal. And perhaps it was done with the same scrupulously objective attitude as the others – perhaps it is the subject and not so much the treatment which is so different. But he did choose the subject. And whether or not it was the influence of Italy – the clear air, the light, the inescapable nobility of Rome – it is a picture of classical calm and beauty. If one says it is unfinished, that is only in the sense of the old convention, according to which one expected complete and equal definition of everything repre- sented, but especially in figures – all the fingers, and so on. This is unfinished in the same sense as some of Cézanne's work – and in fact one can see here very plainly, especially in the architecture in the upper part of the picture, the influence of Cézanne – unfinished in a way to which we have grown used in Andrews' work: the image is complete, and were the so-called unfinished parts divided into what we know to be their con- stituent elements and tidily defined, the impact of the image would be diminished, perhaps destroyed.

Lorenza Mazzetti had made a film, *Together*, in which Andrews and Paolozzi played the chief – almost the only – parts. So this was something of importance in his life, and so was his difficult sojourn in Italy. Thus it was one of the first of that long chain of big pictures which, until his comparatively recent retreat behind a screen of reserve, he went on slowly (very slowly) producing, of which each is unique and different from the rest, but of which one can say: this is an aspect of the world in which he lived at that time, and the picture expresses not only the objective reality, but something of his relation to it and situation in it.

In this Italian picture, more than in anything else in all Andrews' work, one feels the presence of a pictorial ideal rooted in the Italian Renais- sance – the desire for noble shapes, large rhythms, for every element of the composition to be kept pure from all disturbance of trivial accident. It is like an act of homage, and at the same time of farewell, to the great classical Mediterranean ideal, the measured purity of Piero, the dreamlike grace of Leonardo, as if henceforth he was resolved to turn his back on those ideals, to come to grips with the modern world, to let the forms of his pictures be dictated by what he found there – in short, to be of his time.

There followed a strange picture, much smaller, 'Sunbathers' (now in the collection of the Arts Council), of four people sunbathing in a Norwich garden.

Here there is a return to the merciless observation of 'August for the People', but it is a more sophisticated and committed picture. The first, though an early masterpiece, was, by comparison, tentative. Here Andrews is painting people he knows, in a familiar garden. At first sight it is disconcerting, because of its strangeness, its apparent break with all traditional ideas of beauty, proportion, design, a certain almost uncouth, gangling awkwardness. But the longer one looks, the more one is struck by its truth, convinced of its actuality. And gradually, as is so often the case with an original, authentic vision, that which at first seemed ugly acquires a peculiar beauty. For by now Andrews' vision is mature. He has his own quite individual way of perceiving and rendering form, whether human, landscape, or inanimate, and his own equally personal feeling for a pictorial whole.

Here are the very long legs – objectively considered, quite without grace – which from now on often appear in his pictures; and the fat man in the deck-chair, in front view, the thin, very elongated young man in side view, with a tiny hat perched above his profile, the girl sprawled in the foreground, surprising as they all are, become, in the course of contemplation, as pleasing as Gainsborough's early picture of Mr and Mrs Andrews, and not without affinities to it. And, unexpected as the composition is, the more one looks the more one sees how deeply considered it is, how every shape plays its part and indeed how much scholarship – whether conscious or forgotten – underlies the whole work. The contrasts of light and dark are strong, the air seems to glow as if through stained glass; the picture has the rare, dreamlike quality of a hot day in the cool North: vibrant, still.

Then a new artistic influence makes its appearance – in general, French Impressionism, in particular, Bonnard. This might in some ways seem foreign to the astringency of Andrews' real nature. But looking back, one can see it as a natural and necessary reaction after the long discipline of the Slade, so heavily biased towards tonal painting and so firmly founded on the Renaissance tradition of drawing. For a young artist resolved to look with his own eyes, Bonnard is after all a very understandable attraction, for more than anyone else he preserves the surprise of the uninterpreted flatness of our natural vision, a seeming chaos out of which he extracts

unexpected contours and upon which he imposes order, and all by means of areas of vivid colour.

The first big picture in which this influence is strongly apparent is 'Late Evening on a Summer Day'. Taken separately, especially in terms of silhouette, the elements of which it is composed are still characteristically Andrews shapes, but the experimental bright colour, very much after Bonnard, seems to have preoccupied him so much that the design, compared with his best, lacks tautness, and is a little slackly strung out through a scattering of couples and single figures – scarcely more than boys and girls – settling to sleep or amorous play, after a party, in a garden-room and verandah open on to the purple summer night. It is the first of a series of party pictures in which Andrews confesses his susceptibility to glamour.

A dictionary definition of glamour is: 'allure, charm, a deceptive and fascinating quality about a person or place that attracts in spite of the reality; seductive fascination'. Almost of necessity, it operates chiefly by night. By contrast, daylight appears innocent, and, besides, too clear and open, too searching, for deception.

At about the same time, Andrews painted the picture 'Girl on a Balcony', now in the National Gallery of Victoria, Melbourne (Felton Bequest). A nude girl, pensively resting her head on one hand, sits in a white-painted iron chair, with similar chairs empty around her, on a terrace bordered by a balustrade of little, full-bellied columns, overlooking an expanse of water, surrounded by plane trees, on which a few boats move. This setting was taken from photographs of the Luxembourg Gardens. The colour is cool and silvery, and the Impressionist and Bonnard influences are more digested and assimilated. The picture has a classical quality, but whereas the one done in Rome spoke clearly of the Florentine tradition of draughtsmanship, this appears rather to descend from the Venetians, with their freer handling, atmospheric subtleties, and languidly voluptuous nudes in landscapes. The mood recalls Giorgione, and in spite of the improbability of the scene, it is, in an odd way, real.

And now for a time the work divides into two streams, which run parallel: day pictures and night pictures.

There is, however, one very strange work (not very large) which falls into neither category but successfully combines them both: 'Liony Piony' – a theatre scene taking place in daylight – or rather, a dream of a theatre scene, for it is made more real than it could be on the stage. The

youthful Androcles (based on a photograph of Nijinsky) is half-seated, half-reclining, in the long grass, and it is no longer a question of a back-cloth and stage-set; we seem to be looking at an actual landscape. The silvery-golden flicker of sunlight on thick vegetation envelops everything, man and lion, and the lion is more than a stage one, yet less than a real one, while the sunlight has the magically heightened quality of stage sunlight. But is there not a memory, in the pose, of Michelangelo's newly created Adam? Yes, surely, and here he plays in the Garden of Eden with the still harmless beasts; and his head and neck and lifted left hand remind us of those moments of almost superhuman grace and beauty which the theatre sometimes fleetingly achieves.

Decidedly, a picture of glamour.

The most remarkable of the day pictures are the 'Digswell Man' (or 'Man in a Landscape') (1959), and the large 'Family in the Garden' (1960–2), while the night pictures of this period, which included some paintings of the Colony Room, culminated in the large 'Deer Park' and still larger 'All Night Long'. After this, Andrews' work changed; but it was the night scenes through which he continued to experiment, and develop a new style. The carefully studied day pictures came to an end, marking as it were the end of his apprenticeship, by a masterpiece: 'The Family in the Garden'.

In this picture we see from the outside the same latticed porch which we saw from the inside in 'Late Evening on a Summer Day', but it is at once clear that this is the reality, while the other was part of a contrived setting, the decor of a dream. Here we have again the sharply analytic, objective attitude which produced 'Sunbathers', but in a purely pictorial sense as well as psychologically this work is immeasurably more massive.

He worked on it for three years, and one feels that, as so often with Andrews, the first conception was probably not visual, that what lies behind it might have made a book, but that his preferred language is painting. And that being so, and the decision made, it is pure painting, in the Great Tradition brought up to date, and every touch personal. The proportion of clear, undisturbed areas to broken-up, complex ones, the flattened serpentine curve sweeping through the picture, the angular shapes, the clearly defined planes, the cool, luminous colour – all are intensely characteristic.

The great Italian paintings told stories, and were no worse for that. The story we read here is like one of Chekhov's – elusive, almost eventless, and

yet seeming to fill the dimensions of a novel. The artist's father looms large in the foreground, and the chain of figures in sharply diminishing perspective curves away, through the brother drinking tea, into a line not quite parallel with the picture-plane; the brother is linked by the glittering whiteness of the tablecloths and crockery to the sister, whose dress appears to touch the point of the extended garden-chair on which the mother, very small – as if shrunk into herself after all her labours in producing, rearing, and sustaining – rests, with her feet up; and behind her sits the little grandmother, who in fact died before the picture was finished. The large shape of the father in the foreground is answered by the two tiny ones at the inner end of the line, which runs gently back into the picture and is caught up and turned by the herbaceous border and the trees, and carried round again towards the porch, where a figure – the artist, perhaps? – is just vanishing into the darkness of the doorway. Not a story in the sense of a narrative, yet in painting it seems a story. It is not just any family – an academic exercise – but the artist's family, and his home, painted as objectively as possible, but with profound knowledge and affection. Everything shines in the luminous Norwich air. An apple tree casts its crisp, light shadow on the lawn. One seems to smell lavender, and fresh linen dried in the open. The people are real, each one heavy with an individual life, and death. The mother and father, placed at opposite ends, are like supporting pillars, and the children grow up between, protected but encouraged. One can sense convention, but also elasticity, mutual affection and respect, and the very solid and secure foundation upon which the painter grew up, and which he left, like the younger sons in fairy-tales, to try his fortune in the great city; and one feels that if he were transplanted, as a sapling, into a less peaceful climate, exposed to storms and unpredictable dangers, there would be reason to hope that enough of this wholesome earth would cling about his roots to ensure their getting a firm hold and maintaining his equilibrium.

Later, in 'The Colony Room', 'The Deer Park', and 'All Night Long', we see what Andrews found in the great city. But before that he had moved to a sort of artists' colony in Digswell, where he lived because of the difficulty at the time of finding anywhere in London, convenient for work, that he could afford. He did not like it. And probably it was there that he wrote, among those 'Notes' in 'X': 'For the sake of familiarity (which is much more valuable than strangeness) live anywhere for a long time, even if you don't like the place.' And the picture of the Digswell man that he

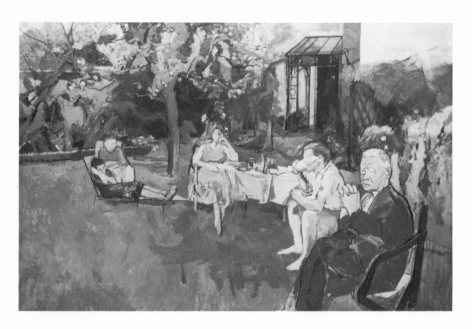

MICHAEL ANDREWS
Family in the Garden
Oil on canvas, 78 × 118 in
Calouste Gulbenkian Foundation,
Lisbon

painted there speaks of this discipline.

The man was the gardener, and was not quite what is called normal. Andrews did not like to embarrass him by asking him to pose, but built up the work by watching him as he passed every morning and evening. There is a painting, belonging to the Arts Council, almost as big as the final one, though more of a sketch, which, like the small studies, gives a feeling of having caught more of the man's peculiarities; but the other, the very worked one, gives a quite extraordinary sense of the enduring actuality of the landscape – a maltreated countryside of raw red and green, convincing us that it continues to exist while we turn away from it and sleep – and of the recurring reality of the doomed man's twice daily passage through it. One almost feels the clay sucking at his boots.

In 1962 Andrews was living in London again. And now followed a period of considerable upheaval, of choices and decisions. One of his last straightforwardly studied daylight works of any size (there were several very small ones) was done at this time, the 'Portrait of Timothy Behrens' – a good painting, but one can feel that his heart was more engaged in the fairly large night scene of 'The Colony Room'. This, too, is studied. Every figure in it is a portrait, even if from the back: Francis Bacon, Lucian Freud, Muriel Belcher, and many others; and the whole is still in the Renaissance tradition, a remote descendant of Masaccio's 'Tribute Money'. But in spirit it is the prelude to a new phase, and indeed before it was finished, and as if in an irrepressible burst of energy, in the space of three weeks Andrews painted the wildly fanciful 'Deer Park' (7 × 8 ft), now in the Tate Gallery.

It was 'sparked off', he said, by the quotation from Mouffle d'Angerville's *Vie privée de Louis XV* which Norman Mailer puts at the beginning of his own *Deer Park*, and which begins:

the Deer Park, that gorge of innocence and virtue in which were engulfed so many victims who when they returned to society brought with them depravity, debauchery and all the vices they naturally acquired from the infamous officials of such a place.

How far Andrews has travelled from that first 'party picture', 'Late Evening on a Summer Day', which by comparison appears a very innocent affair, and a relatively simple arrangement of figures and other elements placed here and there from considerations of surface pattern. Here he has launched into the bold three-dimensional complexities of a flamboyant

[46]

baroque design, and seems intoxicated with a sense of his own new powers as much as with the subject. The entire work expresses speed, in its sweeping curves and swirling movement, and its streamlined staircase leading to the upper floor, of which we see the underside cutting off the view of a vast park – adapted from Velasquez' 'Boar Hunt'. The ground floor is open on to the park, which seems to be growing light with dawn. Again the setting seems contrived to provide the framework of a dream. The furniture spills out into the landscape; a grand piano is seen quite far away; the dark, characteristically serpentine curve of the staircase, springing up vertically on the left of the picture and streaming out horizontally across the top like a waterspout, the dark foreground, and a partition on the right partly supporting the upper storey, all combine to make a large, bold shape like the huge capital letter of an illuminated manuscript, about which the figures and other small forms spring and wreathe in embellishing flourishes. Everything seems to come and go and flow into something else in a continual flicker of movement, revolving round a young man, quietly seated, to whom Andrews has given the well-known features of Rimbaud, who, especially through the *Illuminations*, was a potent influence on him at that time; and this firmly painted head becomes the unmoving centre of the whole swarming, fluid, visionary party – as if it were *his* vision. And there is still a kind of innocence, even here. Everything seems marvellous, as if some young man had stood outside in the street, face glued to the glass, gazing in at this fantastic party until, falling asleep, he had found himself, in a dream, on the other side of the window. There are no moral judgments. That which is ravishingly lovely (Marilyn Monroe is seen upstairs) is acknowledged to be so. Depravity is presented with a kind of wide-eyed wonder. It is an exuberant sketch, at the high point of youthful poetry, and had it been taken any further it would have lost everything, for the very essence of such a sketch – as of glamour – is that it is full of mutually exclusive possibilities, and hints at the fulfilment of impossible dreams, the reconciliation of irreconcilable contraries; but once the final choices are made, and definition replaces suggestion, the magic escapes, the world shrinks back to its imprisoning actuality.

The next, and most ambitious of these party pictures, now in the National Gallery of Victoria, Melbourne (Felton Bequest) is the huge 'All Night Long'. Writing of this and the 'Deer Park' together, in *Private View* (1965) John Russell says:

What is going on has elements of orgy, elements of nightmare, elements of a stylised 'good time', and elements of fugitive deep feeling. If these pictures are about anything, they are about the contrast between the shoddy machinery of pleasure, the collective apparatus of excitement, and the separateness in which the individual proceeds towards disintegration. Recurrent throughout is the extraordinary, contrary, confounding beauty of youthful human beings.

This is true as far as it goes, but it does not touch on painterly matters, on the change of technique and style in the later picture.

It is in this picture that Andrews makes a definite break with his youth and finally turns his back on the traditional methods of painting he had learnt at the Slade. The delicate tonal transitions of the 'Deer Park' are gone, and with them the dreamlike quality and the poetry. The whole scene takes place under glaring lights – akin, one feels, to the light of disenchantment – and everything is as harshly defined as in a poster. He had been using photographs for a long time, but here he keeps more rigidly close to them, so that although he has built up, again with a baroque freedom, a very bold composition, it is more staccato; the separate elements, slightly intransigent, have resisted unification and asserted themselves against the conductor. It is full of interest, and can hold one's attention for a long time, and invite repeated scrutiny; but it is without mystery, and fails to bewitch. Nevertheless it was a brave step to take, on the part of a young artist who had been so thoroughly through the mills of tradition, towards the development of a new technique, which he clearly felt necessary for expressing the world of today.

It is interesting that both these ambitious compositions look better in the colour reproductions in *Private View* than in reality – probably because the reduction and inevitable loss of detail have simplified, condensed and strengthened the design in both cases, but especially in that of 'All Night Long'; but possibly another reason may be that, seen on the page of a book, an illustrational quality is more acceptable. And there is such a quality in these pictures, in contrast to 'The Family in the Garden', which, for all its seeming 'story', is entirely painterly. Perhaps a growing consciousness of this may have contributed to the eventual disappearance of human beings from Andrews' pictures; but not immediately, for in fact the next three pictures were, if anything, even more story-telling, though

in a symbolic way. They portray a single party, at its beginning, middle, and end, the setting being taken from a photograph of a luxurious indoor swimming-pool with palms and plate-glass windows; but the visible scene is no longer the principal subject, for these pictures are concerned with invisible, self-questioning, psychological matters – with the inflation and gradual deflation of the ego, experimentally represented by formal distortions.

After that, Andrews conceived the idea of a long series of pictures called 'Lights' – again in Rimbaud's sense of *Illuminations* – which had, for him, a profoundly symbolic content, though at its face value it simply portrays the voyage and adventures of a balloon.

It happened that he saw a very beautiful photograph of a balloon ascending over a wide landscape, at about the same time that he read a book in which occurred the phrase: 'this skin-encapsulated ego', and in a flash this conjunction seemed to crystallise what he had been thinking about for a long time.

The first painting, which is very wide, shows a white balloon ascending over a very dark green, undulating landscape, with trees, rocks, and inkily dark lake. There is no skyline, because it is seen looking down from above, from a higher balloon, the cable of which, blurred by its nearness, cuts slanting across one end of the picture. What is quite extraordinary is the sensation it gives of floating, drifting, movement. It looks as if blown on to the canvas in a single breath; and the paint was, in fact, after very long preparations, sprayed on. This picture, however, is more like a *painting* in the traditional sense than any of the subsequent ones so far, and, I think, more beautiful.

The next, an upright one, shows the balloon – this time black – dropping gently down at night into the well formed by huge skyscrapers. Most of the windows are lit up. The paint is matt, also sprayed on, but the light in the windows is painted with a brush, each with a single movement. In a block of white-lit ones near the bottom the effect is of a page of thick capital letters, of some text which one cannot quite read – perhaps in a strange alphabet – and this has a formal relation to the clear white capitals of the title in the lower left corner, 'THE SHIP ENGULFED'. In the well of shadow right at the bottom, the long curves of one or two large cars flash and glimmer, electric blue. This picture approaches the appearance of Japanese colour-block printing.

Then there was a large horizontal picture of half a liner, also at night,

and lit up, passing along a wide river, on the banks of which one gradually perceives the buildings of a great city, layer beyond layer. There are no figures, unless very small and scarcely visible; and there may be a connection between the facts that Andrews has stopped painting the human figure (except on the most minute scale, in which the individual is reduced to a mere ant among millions) and that he has become increasingly able to finish his pictures. One feels that his relation to his subject-matter is becoming cooler and more detached than at any time since his first 'summer picture' – that his energies are being concentrated on problems of technique.

At the end of 1974 he exhibited four large pictures done in that year and the preceding one. They complete and sum up the change, the earlier stages of which we have already seen, from the traditional disciplines of oil-painting in which he was trained, to a technique relying on contemporary inventions and involving different pictorial aims. The basis of his new method is: to eliminate as far as possible the fallible human touch, the trace of the emotional personal gesture – as if he feared and mistrusted these things.

It is already many years since, in amassing material for his pictures, he abandoned the practice of making studies, such as pencil drawings – though sometimes he has made small paintings from photographs. He arrives at his compositions by moving prints around, and making new photographs of the resulting collages. The image thus composed is transferred to the canvas, mathematically enlarged, determined by a multitude of measured or calculated points. The paint – acrylic – is sprayed on, in areas controlled by stencils or some equivalent system of limitation, such as masking tape, sometimes in almost incredibly subtle gradations and colours. Fine lines and very small touches must still require the hand-held brush, but as far as possible an apparatus of modern inventions is interposed between the artist and the canvas, to guard against the direct touch, so that there should be no fumbling, groping, slurring, or mess of any kind; and to be expressible by such means, the conception must be correspondingly clear. (All this is in keeping with the activity of painting being 'the most marvellous, elaborate, complete way of making up [his] mind'.)

Inevitably, in the basic rhythms, and in all the choices and decisions throughout the execution, and through the movement of hand and arm whatever the tool held, something characteristic of the personal gesture

remains, but with the minimum of spontaneity, the maximum of deliber-
ation. And this quality of remote control appears itself to be expressed in
the prevailing blue colour of all four of these latest pictures – the coolness
of the intellect, the very colour of distance – the ethereal blueness of sky
and sea reflected over and modifying all the other elements.

In spite of the cleaner, flatter treatment, however, in the first two of
these pictures Andrews is still using tone. In the first, 'The Pier and the
Road' of the title stretch at right angles to each other, modelled in bright
sunlight and shadow, and drawn in all their elaborate perspective with
Florentine sharpness, almost illusionistic. The road rushing towards us
expands nearly to the width of the canvas, which it seems perpetually
about to leave, falling forward over the edge into the nothingness of
unrelated three-dimensional reality. It seems to remain with difficulty
only just attached to the two-dimensional surface by the pull of the long
line of the pier, and this unease, combined with the fact that in all this
brilliant sun there is not a living creature in sight, gives a disturbing
Surrealist effect – not without beauty – a little like a deserted stage-set, or
exquisite architectural model.

Even more like an architect's model is 'The Pier Pavilion', for the little
figures are too reduced by distance to impinge on us as people. Seen from
above, and also strongly modelled by light and cast shadows, the whole
scene lies on the canvas like an aerial photograph, but with a curious
absence of scale, and very clear-cut, as if it were a toy. But all is held at a
distance at which it is more self-contained than the last, and therefore
more naturally appropriate to a flat surface. And it is both mysterious and
reassuring that, after more than twenty years, many of the shapes,
especially of the tiny figures on the beach and round the pavilion, resemble
in character those in 'August for the People', and there is also a similarity in
the colours and their relations. This is the most poetic of the first three of
these last pictures, and will probably have the most lasting appeal.

'The Spa' (1974) moves furthest from the European tradition and
closest to the Japanese. It is a fantasy, composed from photographs of
Manhattan and Scarborough – a blue nocturne, sprinkled with lights. We
see the large head-lamps of a line of cars along one side of a coastal road,
and further away, on the other side, the small tail-lights of the other line.
This road widens as much, and comes as far forward, as that in the picture
of 'The Pier and the Road', but whereas that one seems to be continually
shooting towards us, this one is restrained, bent downwards, as it were, by

a large curve, and by this device is held back firmly to the picture-plane. In addition, most of the headlights have vertical reflections, which makes them appear like pairs of tassels, and has the effect of stopping the movement of the cars and pinning them to the surface. The whole picture is entirely static. It is also pure, insubstantial appearance. Road and sea, bridge, trees and houses, are presented as flat shapes, without light and shade or change of colour, not referring to other aspects of themselves in space, nor backward or forward in time to other moments, nor to any thought, idea, or event. On its own terms the picture is faultless, but those terms are entirely decorative. And I think that, having gone to such extremes, Andrews may have realised that the European tradition of the three-dimensional, tone-built aspect of things is too deeply embedded in his nature to be torn out with impunity.

In the fourth and last of these pictures, 'A Shadow', movement returns – movement and the breath of life. It is a much simpler image than the other three – a shadow, on the sand, of an unseen balloon, and nothing else but a scrawl of seaweed, a line of foam at the edge of the shallow wave just turning over, and the sea and sky. The treatment is different from the colour-block, print-like flatness of 'The Spa'; it is full of subtle variations, and no doubt it is Andrews' perfect mastery of his means which has allowed the colours to fall on the canvas so lightly, in such dissolving nuances, that they seem accidental traces of blown vapour. The shadow floats over the sand like a beautiful question-mark, and though the image is complete in itself, we feel it connected with life outside, with the real but invisible balloon, and with a mind asking questions – as if some passionate explorer, living between sea voyages an exemplary, tightly regulated life on land, were suddenly off again, having felt once more the call of the open that he has to follow.

Thinking again of 'The Family in the Garden', I remember how it suggested to me a comparison with Chekhov; and it occurs to me now that that picture was painted as it were from the inside of the world that Chekhov shows us. For Andrews is an optimist, and was then young; and Chekhov is a tragic writer, the underlying theme of all his work being the gradual bruising of youth by 'real life'. No one has portrayed with greater delicacy and sympathy the sheer marvellousness of youth, the immensity of its dreams and ambitions, the purity and height of its ideals, its ardent faith and hope, and the conflict of all this with the world as it is: how these high fires are slowly quenched and sink to ashes. But in Andrews' pictures

we still feel – as in his youth – the buoyancy, the confidence of victory, the will to succeed, the determination to survive. We feel his acceptance of the world as it is, and his ability to deal with it; his acceptance of modernity, his delight in the beauty of machines, in the streamlined perfection of curved wings and blades, of aeroplanes and fast cars and liners, in bright lights and speed, in new kinds of materials, in the glitter and luxury of expensive holiday places. We feel, too, that he intends his pictures to take their place as equally brilliant objects in this dazzling phase and section of civilisation. His equipment is not shabby, nor has he allowed it to deteriorate. It is, on the contrary, more immaculate, fresh, and sparkling than ever.

So here let us leave him, with the balloon in mid-air, and await the sequel.

FRANK AUERBACH
Head of E.O.W. 1955
Oil on board, 31 × 26 in
University of Cincinnati

5

FRANK AUERBACH

It is seldom that one remembers the full strangeness of the first impact of works of art with which, over the years, one has grown familiar. But I remember the extraordinary effect of Auerbach's early paintings of Primrose Hill, all in yellow ochre, grooved, engraved, as if in wet gravelly sand: as if one had fallen asleep after long contemplation of some Rembrandt with a glimpse of mysterious parkland in the golden-brown distance, and then in a dream found oneself actually walking in the landscape. And that first large head of E.O.W., mud-coloured, silvery, and greenish umber, as haunting as if one had dredged up from the Nile the half-effaced relief of some great head from ancient Egypt: the powerful brow, the bony ridges of the eye-sockets heavily shadowing the down-bent eyes, the strongly marked cheek-bones, and then the narrow nose which still does not quite prepare one for the small, fine mouth – a severe, spiritual face, and, above, the great mass of the cranium, the hair sweeping round and round and finally lost in widening circles: uncannily alive.

There were also portraits of Leon Kossoff, among them two heads very much larger than life, which seemed as if the planes were carved out of a stubbornly resistant rock-face of grey stone, and further defined with white and black paint, which looked as if it had got there by itself, by accident, and yet was delicately exact. The effect of a combination of art with natural forces and materials is very strong, and contributes to their beauty, mystery, and reality.

This would perhaps be the best place for a few words on the unavoidable subject of thick paint.

The emphasis on material in modern art probably arises largely from the artist's difficult position today. He is not wanted. He has lost his status as the skilled practitioner of a recognised craft. It is hard for him to earn a living. More than most, he must be tormented by doubt as to the worth of his work, his own worth, sanity, even reality. Natural, organic things – feathers, fibres, wood, bone – such as many modern artists have incorporated in their work, have a reality which becomes ever more precious as the

world fills up with plastics – and to handle real stuff, even thick paint, gives to some extent the feeling of being a craftsman, of being real oneself. This has probably contributed to the comparatively recent excessive attention to what was always known but taken as a matter of course by good artists, namely, that any art develops out of the possibilities inherent in its medium. To make an image that is real, that convinces, even surprises, himself – this is what the artist has always wanted, but today, in his desperate situation, he wants it probably more than ever before, except perhaps in very early times when it was still associated with magic.

Something must also be said here about Leon Kossoff. Auerbach was born in Berlin in 1931, and came to England in 1939. From 1948 to 1952 he studied at St Martin's School of Art, where he met Kossoff, more than four years his senior, who, having done his military service, was always a year behind Auerbach at the schools. Each, however, was strongly affected by the other, and a lasting friendship grew up between them. Both attended Bomberg's evening classes, and, after St Martin's, continued their studies at the Royal College of Art. When Kossoff married, Auerbach took over his studio, where he still lives and works.

Undoubtedly the strongest influence on both was that of David Bomberg, an important painter and quite extraordinary teacher, inspiring his followers with something like religious fervour. Auerbach and Kossoff were by far the best of his students, each developing his own very individual personality. But in those early years, in spite of the differences, their work had much in common, which caused their names to be linked, as they still are even now, though less often.

There were qualities which they both acquired from Bomberg – a faith in good drawing as the absolute foundation of visual art, a vehement integrity, and relentless emphasis on fundamentals, on organic wholeness. Bomberg felt himself in the true line of descent from Giotto, Michelangelo, and Cézanne, regarding Cézanne as having cleansed art from the 'stifling adhesions' gathered over a long decadence. 'Cézanne is father to me and the artists of the future,' he said. And his passionate love of drawing, and even something of his personal approach to form, have remained characteristic of both Auerbach and Kossoff. But their situation is like that of brothers who appear to strangers as having a strong resemblance, while inside the family and among close friends their differences seem greater than any likeness.

At first they often painted similar subjects, especially building sites, and

this was partly responsible for the coupling of their names, added to their use of exceptionally thick paint (not derived from Bomberg) and its restriction to the earth colours. But in their attitude to colour itself, all three differed radically from Cézanne and from each other.

Bomberg regarded feeling as almost more important than appearances – a sort of physical sensation of mass, weight, strains and stresses, pushings and pullings and directions of growth and movement working from within to create the outward and visible form. In this respect Kossoff has remained closer to him, while Auerbach's approach is more intellectual and visual.

Auerbach seems determined to restrict his painting to the representation of parts and aspects of the physically visible world familiar to him, excluding comment, memory or the expression of emotion. In earlier times this would have resulted in paintings closer to the appearances seen or easily recognised by non-painters. But the visible world in all its aspects has been so thoroughly explored that in so far as the representation of it constituted a problem to be attacked and solved in publicly acceptable ways, this has been done, and the problem has therefore ceased to be of public interest. Every new attempt is now a personal and private adventure for the artist, and, on the whole, the results are becoming more and more personal and private. It has always been the case with every good painter that his work is a very subjective, personal and peculiar reflection of the visible world. If it were not so, the pictures would be of no interest. Yet it is possible and indeed probable that, in the past, many great painters – as various, for instance, as Titian, Rembrandt, Velasquez, Vermeer, Degas, Monet – thought in terms of arriving closer to the truth of actual appearances than anyone else had yet done, and were scarcely conscious that they were really externalising their inner world. Today I think we know that there is no such thing as an impersonal, objective vision which is 'true'. But there is an accumulation of inherited skills, developed and handed down through centuries, which puts it within the power of very moderate talents to reproduce what they see in a way that conforms to a very general expectation, and is therefore trite and commonplace. Unfortunately this kind of work is often described as 'traditional'; the right description would be 'decadent', and it is against such decadence that Bomberg's fulminations were directed. The few painters working in the genuine Great Tradition are well aware of all this, and it adds to their difficulties by pushing into the foreground of their consciousness the

[57]

necessity for honesty and the avoidance of clichés. But creative work can only go forward in a positive way, with some degree of warmth and spontaneity; therefore these painters all invent their own procedures, designed to make it impossible to use worn-out formulae, and thus to release all the creative energy which would be inhibited by their having to be on their guard.

A poem by Jacques Prévert, describing the method for painting the portrait of a bird, expresses in a vivid image this modern attitude, of which Auerbach's approach is an extreme example. First of all, he says, the painter must paint a cage with an open door, then lean his canvas against a tree in a wood, and hide in silence, waiting without losing heart, if necessary for years, the speed or slowness of the arrival of the bird having no relation to the success of the picture. When the bird arrives – if it arrives – the painter must remain quite quiet while it goes into the cage, and then gently close the door with the brush and add a few necessaries. If the bird does not sing, it is a bad sign, a sign that the picture is bad; but if it sings it is a good sign, a sign that you may sign the work.

Auerbach says he has 'a deep belief in painting as an experimental activity'. This is not uncommon today, though every good artist is unique in his experiments. The attitude itself and the phrase describing it are borrowed from science, probably because it was felt that art had lost its way, while science was advancing further and further into the central mysteries of existence, and not only making discoveries but by their application affecting the life of all the world. And so it must have seemed that art could not do better than imitate the scientific approach.

Doubt at the deepest – or highest – levels has always been with us, but today more than ever before; and science perhaps has learnt how to make a virtue of it. Yet scientists themselves function more like artists than artists used to think. They have to have ideas, visions, guesses, even a kind of faith, before they can decide what experiments to set up; and in their minds too the image of the world and of the universe is a subjective one, and also a provisional one, liable to be changed by future discoveries. Nevertheless, even though their conclusions may never be final, they have to their credit an immense body of facts. Scientists are the people *who know*. And their knowledge can be shared for common use, and this is comforting. Even their work, their experiments, are often communal. But an artist does not have this comfort. He works in solitude. And there is nothing but sensitivity – his own and that of a few others – to assess the

results of his experiments; there is no proof. Nor do these results add positively to a common fund, of undisputed service to other artists. The only comfort that an artist can derive from associating his way of working with that of scientists is the feeling that he is steering in the same direction as that chosen by the most enlightened minds of the age. And even this is open to doubt. However, for Auerbach I think it means that he hopes, by dint of looking and working faithfully and persistently, to stumble upon the right solution, the right conclusion, of a painting, which he was not able to imagine beforehand but which he will recognise as being right because it will be like the person or place – hence true – but in a way that surprises him – hence a discovery; and it will be self-sufficient and satisfying considered purely as a formal conception; and also it will be as forceful and economical a statement as he is capable of making of that hitherto unrecognised aspect of his subject.

Part of his procedure (making the cage) involves an arbitrary limitation of means. In this he is like a poet who wants to purify and revivify a language, and so deliberately denies himself the use of a great many words, and, confining himself to a few basically necessary ones, tries to wring the last drop of their possibilities from them, to see how much he can make them say, and with what newness and force. Thus, after his first really characteristic paintings, which were already very remarkable, Auerbach began, in the early 1950s, to restrict his range of colour to an extraordinary degree, the most extreme examples being the pictures of Primrose Hill, already mentioned, all in yellow ochre. There is also a picture of a building site at St Pancras, with very small amounts of black and red, but the scene really created in yellow ochre; and even in 1960, after a few years during which he gradually increased his range of means, he returned very close to these severe limitations in two large and impressive pictures of an Oxford Street building site and one of Maples' demolition. Obviously there was no way of achieving his aims but by sheer vigour of drawing – sometimes with wide brushes leaving clear tracks with raised edges, or with a very loaded brush, or with a knife, or, so to speak, etching into the ground of paint – making grooves and leaving a burr. In relation to shapes drawn in these ways, comparatively smooth areas became legible, to some extent by the direction of the marks making them, but probably more by their context, as important planes, such as horizontal ground or vertical walls. This technique, combined as it then was with a high point of view, bringing the distance near and excluding the sky, gives an effect of

FRANK AUERBACH
Oxford Street Building Site II 1961
Oil on canvas, 76 × 60 in
National Gallery of Victoria,
Felton Bequest, Australia

tipped-up, shallow space, and of the convention of low relief. In some building sites of this period, and also in three recumbent nudes, back view, there is more colour – earth-reds, bluish-blacks, dull ivory and umber – but all the elements are similarly compressed into a shallow depth, with the same poetic sense of reality being achieved by means of a severe convention. The first sight of these paintings is like coming upon something from an earlier civilisation.

In 1956 and 1957 he did a series of large, heavily worked chalk and charcoal drawings, on which he worked so long and hard that in places he wore the paper into holes and had to patch it. In these drawings he used a full range of tone from white to black, often making the lightest planes by firm strokes of the india rubber. In spite of this, there is no *morbidezza*. When the form is finally found, it is emphasised with the cutting hardness of a carving. Indeed, the sense of energy, of force, is quite extraordinary. In spite of having taken so long, the drawings give the impression of having been done with great speed and directness, in a creative whirlwind.

It is interesting that Auerbach, who is fundamentally a draughtsman, in his paintings draws principally with line – thick, fierce, and broken, but still line – while in those large drawings the form was made and the effect of solidity achieved mainly by the use of areas of light and dark. Yet, according to the tools and materials, drawing on paper is done with a point, and painting by placing one area of colour next to another. He has hammered out almost opposite procedures, wresting the media out of their natural use, probably from his feeling of the need to renew the language. And possibly he stopped doing those large charcoal heads because the tonal effect made them very like monochrome paintings, and emphasised the fact that, both in conception and treatment of form, they were in the Renaissance tradition. Indeed, two or three of the most beautiful seemed to belong to that age as much as to the present. Yet all were personal. In a series he did three years later, though the treatment was a little newer, the conception was still very similar.

But, returning to the first series: Auerbach's approach to form in those drawings was different from that in his paintings, excepting a few very early ones of nudes, notably one of a man, mostly in green, of 1950, and one of a woman, golden-yellow, of 1952, which have the same solid, three-dimensional effect as the charcoal heads, although in the later, golden painting the tone is already more muted and subtle. But the paintings of 1953 and the next few years, whether heads, landscapes, or

figures, all tend towards the convention of the relief. Even that great head of 1955, although we feel the full mass and depth of the skull, looms out towards us as if, behind what we see, it is still part of the rock from which it appears carved. And in 1958 there were three profile heads, also of E.O.W., painted in chrome-yellows and ochre, which in spite of giving a strong feeling of life and reality, and some feeling of mass and weight, again give none of existing 'in the round', but remain, like the ochre landscapes, beautifully and mysteriously suspended in that equivocal dimension of low-relief.

There was also a difference between his treatment of all his heads, both drawn and painted, and of everything else, in that, with nudes and landscapes – or townscapes – he allowed himself a much greater degree of freedom and distortion. Whether he was more concerned to make the heads 'like', or whether they were more resistant than other subjects to his abstracting and unifying desires (probably both are parts of the same mystery), they remained, at least for many years, much closer to normal conceptions, and therefore much easier to read, than the rest of his work.

With some half-length seated nudes of 1958 and recumbent nudes of 1959 he broke away from the relief-like treatment of his paintings, setting his figures clearly in an atmospheric and geometrical space, the bed and figure in the later series quite definitely receding into the corner of the room. And in spite of many personal qualities, the whole conception of painting expressed in these last, very beautiful, recumbent nudes was coming nearer, in general, to a purely visual approach, and, in particular, to Sickert's in his early Camden Town period.

Looking back, I think this point – 1959 – marks the end of a phase in Auerbach's development, each phase being different in its manifestations but motivated by a similar struggle.

When he was young he seemed – if it was actually so, I do not know, but certainly he seemed – less aware of, in any case less concerned than now with, what was going on in the so-called 'art world', with its changing fashions, more monastically apart and contemplating only the greatest, loftiest examples; more deeply immersed in his own quite private world, enclosed in a dream, obsessively painting and repainting the same head for two years, until one felt that the gradually thickening layers of paint contained, within the final image, all that had gone to its making, as a living head becomes subtle, marked by the experiences of years; and the earliest Primrose Hill pictures had the same quality. The solutions he then

FRANK AUERBACH
Primrose Hill, winter 1961
Oil on board, 36 × 54 in
Private collection

found to his problems were extraordinary, poetic and mysterious; and one never felt that the claims of 'painting' had won: he had found an answer, a way of representing what he loved, which was so new, so courageous, that it really seemed a new language – risked not being painting at all. And this is how art is stretched, and advances, or at least continues. At a profound level, but not an obvious one, he was in the true, great, European tradition, on the Northern side; though, strongly Northern as he is, ardently concerned with the individual, the particular, the actual, the everyday, the private, and no less passionately believing in the value of experiment and discovery, right from the beginning one can also see how all this is balanced by a love of grandeur, a desire, half-nostalgic, half-ambitious, to make monumental images comparable with the great art of the past.

If one thinks of all the pictures Auerbach had painted up to 1958, one certainly receives a quite powerful impression of somebody's inner world, of the landscape, so to speak, the quite peculiar country of his mind, fascinating, mysterious, unlike everyone else's. But now, sixteen years later, I think that impression was deceptive, and misled many of us in our estimate of the work that followed.

He did indeed give us a world – but a world of his making, not of his seeing. There have been many painters with such a strongly idiosyncratic personal vision that the chambers of their mind could only be hung with their own involuntarily determined reflection of the world; and when we come out into the street after seeing an exhibition of their work, for a little while their vision continues to impose itself on us, and we seem to see everything through their eyes. But Auerbach is not one of these painters. His strength, his qualities, are of a different order. His real interest is form, his underlying and enduring passion: the expression of his experience of the visible world in terms of form, articulated into self-contained systems. From his earliest to his most recent work, what persists throughout is the angular character of the shapes and their rhythms, expressive of extraordinary energy, naturally less marked at first, but recognisable, and gradually becoming clearer and stronger. And this, which really answers to a feeling, takes the place, in him, of a personal vision, and gives his style its individual stamp.

His attitude to colour is that of a craftsman to his materials – a readiness to try all ways of using it in order to make form and organise his pictures. Very probably his choice of yellow ochre and the other earth-colours,

when he was young, was dictated by their cheapness, and though nothing can take from the beauty of all that early work, quite possibly much of that beauty is fortuitous, and the intention something much more austere, not addressed *to* the eye, but *through* the eye to the understanding. He was not, and is not, concerned with externalising his inner world, but with remaking the external world that he actually sees, in a new language, and in such a basic way that, strangely enough, the appearance is of secondary importance. He cannot imagine how the results of his experiments will look, and is literally surprised by them; and this is so, not only for a single experiment, but for a whole series, so that, sometimes, a succession of pictures brings him to a position he had not foreseen, and from which he finds it necessary to withdraw.

This, I think, is the clue to which we should hold fast in following him through his changes and phases.

Auerbach's reconstruction of his experience is half-intellectual, only half-visual. Fundamentally, his objectives do not change, but from time to time he adopts a different strategy. One may not like everything he does, but one can hardly fail to admire the seriousness, the tireless vitality, and complete dedication with which he will set up a new framework for his experiments – make a new cage – perhaps use a different set of colours, even try a different approach to form. Thus, although one feels that when he looks at a nude he sees the skeleton more than the flesh (for he is always concerned with structure, both of his subject and his work), perhaps those recumbent nudes of 1959, gleaming in the glistening darkness of the studio, were beginning, quite contrary to his intentions, to look too much like actual appearances; and he would take that as a warning that it was time to retreat, and advance by a different path.

In fact, in the next few years, he explored several directions. In 1961 he did a series of paintings – heads, nudes, and landscapes, and even two paintings after Rembrandt – entirely in black and white. In the best black and white heads (the best of all, I think, is a little one belonging to Mr F. S. Hess) he achieved for the first time a formal organisation as perfect as in the best nudes and townscapes.

After this period of abstinence and purification, Auerbach seems at last to have felt the seduction of the richness of full colour – whether in art or nature – and a longing to do something of that kind. And in 1962, while retaining yellow ochre and other earth-colours, he began to use, in addition, pure bright blue, green, red, and yellow – blazing like summer

sky, green grass, poppies and buttercups. He did this especially in a series 'E.O.W. on her Blue Eiderdown', and in some heads. The colours appear curiously arbitrary, and yet each painting is, in its total effect, surprisingly like the scene under certain conditions – usually electric light. In the 'Blue Eiderdown' pictures the colours seem to have been used at first locally, for the nude, the bed, the floor, and so on, and no doubt their choice and proportions, surviving through later transformations, largely account for the resemblance – the feeling of the room itself – which is uncanny, because after prolonged working these pictures became very difficult to read, and in black and white photographs almost impossible. And so one is driven to the conclusion that, although he doubtless began with a simple, direct statement, he was all the time looking for something more complex and ambiguous.

In the early work, the extreme restriction of colour had precluded anything approaching realism of effect, and he had concentrated on facts of form and structure unaffected by light. This restriction of means, and concentration on almost unconditioned facts – something like Friedländer's 'absolute idea' – made the pictures difficult to decipher, and, beyond this, rendered them permanently mysterious. And probably he had come to feel both these qualities – but especially that of not being too quickly legible, as very important in his own work. But now that he had opened the door to colour – and colour which, however arbitrary, was identifiably local – he had exposed himself to new difficulties. While allowing himself this luxurious increase of means, he balanced it, to some extent, by denying himself all modulations of colour, and all but the two extremes of light and dark in the matter of tone. But if he had made the few unmodified colours to which he restricted himself correspond entirely with the things to which they actually belonged, the effect would have been that of a grossly simple, banal realism, which he can never have wanted. In this way, we may suppose, he was drawn to accept the accidental effects of light, which, as we know, break up and destroy the unconditioned concept, or absolute idea, and present us with something relatively unfamiliar and often not immediately legible. Nevertheless, he would always want to make the three-dimensional forms so that they could, even though with difficulty, be interpreted. And in these pictures, which, together with some heads of about the same time, are the thickest of all his paintings, he seems to have tried in an almost frenzied way to make the form by sheer force of gesture out of the paint itself, piling it on with

ever-increasing emphasis. This in a way compensated for the absence of subtle variations, but less from the point of view of creating form than from that of liveliness of surface, for it made the paint sumptuous, so that an area of one colour, being full of little lights and shadows that change with the movement of the spectator, acquired the vitality of a field of sparkling snow. The human figure, or head, was finally made by stressing the skeleton, giving structure and pose from the viewpoint of traditional perspective, and though in some heads eye-sockets and cheeks were literally cavities under over-hanging brows and cheek-bones, in general, boss and hollow were not logically used, so that Auerbach was understandably annoyed when these paintings, because of their thickness, were considered to be almost sculpture. What he had in fact achieved, without recourse to variations of colour or tone, partly by texture and partly by exaggerating the destructive function of light, was a quite new kind of Impressionism – an equivalent in colour, richness and baffling complexity, of actual appearances full of confusing accidents. He may not even have wanted this. He may simply have followed, in curiosity, to see where that particular path led.

The work of the 1960s reflects a more than usually feverish and restless searching. While Auerbach seemed increasingly attracted towards ambiguity, we also find occasionally a relatively clear and straightforward painting of a head, sometimes in the sober earth-colours of his early years. Then follows a series of seated nudes, and a few heads, in which his self-imposed restrictions are different again. Although he limits himself to pure primary colours (and black and white), here they are at no stage used locally, but rather diagrammatically, like explanatory colours on a map (not by area, but by line), while the white-painted ground becomes, within the lines, the basic colour of the heads and figures, as well as of the setting. For instance, a seated nude may be drawn entirely in dark blue on a white ground, and then worked over in red in a slightly different but kindred rhythm, which has the effect of defining the shape more fully and so making the whole more rich and complex, and yet of simplifying it by stressing and tying up some parts more closely; or a head, painted by electric light in white and blue and red, may finally have a thread of light yellow squeezed straight from the tube running over it like light itself running over ridges of hair and bone and making a new melody across the others, and, according to the way one focuses, seeming to enhance the image or to destroy it by flattening it into an ambiguous pattern of shapes.

Before this series, and after the entirely black and white paintings, there were a few large cityscapes and kindred subjects, clearly related to the very early ones, and, like them, in earth colours – yellow, brown, red, and black – notably 'Rebuilding the Empire Cinema, Leicester Square' and 'Smithfield Meat Market'. And it is strange to think that these were being painted at the same time as the 'Blue Eiderdown' pictures and certain heads, which are at first sight so different. Yet they did have something in common, namely a reassertion of the unity and importance of the over-all picture-surface, though achieved by different means: in the one case by an almost illegible, glittering luxuriance which, like a veil drawn in front of the scene, brought everything up to the surface in its mesh – the Impressionist way; in the other, by a return to his early, shallow-relief-like technique and severely limited earth-colours, which had little to do with seen effects but were a pictorial creation interesting in its own right and with its own difficult language of representation. This was the case with the townscapes of 1962.

Up to this time Auerbach had continued, with few exceptions, to treat these subjects as if within the shallow depth of a relief, with the more distant parts parallel to the picture-plane, but, in proportion as he admitted more variety, broke through to greater depths, and lowered the horizon, they became, for all their severity, more and more like actual, recognisable views. One marked exception to this parallel treatment was the powerful 'Shell Building Site' of 1959, in which the space is quite violently hollowed out and recedes diagonally, as in the recumbent nudes of the same year. By almost imperceptible stages he had that year, perhaps to his own surprise, reached a degree of realism from which he clearly felt it necessary to withdraw sharply, and in the black and white paintings of Primrose Hill and of the Carreras Factory he returned to a frieze-like flatness. But now, in 1962, he seems to have felt a desire once more to set as it were the walls of his excavations at different angles, but in a less realistic way, as in the 'Empire Cinema' picture – in which he even makes openings to the outside light – and in 'Smithfield Meat Market', one of his grandest works, he creates an almost baroque architecture of weighty forms and fierce rhythms winding violently between them into the distance. Both these pictures speak of his study of Rembrandt. And in the 'View from Primrose Hill' of this period he also uses fluid, twisting rhythms which work up from the foreground away and away into the distance, where unusually sumptuous colour, glowing reds and golds, even suggest an

atmospheric effect. Yet all these, and other pictures of that time, are satisfying developments of his early language.

Then, in the 'Gaumont Cinema, Camden Town', the space is hollowed out much more realistically than ever before, bounded by the sweeping curves of the theatre, and, on the left, at an angle, by the bright blue cinema screen – which is also like an opening into light. In this picture he combines many features of the three last-mentioned London scenes, and, in addition, the crusted richness of the heads and nudes of the same period is here used to create the interior architecture and the audience.

Perhaps at this point he may have felt again that, at least for a time, he had pushed as far as he cared to go in the direction of traditional representation, as developed from the Renaissance to the early twentieth century, for suddenly he withdrew again to a much less realistic idiom, in two pictures relating back to the earliest landscapes and also to the strangely Egyptian-looking Oxford Street building sites. They were the two pictures of the 'Sitting Room', dominated by the big, wavy-edged, light-filled shade of a standard lamp, and although they immediately give a sense of a warm, glowing, lived-in room, it is only very gradually that one deciphers all the hieroglyphics, and suddenly, after quite a long time, becomes aware of a woman's head and shoulders in profile, very large, in the left foreground. Once more these pictures are painted in earth-colours, but differently used, with a new pictorial effect, beautiful and exciting, and of a rather map-like flatness, in which the areas interlock with a very equal tension, so that one has to learn to read what is near or far, what is a solid object and what a flat thing behind it (but once learnt, it all remains clear) – a little as with Bonnard; though whereas Bonnard saw things suddenly in a surface relationship which made them all into a new pictorial whole, and at the same time revealed each person or thing under a new aspect, and then worked away from the subject in order to preserve that revelation, for Auerbach the revelation comes at the end, on the picture, through working.

These two pictures, which take up some of the threads of his early work, do also break new ground, and lead on to two pictures of Primrose Hill, in 'Winter Sunshine' (1963) and 'Spring Sunshine' (1964). In these he has once more found a new way of translating his experience, for one can read the distances, the lie of the land, the scatter of trees – even the brightness of the day; yet all is stated with the economy of the Bayeux Tapestry. The ground colours are pale and sandy, warmed with pure yellow, and

traversed by thick lines of inky blue-black and deep red, which, while drawing trees and paths and other features, also divide the surface into areas of equal tension, combining the map-like flatness of the 'Sitting Room' pictures with the technique used in the series of heads and seated nudes in primary colours and black and white.

These Primrose Hill paintings in turn lead on to a long series of Mornington Crescent pictures, much heavier in effect, in which the strong, densely packed colours are held in balance by a severe linear structure, heavily stressed and stitching everything to the surface in a different but still tapestry-like convention. And probably these town-scapes and their successors, together with the heads and nudes which have accompanied them, are once more leading Auerbach to a point from which he will have to make another sharp change.

Over and over again one can see this sequence repeated in the course of his painting life. And through all his work we feel the conflicts which produce it: between the known structure and the unexpected aspect discovered while working; between the desire to make the painting 'like' and yet to make it new; between traditional drawing and the impatient longing for a more powerful and immediate impact, perhaps attainable by means of some bold distortion or invention.

One can see that, painting the same subjects for twenty years, Auerbach must have a profound faith in the infinite resources of the art itself – a faith that it is possible to make great art out of the everyday world surrounding him. For, as I said earlier, his work stems from the more intimate side of the Northern tradition, concerned with the quite particular and physical Here and Now – the tradition of Hals, of the Dutch painters of genre, of the French Impressionists, and of Sickert. Yet one can feel, pulling against his affection for the familiar and the everyday, his love of the great, fierce, twisting design of Tintoretto, the violent movement of the baroque, the dramatic and heroic. But he has (presumably) a modern conscience which forbids him to express his love of violence and grandeur in the ways which, for instance, Delacroix still felt free to use, in imaginative compositions, compelling him instead to study the modest subjects he knows well until they yield a formal grandeur of their own.

The one exception to this is the series of paintings commissioned by David Wilkie. They were done over several years, from about 1964 to 1972, and were all connected with Titian, either free copies or, in one case, a subject such as Titian might have chosen. And these excursions into

unusual territory prompt a train of questioning and speculation.

Auerbach has often said that painting ought to be, and that all good painting is, 'about something'. But, in using words about a wordless art, one is continually running into the dangers of misunderstanding and misinterpretation. To have 'something to say' in painting does not imply a subject such as 'Bacchus and Ariadne', or an encounter between human beings, or any subject at all, as understood by writers. It refers to vision, to seeing in a truly fresh, personal, original way. And it could cover a response such as Auerbach's, only partly visual. Yet there can be no doubt that, over and above this quality of an original vision, paintings which represent, say, a loved and intimately known landscape, or person, or room, or group of objects, do gain something very important. Probably the painter's feelings for what is represented sharpen both response and technique, make them more exact, tender, and profound than when he is less concerned; and probably also the desire to make the painting 'like' conflicts to some extent, at first, with a purely painterly approach, and this, with a determination not to compromise, provides a stimulus which pricks the work on to a conclusion more moving, more intense, than usual. This, I think, is what Auerbach means by paintings being 'about something'.

But still there remains something beyond this. The very greatest paintings of all are 'about' the same great questions which exercise the minds that use other languages – as Sickert said: 'Love and Death – Love and Death – the only two subjects of all great art'. And in former times there were many painters less than the very greatest, but still good, who tackled these themes, and whose pictures were none the worse for it. Even today there are a few. But for much of the present century serious painters have been so concerned with painting itself that they have preferred to steer clear of anything which could be labelled illustrative, or narrative, or in any way literary, though all these interests are beginning to creep back. One can only speculate as to whether, if contemporary attitudes had been different, Auerbach would have spontaneously dealt with subjects of this kind, or whether it is, quite simply, foreign to his nature. It may well be half and half – that he has a natural dislike of exposing deep emotions, and that formative influences have confirmed this inhibition.

However that may be, David Wilkie's imaginative patronage has brought out at least something of that side, which we should otherwise never have seen at all. For dealing with the subject 'at one remove' acted as

a release, like a carnival mask permitting unaccustomed behaviour. Thus, in the two paintings after the 'Rape of Lucrece', Auerbach has concentrated on an analysis and emphatic restatement of the design and movement (to the exclusion of much else) which has had two results: one, a concentration on the very bones of the human drama – the extreme violence, the sexual passion, the desperation, the woman's terror, the hint of death as a way out – all expressed in the shapes made by the movement of the two figures locked in struggle; and the other, that he has pursued his analysis to such a degree of abstraction, of near-illegibility, that this in itself operates as another of those distancing factors necessary (for him) for the release of the naked emotions of the subject.

While one painting stressed the linear rhythms and the other worked more in areas, both retained some interest in the human form itself, as well as the large shapes underlying Titian's designs. But the painting after 'Bacchus and Ariadne', finished about seven years later (1972), is something altogether more extreme. The fierce lines have become straight, as in all his work of the same period, and it is entirely characteristic of Auerbach himself, reducing the Titian to a stripped skeleton of its rhythm and movement – a bare, schematic summary. The bright colours are used diagrammatically, to clarify and complete the analysis, but also emotionally; and, compared with the earlier studies, it has much more the effect of an independent work, of a modern picture celebrating the joyous frenzy of a whirling Bacchic dance and pursuit, or a 'Rite of Spring'. The carnival mask has been marvellously successful.

'The Origin of the Great Bear' ('a painting on a theme which Titian might have painted') does not immediately strike one as more than a Primrose Hill landscape. And yet it is more. And the longer one looks at it, the more one realises that here is a painter who has evolved, on the basis of the great European tradition, a distinct pictorial language of his own, to a degree which would allow him to tackle, without embarrassment, any subject he wished. And this point of maturity has been reached, certainly in part, through the exercise of absorbing David Wilkie's injection of Mediterranean grandeur.

6

FRANCIS BACON

Francis Bacon, the most brilliantly original painter of the mid-twentieth century, is also the most firmly, widely, and deeply rooted in the great European tradition. At the beginning of his career his roots, like those of a young tree, gripped only the more recent, surface soil, but then, having something of a hold, thrust deeper and spread wider.

In the early years there was some influence of Giacometti, though not immediately obvious except in some pictorial devices which, however, Bacon turned to a different use; but one feels an affinity in the seriousness of their ambition, and in their determination to make, out of their personal difficulties, great art; and almost certainly there was a profound influence consisting in the encouragement of Giacometti's example, persisting, against the stream, in *representation*, and producing work in the highest degree relevant to man's deepest concerns.

The older man started younger, studied, and at a much earlier age became an accomplished professional.

Bacon had no academic training. He was like somebody coming into a theatre in the middle of a play without knowing the language, but so immediately and intuitively sensing what the drama is about that, quickly picking up a few words and phrases in the current idiom – which happened to be Surrealism – he at once, as if sleepwalking, steps on to the stage and begins to take part – even an important part – in the performance; and in hardly any time, swept on by genius and destiny, he is playing the lead, and becomes the great tragedian of the age.

Gradually, from inside the profession, he looks back to the supporting traditions of his art, and learns the true language of his medium. With superb confidence he turns only to the greatest masters, beginning with Velasquez, to learn their secrets, for nothing less will enable him to give form and reality to the ideas and themes that obsess him. So much has already been written about his technique that it is unnecessary to recapitulate the phases of his development; it is enough to say that, knowing what he wanted, by incessant practice he achieved the mastery he desired.

It was always Tragedy that he wanted to present. At first he felt that Tragedy absolutely required some exalted representative of the human race, such as a king, elevated in dignity and destiny above the common man. Hence his use of the Pope. But with increasing mastery he found – as Giacometti had done already – that there is mystery and tragedy enough in the actuality of everyday, in the universal human condition, and in any and every example of it.

Giacometti's art is more objective. He looked with a relatively open mind, and accepted what he saw. And he appears to have seen that, on the whole, man does not complain very much. He is solitary and vulnerable to a frightening degree, yet astonishingly patient and tough. If Giacometti's art has 'the accent of the religions without hope', and even an elegiac note, it also has the tone of acceptance, and is, in its final effect, classical, even serene.

Bacon's art, on the contrary, is always a drama, and almost always a cry of despair. The preponderance of this note in his work is probably unique in great painting, and he covers the whole range of its forms, from helpless fury – like that of the spirits typified by Filippo Argenti, whom Dante saw and Delacroix painted – to sullen resentment of inescapable doom. The relatively few exceptions flaunt a Promethean defiance.

Whether or not his personages are exalted, there is always the feeling of a theatrical presentation. They are isolated and as if elevated on a stage. Often a curved floor-line contributes to this effect, and so does the stark prominence of chairs, beds, and platforms – the minimum that will serve. Michel Leiris remarks that it is the traditional Christian iconography of the Old Masters, with the central motif of the Crucifixion and supporting side panels of saints, sometimes with donors, and little scenes of daily life in the background, which determines the architecture of Bacon's so-called Crucifixions and other triptychs; but he adds that nothing of the content of the Old Masters' pictures remains, only the architecture of the composition, with no meaning beyond its very structure – or at least no meaning that can be expressed in any coldly logical form. This last phrase is a very necessary modification, for it is impossible to use these old pictorial constructions without some resonance from their original meaning echoing into the bleaker modern works which thus allude to them. And, incidentally, it is known that Bacon often has Yeats in mind, especially the poem called 'The Second Coming'. One may say that it is in a kind of horrifying travesty that the grandeur and boldness, the spaciousness and

large magnificence, of the Mediterranean baroque compositions reappear in Bacon's work; the fact remains that they do reappear, through all the developments of his style, and that they make a bridge for the spectator between the old art which he can accept with ease – possibly because it does not mean anything but 'art' to him – and this new and shocking art which he finds difficult – possibly because it means more than he thinks proper for art.

There is also, in addition to the general reference to the Old Masters, probably a specific echo from Grünewald's Crucifixions, and certainly from the Cimabue that was ruined in the recent floods in Florence.

In any case, these echoes and allusions work in the same way as the many allusions and quotations in Eliot's work, and Thomas Mann's half-ironical method of using tradition – in the way that, if you say: 'There were no roses', you enrich your very denial, for their absence, however empty, is unavoidably coloured by a reflection from the image of roses you have called up. Thus these echoes and allusions connect the new with the old, conferring as it were the stamp of an illustrious descent, and the very authority of tradition, even while seeming to some extent to flout it; and also they give a sudden insight into all that disturbing contemporary material here used for the first time in art – that, spiritually and emotionally, man has not changed, that the fundamental patterns persist, and the great questions remain. In short, Bacon's insistence on the Grand Manner, in an age which has in general rejected it, suggests that, after all, the subject calls for it.

There is not only a sense of theatrical presentation of the scene, but also of performance in the execution.

Bacon's art is much more conceptual than Giacometti's. Certainly he paints his own vision of the human form, of the people he knows, of his world; but *not in front of it all*. He paints the impression it has left on his memory.

No one can remember all the elements that make up an impression. Therefore many artists who have worked from memory have filled the unremembered lacunae by means of a kind of logic – a formula. Artists who work from drawings do it all the time; with the best, the framework of the drawing 'from life' can to a great extent sustain the painting all through, while they furnish what is lacking out of their store of observation and knowledge, guided by happy inspiration; but it must be admitted that a quantity of almost mechanical padding seems inevitable.

But Bacon does not draw from life, and has always wanted to cut out the padding, to have, as he says, 'the grin without the cat', and in early works he does indeed give us almost literally this – the screaming head with the merest ghost of a body. But it is not a solution that could satisfy any properly ambitious painter for long.

Everyone has seen brilliant small sketches, in which a single brush-stroke creates a whole limb or even more, thus giving the entire composition a vitality, a coherence, a swift movement, which are all lost when the painter tries to enlarge it to the scale of an 'important' work.

Sickert knew this, and knew that the pen and pencil studies which he made with lightning rapidity to catch the vanishing instant of life were full of unconscious accidents, and that when squaring them up for a painting it was essential to reproduce every accident with mathematical exactness. Bacon, however, not drawing from life, and feeling the necessity for his paintings to be on a large scale, and being concerned to trap something even more fleeting than Sickert's quarry – the sensation of actual movement, as of a head turning, or the whole body, and many other kinds of movement, and even, as he has said himself, something like the trace a person leaves in passing through a room, the sensation of a living presence – has found a way of dealing with the problem by enlarging, with the help of very large brushes, not a small sketch, but the whole process, including his own physical movements; so that, after endless rehearsals, repetitions, he is able to allow his arm a swiftness and freedom of movement like that of a marvellous dancer, and his pictures appear as if still vibrating from their creation in a Dionysiac frenzy. The accidents – which Sickert found so necessary – occur inevitably through working in this way – paint splashing and spurting and varying in unforeseen ways. Bacon uses his judgment as to whether to retain or destroy these accidents, and even entire canvases, and thus enlists the cooperation of this mysterious ally, which he calls Chance, without surrendering to it, but remaining in control.

It is a procedure reminiscent of Goethe's for the conduct of life itself, described in a passage in *Egmont*, which he uses again to close his autobiography:

The coursers of time, lashed as it were by invisible spirits, hurry on
the light car of our destiny, and all that we can do is in cool
self-possession to hold the reins with a firm hand, to guide the wheels

now to the left, now to the right, avoiding a stone here or a precipice there. Whither it is hurrying who can tell? And who indeed can remember the point from which it started?

Whatever name one gives it, there is a power which cannot be explained which Goethe called 'the daemonic', and which he recognised not only in himself but, for instance, in Napoleon and Mozart; Picasso had it; and it is surely this daemonic element which lifts Bacon high above all the other painters of the present time – this, and the fact, which goes with it, that he is able to handle, as very few can today, the great themes.

For the truth is that Bacon's works are great religious paintings. The very agony of his unbelief becomes so acute that, by the intensity of its involvement with final questions, the negative becomes as religious as the positive. He paints a present Inferno, relieved only very rarely – as, for instance, in the picture of the Arab walking, carrying a child – by moments of respite, of tenderness – but with no issue other than dissolution and annihilation. Eventually it must always be through the eye that visual art is judged; and at the very first glimpse of a Bacon, before one can read it, the impact of the strange and powerful disposition and character of the shapes, sometimes reinforced by the green and violet colours of decomposition, produces an instantaneous reaction: the flesh shudders, the heart almost stops. In this, his pictures are the exact opposite of representations of terrible facts by inferior artists (the Hiroshima drawings, for example) which give no visual shock but have to be laboriously read for their information, and so produce a feeling of embarrassment, because they ask us to extend our sympathy to them as works of art, and their content shames, and possibly confuses, our critical faculty.

But with Bacon there is no such difficulty. The effect of his Retrospective Exhibition at the Grand Palais in 1971 was immediate and overwhelming. Here we were presented with the spectacle of his inner world externalised: the world, life, reality, such as he finds and feels them mirrored, living and remaining in his mind.

It was beautiful as well as terrible – beautiful in its spacious grandeur, in the springing, tigerish vitality of line, and in the relations of the large areas of colour; beautiful, but absolutely not decorative, because one knew immediately that it was not an affair of adorning surfaces but of profound depths of feeling.

There was nothing arbitrary. The material of such a vision is uncon-

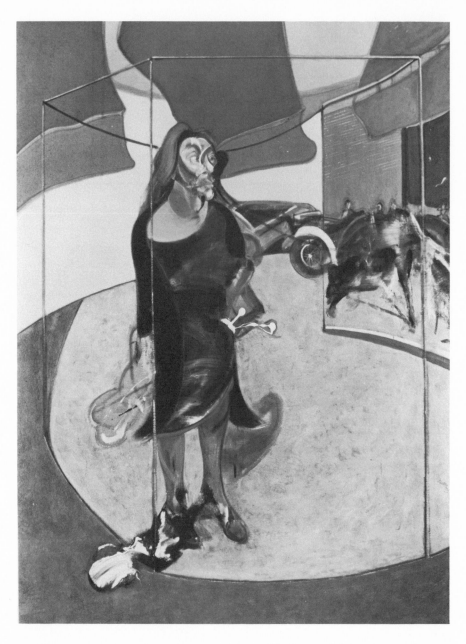

FRANCIS BACON
Portrait of Isabel Rawsthorne
Standing in a Street in Soho 1967
Oil on canvas, 78 × 58 in *Staatliche Museen*
Preussischer Kulturbesitz, Nationalgalerie, Berlin

sciously, involuntarily, filtered, selected, and distorted. But to give it a clearly defined body involves tremendous conscious efforts, of construction, of abstraction, of mastering techniques, and of keeping the vision itself clear and present to the mind. For as soon as something, however slight, begins to appear on the canvas, it has the advantage of physical reality, by which the inner vision is in danger of being eclipsed. One can feel how he has battled to preserve it – to serve it – one might almost say, to assist it to embody itself; for the work persuades us that his presentation of it becomes increasingly exact.

Bacon has learnt many painterly skills. He has understood and adapted to his own needs the dissolving subtleties of Titian's and Velasquez' rendering of flesh, the bold organisation of High Renaissance composition, the audacious modern use of colour, the drawing of swift movement of Michelangelo and Degas. The plastic qualities of his work are so strong that one has the sensation of his having taken stuff in his hands and twisted it with superhuman power in the process of creation. Through a desire to give something like an illusion of movement, by fusing two or more positions he has arrived at new but convincing distortions – a more sophisticated solution to the problem than that of the Futurists, though sometimes the heads are reminiscent of Boccioni's drawings, which in turn derive from Cézanne; but usually they are still more twisted, and the entire human form is violently remade by the curves of the movement, as if it were fluid.

One cannot call his middle-aged male nudes beautiful in themselves, in the way that Michelangelo's young naked athletes on the Sistine ceiling are beautiful; yet, if we could clear our minds of prejudice, we should acknowledge, or discover, that a great part of the delight we experience in looking at those *ignudi* comes from the plastic qualities, the movement and rhythm of the clear-cut volumes, and the fiercely biting sharpness of the elegant, sinuous line; and the abstract qualities to be found in Bacon's nudes are similar in kind. Let anyone who doubts it compare reproductions. The abstract qualities of the clothed figures, too, can be compared; and even those of some of Bacon's extremely distorted forms resemble in their energy some of the twisting groups in 'The Last Judgment'. And it is these qualities, more than anything else in his painting, which give us the heightened sense of reality which we receive from all great art.

Once one has seen this affinity, one realises more and more the extent of Michelangelo's importance for Bacon – so many of his seated figures of

recent years (above all, the nude ones of George Dyer) are full of echoes of the painted figures in the Sistine Chapel. And then one begins to notice memories of Michelangelo's carved figures also, together with an increasingly sculptural tendency in the painting. 'Lying Figure in a Mirror' of 1971 recalls all four of the reclining figures over the Medici tombs – and even the bold architectural curve, as of the earth, on which they rest.

In David Sylvester's 'Interviews' with him, Bacon speaks of his interest in, and ideas for, sculpture; and looking back, with hindsight, one can trace an overall movement from a purely pictorial approach to a greater concern with the three-dimensional qualities of his images. For instance, in the 'Red Pope' of 1962, in spite of the suggestion of a turning movement, of a revolving daïs, we accept unquestioningly the aspect and the instant depicted: the painting affects us, fundamentally, in the same way as a Titian. Then, in the 'Study of Red Pope, 2nd Version' of 1971, new elements appear. To right and left of the dark vertical structure there are curved windows opening into the lighter, wider world outside, and in the right one we see the upper portion of a dark-clad figure contemplating the Pope. Or do we? Might it not be a mirror rather than a window? Might not that figure be a reflection of just that much of the Pope's head and figure which would let him appear to be in ordinary modern clothes? It is ambiguous in the profound way of great symbolic myths, which seem true whichever way you like to take them. But plastically it opens up a new pictorial world, towards which we can now see that he has been advancing for ten years, and which we find again in what was, possibly, the very next picture, 'Study of George Dyer'. Now we see that, in both cases, the narrow left-hand panel really is a mirror, and, in this picture at least, so is the right one – although the line of the base contradicts it – for it presents the opposite view of the right leg. But while these fragmentary reflections give us, intellectually, a more rounded conception of the figure, emotionally the mirror-panels work as genuine space, and give us the sensation that we could walk right round behind the throne, or whatever it is; in the 'Study of George Dyer' especially, the effect is of a brilliantly clear-cut, solidly sculptural figure seated in some little red belvedere, open all round to the blue summer weather, like a statue on an Italian hill.

With all its originality, this new pictorial world which Bacon now reveals to us is founded on the absorption and clarification of long traditions.

In all primitive art, and in the Renaissance before its full development,

there was an audacity, a freedom and power of design, which later became toned down to accord with realism, in the sense of normal physical vision. In fact, as long as normal vision was a subject of exploration, it was itself stimulating and exciting, but as soon as a phase of discovery was over, the results acted as strangulating restrictions on all but the boldest, most imaginative and inventive spirits. This pattern was repeated in the history of French Impressionism, and even today most figurative painting still suffers from that stultifying legacy.

In the Renaissance it was the Venetians – and Titian above all – who were concerned with appearance, and from whose work most modern painting, both very good and very bad, has developed. But the Florentine painters not only lived and worked among sculptors and architects but were often sculptors and architects themselves, and their painting is less to do with appearances than with the presentation and creation of a clearly understood three-dimensional world.

Bacon's 'Three Studies for Figures at the Base of a Crucifixion' (1944) are descended from the most powerful strain in the art of Florence; the 'Painting' (1946) is essentially as bold in invention, yet it is already slightly muffled by a conflicting influence – the more densely interwoven tapestry of Venetian painting. During the next fifteen years, he was acquiring the skills of the Venetian tradition – mostly by way of Velasquez, Degas, and Monet; and notwithstanding all his originality, this discipline to some extent curbed the natural dramatic force of his imagination and his instinctive way of designing his pictures. His van Gogh series marked the beginning of his liberation, and in 1962 he produced the 'Three Studies for a Crucifixion' which at one blow recovered all the ground lost since the 1944 triptych and united it with his other gains. From then on, with the succeeding Crucifixions and triptychs, and all the sitting and lying figures against clear backgrounds, the Florentine strain reasserts itself, both in design and in the plastic quality of the figures. In particular, the reclining nude studies of Henrietta Moraes suggest a consciously sculptural pre-occupation, for they give the feeling of having been imagined from other points of view – indeed, completely in the round.

But still one can see the almost continual tension in Bacon's work between the love of clear, sculptural form and the fascination of what *he* means by 'appearance', which is to do with intangible and elusive aspects forever vanishing, and bound up with ambiguities and distortions which, if not actually irrational, seem to affect us irrationally, in an immediate and

magical way, because we are ignorant of the intermediate links.

One picture exemplifies this tension in an extreme degree: the quite extraordinarily beautiful and evocative 'Triptych Inspired by T. S. Eliot's poem "Sweeney Agonistes"', of 1967. It balances on such a fine edge that it retains the best of all worlds: in the centre panel the sumptuous painterliness of all the blood-drenched paraphernalia contrasting with the stark modern design of the railway compartment and the blue night outside – 'the violet hour' – and in the side panels the astringent coolness and emphatic architecture (modern Florentine, as it were, foreshadowing that in the 'Study of George Dyer' just discussed) – in which recumbent figures rest, like deliquescent sculpture, on canopied platforms in summer gardens, giving the feeling of a sleeper struggling to rise out of a drug-induced dream, but, on the very verge of breaking through into the sunlit, solid world, sinking back and beginning to melt into the ground of his own vision.

As his figures become more sculptural, there is something in the way in which Bacon uses distortion, like superimposed movements, to make the image more like a person than a literal portrait could ever be, which is related to the art of the great mimes, who can make us feel that they no longer have a solid bone in their bodies – they can seem to transform themselves into water spilt from a bucket and spreading over the floor, and before one's amazed eye can begin to analyse how it is achieved, in a flash they are up and changed into something else. And although with Bacon of course the paint actually remains there on the canvas, still it is so mysterious that our eye is perpetually baffled and can never really analyse how it works.

Neither can he; and this mystery of the functioning of paint itself, and of the function of distortion in producing the mystery of appearance, are the things for which he relies on the help of chance towards achieving portraits which are 'like' (but not literal) and which are also – or which he would like to be (for he would never claim that they were) – great images. As the years pass, this partnership grows more close, more perfect; Bacon himself grows more adept and masterly, both with the brush and with his way of throwing paint; and his own personality becomes more crystallised. Memories, both of the great works of art and of the people most important to him, instead of fading with time, acquire, on the contrary, by dint of being gone over and over, an increasing reality and monumentality. And as his own aims become clearer to him, so his pursuit of them closes in

more sharply. Consciousness and the unconscious seem to work in ever closer harmony.

And what can we say of the very latest works? The many recent self-portraits, which are becoming as numerous as Rembrandt's, appear, like those, to spring more from the love of painting than of that particular face, and are similarly objective in attitude, subjective in result, and, like the last triptychs, with all the brilliance of handling, they seem quieter, gentler, more poignant and moving, than ever before. Of the triptychs one can also say that the forms and intervals are more noble, and that they have a quality of tenderness, but also of remoteness. In the black triptych of March 1974, the bending, turning, Michelangelesque nude in the centre, the back view of the painter on the far left, and the facing view of the photographer on the far right, appear as if once related in the rhythms of, say, a Flagellation, but now widely separated, elevated into symbolic figures, the preoccupations of a lifetime.

And in the very last of all, the cool-looking, wind-blown seaside one, with its violet shadows, kneeling nudes, black umbrellas leaning across their shoulders, the black rectangle rises up from the pale sands like a doorway into Hades, flanked by what seem to be the pale shades of ancestors. More than any illustration could possibly be, this triptych seems a visual equivalent of the eleventh book of the *Odyssey*, with that inexplicable and haunting passage where Tiresias prophesies to Odysseus.

At the Retrospective Exhibition in Paris, the titanic force and completeness with which Bacon had realised his world suggested a comparison with Picasso, and his simplifications, however different in spirit, with Matisse. Now, in 1975, a little more than three years later, it is easier to see that, violent as he is, he has disciplined himself to become a great classical painter. For the exhibition at the Metropolitan Museum of New York sets him in a different frame. Here, only the work of the last six years is shown, filling three spacious galleries, so that we see him only in his full maturity, and also, set in the context of a great museum, which provides the equivalent of the perspective given by time; and in this setting it should be clear to anyone that Bacon is great among the great of all times and places. For, through the individual and particular, he has penetrated to the typical and universal; elevated the domestic, the everyday and the private to the level of the monumental and heroic; and, stripping away the trivial, has seen and presented his friends and contempor-

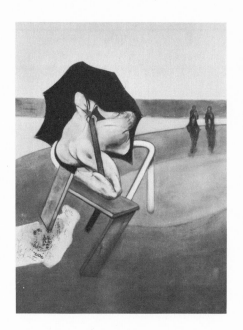

FRANCIS BACON
Triptych 1974–7 (Centre
panel revised 1977)
Oil and pastel on canvas,
each panel 78 × 58 in
The Artist

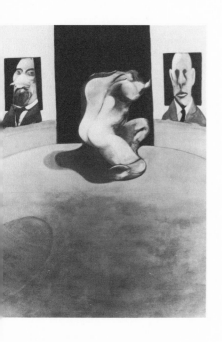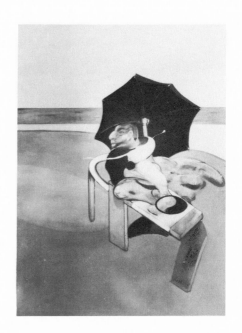

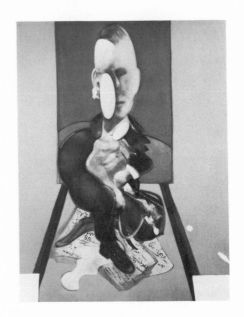

FRANCIS BACON
Triptych 1976
Oil and pastel on canvas,
each panel 78 × 58 in
Private collection, France

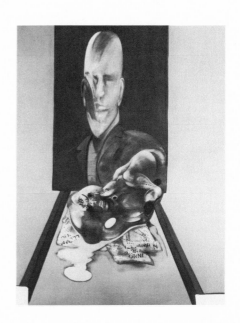

aries 'in the light of eternity', in the Grand Manner, in great and unfor-
gettable images.

POSTSCRIPT

Written during the 1985 Retrospective Exhibition at the Tate Gallery

This exhibition ranges over the whole of Bacon's mature painting life, and, naturally, elicits a few fresh thoughts and reactions.

Firstly, we can now see, over the years, the unfolding of a recognisable reflection of the changing appearance of our time – of *his* time. And, incidentally, it is fascinating that an epoch of history, like a person, can present a visible aspect.

The early paintings, done during the Second World War and the decade that followed, are mostly in ashen greys, browns, blacks, navy-blue and funereal purple – the sad colours then prevalent, partly due to the sober mood of the war itself, and partly the effect of an earlier taste worn dull by clothes-rationing, besides the austere contents of shops, the drabness of buildings needing repair and redecoration; and the black-and-white cinema.

Among the few exceptions to the general character of his work of this period, by far the most important is the 'Three Studies for Figures at the Base of a Crucifixion', of 1944 – astonishingly prophetic of his later work. In this, and two or three other pictures, the intense fiery orange back-ground, clearly expressing his own strong emotions, seems also to echo the emotional and intellectual anxieties of the time; and it is notable that this colour has reappeared in his backgrounds in the last few years, when the outlook for humanity has become more desperate than ever before.

But it is *appearance* in which Bacon is passionately and pre-eminently interested; and, at the end of the 1950s and during the 1960s, the appearance of life – fashions, behaviour, architecture, decoration – changed, especially in big cities and pleasure resorts. A new generation had grown up, and while among some older people a kind of faith and slogging determination and even hope persisted, among the young there was a new recklessness, scepticism, materialism – a writing-off of the future, a will to live in the here-and-now, with all kinds of emancipation. In clothes, this expressed itself in a dazzling efflorescence of fantastic

fashions, bright colours, glittering and sumptuous fabrics; in architecture, in stark severity and utilitarian simplicity; in decoration, out-of-doors in a general cleaning-up, lightening and brightening, indoors in a clearing-away of clutter and thus a seeming enlargement of wall-spaces, with novel and daring colour harmonies and bold inventions. Visits to and from the continent now became easier and more usual, and were a fertilising influence. And all this is reflected in Bacon's work – first in the van Gogh series, with the glowing colours and sunlight of the South of France, and then in a series of pictures done between visits to Tangier, where, even through drawn blinds, the dazzling North African light flooded the pale interiors in which he showed a single, often nude, figure, or perhaps a couple, on some dark piece of furniture of extremely modern design – possibly a development of his own early furniture-designing; I have even wondered whether he himself may have had an influence on a style of interior decoration which was becoming fashionable, and which he then reflected again, surprisingly transformed, in his paintings – as with Monet and his gardens.

The influence of America was now making itself felt, in the division of rooms into large areas of different colours; wall-to-wall carpeting was a further simplification, and lights grew brighter and ever brighter. Even Bacon's night scenes become brightly lit.

He has expressed, in his personal idiom, the sensations of speed and power, the look of modern life in the sunlit out-of-doors: 'Bull-fight' (1969, cat. nos. 60 and 62); 'Isabel Rawsthorne standing in a Street in Soho' (1967, cat. no. 52); and so on; scenes of private life indoors, by day and by night, perceived with a new and disturbing penetration, comparable to that of Pirandello; and, in the so-called Crucifixions, scenes of cruelty and murder, contemporary and of all time. And, in the totality of his work, he has recorded, more vividly than any twentieth-century painter except Picasso, the peculiar beauty of 'modernity' – on which Baudelaire has surely said the last word.

Secondly, this exhibition brings home to us Bacon's continually increasing technical range and mastery, and the heights he has now reached.

It is said that Tintoretto aimed at 'the drawing of Michelangelo and the colour of Titian' – a silly aim, neither desirable nor attainable; and yet it does set a standard, and in effect did Tintoretto nothing but good. And by its light we can see that, in his own unprecedented style, Bacon has achieved excellence in both fields.

It is rare to find subtlety of colour and beauty of *line* – which is not the whole of drawing – combined in the same artist; yet here it is. The power of his line first appears in the 1960s, and in the 1970s it is fully developed, harshly elegant, flowing yet strenuous. Michelangelo will probably remain forever unequalled, yet one may venture to say that Bacon's line is often reminiscent of him, in its power to express form in turning, sometimes whirling, movement. Notable examples are: the central figure in the 1974 Triptych (cat. no. 87); of the same year, the 'Sleeping Figure' (cat. no. 88), and 'Seated Figure' (cat. no. 89); the right-hand figure in 'Three Figures and a Portrait' (1975, cat. no. 94), which strongly recalls (in reverse) the left-hand figure in the Sistine fresco of the 'Creation of Sun, Moon, and Plants'; the whole of the quite amazing 'Figure Writing Reflected in a Mirror', (1976, cat. no. 99); the whole triptych, 'Three Studies of the Male Back' (1970, cat. no. 71); and the two extraordinarily beautiful figures in the side panels of the triptych, 'Studies of the Human Body' (1979, cat. no. 107).

In many of the portrait heads his use of curving lines, and of circles, flattened discs and other shapes, metallically sharp, gives a feeling of the person making the very movements which have helped to twist and form the face by which we recognise him.

Then, as to colour: after the pictures of the late 1950s, that is, of Popes, businessmen, monkeys, and van Gogh (the Sphinxes already begin to look forward to a later style), there are no more all-over, carpet-like compositions. From then on Bacon presents clear-cut, solidly modelled images set against backgrounds so simple as to appear relatively flat. Sometimes they are in fact quite flat, one colour all over, sometimes they are divided into large areas, like severely economical stage-sets with nothing but essential properties – chair, bed, mirror, Venetian blind, electric bulb, basin, lavatory, door-opening, and so on. In them Bacon continues to explore a seemingly inexhaustible range of colour harmonies, each with a single dominant colour. But though they relate to the central image, are tied into it both by colour and shape, and of course contribute largely to the immediate effect, yet it is by the way the colour is handled within the contours of the image itself that he shows himself a great master of colour. Occasionally the motif is a sand-dune, or jet of water, or storm-whipped landscape element, and here to some extent the same remarks apply; but most often it is the human form, sometimes clothed, sometimes naked. And the head, or figure, or coalescent heap of two figures, glows like a

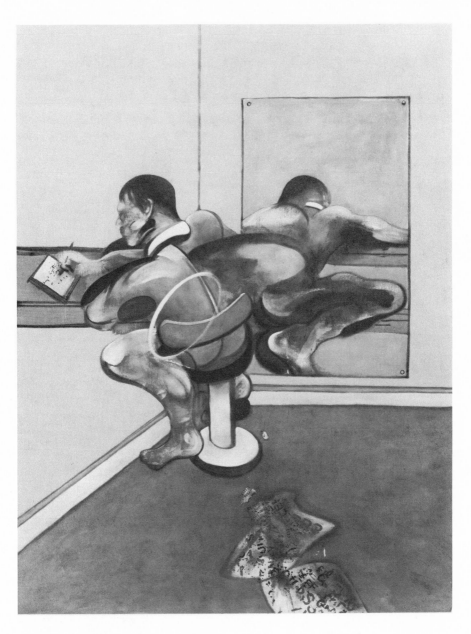

FRANCIS BACON
Figure Writing Reflected in a Mirror 1976
Oil on canvas, 78 × 58 in
Private collection

smouldering fire in which all kinds of burning chemicals produce rainbow variations, or like a polished statue reflecting sunset clouds and blue sky; yet all this is controlled, and in bold, rhythmic strokes the colours create the clear, deeply understood form of a limb or a head, or the seemingly chaotic complexity of tangled bodies in movement.

In composition there is no end to his fertile imagination. His inventions grow ever bolder and more surprising.

Thirdly, there is a perceptible change in the total atmosphere generated by the paintings.

Great stress has always been laid on the agony, desperation, and horrific elements in Bacon's work; but, whether it is partly because, in the present day, violence, horrors, and miseries have become almost commonplace, or whether we ourselves are becoming inured to violence, both in life and art – whatever the cause, his painting no longer seems to place a dispro-portionate emphasis on this side of things. Even the work up to 1965 (which I think is a turning-point) appears in retrospect to have settled into the stability of the classics, and after that, gradually – very gradually – a new climate begins to make itself felt.

In the 'Studies for a Crucifixion' of 1962, so much red and black, together with the curious creeping movement of the coarsely shaped, scarcely human forms on the left, and all the other shapes and colours – of meat, and of something living twisting in agony – all this makes an absolutely immediate impact of the most horrifying brutality, cruelty, butchery, physical torment. I think this is the most extreme point his painting has ever touched in expressing these sensations.

The 1965 Crucifixion is still a horrific picture, but though the walls are still red, they seem less infernally so, because there is only one – not very large – panel of black to intensify them, and because the whole area of horizontal ground is a cool khaki, the colour of fresh cement. Then, the images are all smaller; and all this, together with the mean little shapes of the seated figures in the right panel, and the little figure walking away in the left one, not only convey an atmosphere more quietly sinister and diabolical, but also a sort of hint that there is another world outside.

It is not that there is any diminution of intensity in Bacon's work. He is as acutely aware as ever of the dark side of existence, but, in a way of which younger people, orientated as he is, towards the tragic, are not always capable, he appears now to have become more responsive to other aspects of life, and so to be accepting it in its entirety. The colours begin to be

lighter, more varied, more subtly and sensuously beautiful – as, for example, in the 1967 'Triptych Inspired by T. S. Eliot's Poem "Sweeney Agonistes"' (cat. no. 53). And, as one goes through the later rooms, there is a new sense of a mind grown vaster, of breathing a different air.

There are still pictures which give the immediate shock of something incomprehensibly violent and fearful, as 'Triptych with two Figures Lying on a Bed, with Attendants' (1968, cat. no. 58), and the mysterious 'Two Studies for a Portrait of George Dyer' (1968, cat. no. 57), and 'Triptych – Studies from the Human Body' (1970, cat. no. 69); but they are not appalling like the Crucifixions; and looking at the pale lilac walls of one Triptych and the orange background of the other, we feel that this is not the whole of life, but a bad afternoon in a hotel room.

However, when we come to the '"Oresteia" Triptych' of 1981, Bacon once more reaches an extreme; but it is different from before. Here he rises to the loftiest height of tragedy, of the universal situations of myth. The disposition of the shapes, and the shapes themselves, the central slaughtered figure raised as on an altar, one of the Eumenides fluttering on the left, like an angel, and the figure on the right, like an executioner, approach – more nearly than his Crucifixions – to the formal grandeur of the great Crucifixions of the past; and yet, in spite of the awfulness of it, the cool colours of the setting, above all the large rectangular spaces of faintly coloured white, suggest that this tragic event is taking place in the wide world where sea and sky and daylight are equally real, where all seasons and all experiences have their turn. Yet the composition is static, so that we feel it is all there forever, and we have infinite time to contemplate the iridescent beauty of colour in the images; and to note that the dark red is the colour of dried blood, not freshly flowing; and at length this monumental stillness and severe economy convey the impression that we are not witnessing a single, historical occurrence, but the 'eternal recurrence' of some terrible and inevitable ritual.

The 1976 Triptych (cat. no. 98) is unique in Bacon's work, and therefore I want to consider it last.

The sources of his imagery, its implications, affinities, and complexities, have been traced and analysed extensively, and he himself has been surprisingly willing to cooperate, and explain his attitudes. But all this, however fascinating, is of secondary importance to the quality of the work as sheer painting – a wordless art, most difficult to write and talk about.

He has always wanted to avoid narrative or illustrational painting, where, as he says, 'The story talks louder than the paint,' and to create images which should affect the nervous system directly, without any intermediate boredom. Indeed he has been so successful in this that the time has surely come when it is safe to acknowledge that many paintings which do affect us immediately are also loaded with literary ideas. Sickert went so far as to say that all the best artists were illustrators; and certainly many of them were – even Michelangelo; but it is equally true that great painting has never relied for its effect on 'meanings' expressible in words. Sometimes it has been impossible – in the case of Botticelli, for instance – to determine with certainty what those meanings were. Yet, when an artist, while painting a masterpiece, has been much occupied with certain thoughts and ideas (which may even have partly shaped the work), although they remain private and unexplained they do add a mysterious weight, the sense of a hidden reality – something like the lost secrets of an ancient religion; and the marvellously beautiful 1976 Triptych has this quality.

It belongs, in a way, to the category of his Crucifixions and the '"Oresteia" Triptych', but is more complex visually – and, one cannot help feeling, in its secret 'content' – than either. In pictorial development it comes between the two: more severely formal than the first, less pared-down than the last. There are the formal remains of a Crucifixion arrangement, but it has become very calm, and the central image, of the human sacrifice, rather small; the goblet – of blood, or wine – surely signifies a solemn ceremony, and the bowed figure being gnawed by a vulture inevitably suggests Prometheus. And so one cannot help wondering about the two great heads in the side panels, which look as if they began as portraits, on the canvases (if they are canvases) supported on impossible easels – rather like the portrait heads in the 1974–7 Triptych, which both continue down into a different space. Here, only the left one does, growing forward and downward completely out of the rectangle and seated on some invisible chair, with a little tripod base. Compared with the huge head, the body is very small: one tiny hand emerges from the white cuff of the dark, modern suit, the other whole arm is naked, and seemingly the front of the torso too, but the immediate sensation produced is of a little naked human form being held by the personage with the great head, not of his own hands and arms – held, or even presented, as newborn, like Eve from the rib of Adam. And so one remembers that there is a legend which tells that

Prometheus himself created the first human beings. And looking across to the right panel one sees the tangled couple of other little human forms. And surely those great, pale, dreaming heads, with closed eyes and opaline flesh – is there a wound, and traces of blood, or the reflection of fire? – must refer to Prometheus as creator and artist – have they not, even, suggestions of self-portraits? – suffering, in the central panel, for his presumption and blasphemous defiance. The enveloping coolness of the green-grey background is as non-spatial as the gold ground of Italian primitives, and yet the very ordered litter of papers suggests gilt-edged sacred books lying about open on the floor at the base of all three panels, and in the two outer ones the flower-like, flesh-coloured shadows seem to anchor the figures into this world, while the darkish rectangles behind the two heads suggest another – another mode of being, scarcely possible for mortals to imagine. Useless to try to unravel the ambiguities of lines and spaces, what is vertical and what horizontal. But the complication of forms and images – the large rectangles, the construction where the central figure sits, the great hovering shape of the vulture surmounting everything like a pediment, the Eumenides, the bar, the goblet, the ambiguous lines – all together build up something resembling the great architectural altarpieces of the Renaissance.

Then, thinking of Bacon's wonderful pronouncement about our basic nature being totally without hope 'and yet one's nervous system is made out of optimistic stuff', one may remember that in the Aeschylus drama there are two lines in which Prometheus says that he has stopped mortals from foreseeing their death, and planted in them '*blind hopes*'.

If I should be told that all these speculations are wide of the mark, no harm would have been done; for the picture would remain as beautiful, and as deeply moving, as before, and, if possible, even more mysterious.

So one goes back again to the '"Oresteia" Triptych', in which Bacon appears to have reached an equivalent of the highest wisdom of ancient Greece. For he seems to state the inevitability – the *necessity* – of things as they are, and his later painting is permeated with the buoyancy of reality, strongly enough to reflect back on to the earlier work and pervade the whole exhibition.

There is indeed something of the *terribilta* of Michelangelo, but also a note of gentleness, even tenderness, has appeared.

Finally, the entire show vibrates with his boundless creative energy and

'the optimism of his nervous system'. It has the tonic effect of Homer's lions 'rejoicing in their strength', or of an unbroken sequence of a hundred brilliant summer days.

7

BALTHUS

Going into the Balthus Retrospective Exhibition at the Pompidou Centre, one entered an enchanted world, of scenes which seemed quite real, yet as clear-cut as if carved in wood, painted in harmonies of red and green, and drenched in golden light, and, in spite of their reality, removed to the untouchable distance of dreams. And supposing that one knew nothing at all about the painter, one would probably ask: When did this extraordinary artist live? Then, passing through the rooms, one would feel the centuries sliding together, until at the end the golden light faded into the cold light of day. And I think one might guess the artist to have been a contemporary of Proust.

As everyone now knows, Balthus was born in 1908; and he was a child prodigy.

His first known work, the book of forty black and white pictures of Mitsou, the cat he found and, to his great grief, lost, appeared, with a preface by Rilke, in 1920 – that is, when the artist was twelve. These compositions are German Expressionist in character, and not like the work of a child.

Then, in Giovanni Carandente's book of his drawings and water-colours, there is a full-page coloured reproduction of a work in tempera on paper, roughly 5 ft square, 'The Angel's Message to the Knight of Strättlingen', dated 1921. The caption says: 'This is the artist's earliest known surviving work, completed when he was just thirteen. It is a study for a fresco which he wanted to paint in the chapel of Einigen on the Lake of Thun.' Apart from its almost unbelievable accomplishment – which would probably have been thought above average even in the Renaissance, when boys of that age were already apprentices in studios – it is interesting that Balthus had so soon swung over to the early Italian style, showing more than a preference, a genuine affinity with it. (In fact, the rougher Germanic strain only broke out once again, when his emotions were unusually deeply engaged, in the *Wuthering Heights* drawings.)

The Pompidou catalogue, in the first step towards a complete catalogue

of Balthus's work, reproduces at the end a number of early paintings, beginning in 1923, which are recognisably by a young adult living and working in Paris and aware of various recent movements – portraits, scenes in the Luxembourg Gardens, street and quayside scenes, and so on. In 1929 there is the first version of 'La Rue', followed by more portraits and a few larger pictures with one or more figures, already beginning to show the attraction of the Quattrocento, and then, in 1933, the second version of 'La Rue'.

Every painter of great distinction is born with the seed of his own style already in him, with a predisposition to love certain visual qualities, and those innate preferences combine with early experiences to form his first ideas and ideals of beauty which, however modified with time, always retain something of their original character.

These ideals and preferences are never the same for any two painters, but recognising some of them, now here, now there, they are drawn, in youth, to this and that artist, and so find the nourishment they need and acquire the skills appropriate to their gifts. For artists take fire from art, and always have done. Painters are first moved to paint by the sight of pictures. And indeed it was in this way that the Great Tradition was formed, and has survived (if it has survived) so long. And what calls to and excites artists is a beauty quite peculiar to the art itself.

And so the young Balthus was irresistibly drawn to Piero della Francesca, to his cool, calm, deliberately constructed world, purity of light, purity of form, and mysterious tranced stillness which reigns even in the battle scenes. They must have seemed to say to him, as the torso of the archaic Apollo seemed to say to Rilke, 'You must change your life.' And he did – even if not overnight. For a profound influence takes time to be digested, and to have its effect. In 1927 Balthus copied some of Piero's frescoes at Arezzo, and they showed him that the passage of time does not necessarily bring progress, that a mathematically ordered pictorial construction uncluttered by accidents, composed of clearly defined and simplified forms, is in no way superseded by or inferior to Impressionism, which presents a different, not a truer, truth; so that there was no reason why a young painter of today should feel constrained to use a contemporary idiom. But he knew that he must choose a contemporary subject. He understood the necessity – of which Baudelaire wrote so profoundly – for the artist to discover the beauty of the actual, everyday world – the peculiar beauty of modernity. And so he set about his first big composi-

tion, 'La Rue', the version finished in 1929, representing a corner of Paris behind the old Abbaye Saint-Germain-des-Prés; and it is astonishing that a young man of twenty-one could have invented this very considered, noble and dignified design. It is still painted with the soft, blurry touch learnt from Bonnard – the best artist in the circle of his parents' friends – whose influence prevailed when Balthus painted all those early Parisian scenes, but now it is on the point of disappearing altogether. The workman carrying the plank in the centre of the picture is like a declaration of allegiance to Piero.

So he had, as they say, 'found himself', as early as that.

Most of the better artists living now or until recently, appeared, with the first of their works which attracted attention, to be breaking with tradition, and striking out into new, uncharted territory, so that it took a longish time for them to win recognition outside a small circle of supporters, and longer still before their work could be seen as linking up, across the break, with the main European tradition – stretching and extending it, and expanding our consciousness. But Balthus was already working in this tradition when, in 1934, at the age of twenty-six, he had his first exhibition of paintings, at a time when, probably, more courage was needed to do that than to break away. And he showed that the language which had been thought exhausted is still valid and elastic enough for the expression of new and entirely personal subject-matter. And he learnt so early to understand the structure and movement of the human figure, and to express it with complete control, as only the great masters have done, that perhaps the quality of the drawing in his paintings is often taken for granted and escapes the notice of most spectators except artists (who must envy it), because it is never an end in itself, but a part of his equipment for the pursuit of his pictorial preoccupations. The same is true of his drawing of architecture and objects, and of his management of colour and tone. And there is no one else living who has all this technique and keeps it in its place as the servant of his obsessive ideals.

He has been praised for resisting the temptations of Surrealism, but surely the greatest, most daunting and discouraging difficulty for any young painter in Paris at that time must have been to develop honestly in the gigantic shadow of Picasso. Rilke's friendship when Balthus was adolescent was without doubt of immeasurable value in helping him to find himself early and encouraging him to trust his own inner voice. And a little later, when he had chosen his profession, he would clearly have found

BALTHUS
The Street 1933
Oil on canvas, 77 × 94½ in
The Museum of Modern Art, New York.
James Thrall Soby Bequest
© DACS 1986

similar support in his two great friends, Giacometti and Derain, both characters of exceptional integrity. Indeed there hangs over his work the sense of a fortunate destiny, of his genius being accompanied by favourable winds; for how else, in the world of today, could he have found his direction so early and held straight on so long without being blown off-course? One should perhaps qualify this and say, relatively fortunate in an unfortunate time; but still, there is the feeling of independence and freedom from pressures, of friends and helpers always having appeared at the right time, making it possible for him to seclude himself, to devote himself entirely to his work, and to pursue his researches and seek the solutions to his problems, secure from trivial interruptions and ignoble distractions.

He attended no academy, but put himself to school with the great masters of his choice, studying, copying, learning their secrets – Italians of the Quattrocento and French of the seventeenth century to begin with, and others later.

One cannot better the concise statement of Jean Leymarie:

The two versions of 'The Street' were separated by his period of military service. Between them occurred a decisive crystallisation . . . the limpid sunlight of Morocco dispelled the atmospheric veil and its fluctuations of colour; the static prism of Seurat and Piero della Francesca took the place of Bonnard's ever-shifting kaleidoscope.

The 1933 'La Rue' is Balthus's first masterpiece. Without any reservations, it is a great picture, and even if nothing had followed, would have won him a place in the history of art.

It was, for Balthus, a moment of perfect balance. The lessons of Piero have been completely absorbed, without any slavish imitation. There is in fact much more movement here than in the Italian master. The pictorial organisation is perfect. Balthus is unique in our time in the intensity of his concern with this; but his obsession with his own peculiarly personal subject-matter is similarly intense, and in his best work (as here) his art vibrates equally between these two poles, so that, while the idea of balance usually suggests calm, in his case it is a highly charged condition. In this picture he has not put a foot wrong. Indeed, balance is in a sense the very subject. The plank the workman carries, and the kerb behind him, together suggest the oscillation of a see-saw, but the shoulder supporting the plank is the pivot of the whole picture, the other figures revolving

about it with the symbolic movement of a merry-go-round, suddenly stopped at a moment so marvellously chosen that we could be content to contemplate it forever. The young women, one carrying her child, walking away from us into the picture towards the right, seem doomed to be sucked into the inescapable round, though one of them holds out her hand as if to ward it off, to try to stop the movement – yet pictorially the hand actually contributes to it; and, besides all that, is a typical Balthus gesture. Only the boy who comes so splendidly towards us, hand almost on his heart and eyes fixed on some inward vision, seems to proclaim that genius, with the courage of youth, can break through the circle and move straight forward. But the little girl chasing her ball is caught in the movement, and so are the boy and girl behind her, who seem to be an echo of Zephyr pursuing Chloris in Botticelli's 'Primavera'. The picture is full of echoes, and the total effect of clean-cut shapes, the rich blacks, creamy whites, vermilion-red and pale turquoise-blue, all bound together in golden warmth, recalls the whole Quattrocento, which had its own way – better fitted to its purpose, one may think, than that of Impressionism – of representing a scene like this, in a rather enclosed street, saturated and glowing with trapped light. And even today, fifty years after it was painted, we can be taken by surprise, in the older quarters of Paris, at its truth to the characteristic appearance of a locality and its inhabitants. And just as in real life, watching people in public places, although we do not know them and their stories, we can feel the reality, the weight, of so many private, invisible dramas, so Balthus in this picture has given every figure the dignity of an individual destiny, and so the whole life of the street becomes real, circulating like blood, connected with the city beyond it, and with the life of the whole world.

Yet, after this triumph, there are only three or four more such large compositions, which stand up like towers at intervals along the road of his development. Between them, and beyond, stretches a succession of very various works, the most important being paintings containing from one to three figures, whole or partly cut, on a large scale, and large in the picture – that is to say, in the sort of proportion that came into favour in the High Renaissance; for, at the end of the fifteenth century itself, painting was changing, in its aims and achievements – but with an almost concerted movement, rolling on along a broad front, starting in Italy but taking in Spain, France, Flanders, and Holland, whereas Balthus, solitary in his time, was struggling along a stony and difficult path towards similar

goals. And in spite of that feeling of a favoured destiny, one cannot but be struck by the sheer hard work, the persistence and determination, indeed, the 'infinite capacity for taking pains', of making study after study for the same picture; and not only that, but the subduing of a rather contrary, almost refractory side of his own nature, in order to carry on in the direction of his choice. For, in the same year in which he completed 'La Rue', 1933, he produced the pen-and-ink illustrations to *Wuthering Heights*, in which all that side of him lately held in check by the severe Mediterranean discipline which enabled him to paint that picture, found its uninhibited release. From that picture one would not guess that he also had that wild Northern side, that violent Germanic *Sturm und Drang*. And also, in Switzerland, he had met and fallen in love with Antoinette de Watteville (whom he later married) – still in the same year, but earlier – for in the drawings, we are told, he has given her features to Cathy, as his own to Heathcliff.

Looking back incredulously, in middle age, Gertrude Stein once asked Picasso if it was possible that they had really done so many things in one particular year. 'You forget, Gertrude,' Picasso answered, 'we were young then.' And so with Balthus, sometimes the amount of life and work he crammed into his early years seems incredible.

But to return to the Brontë drawings: of course one likes them; one is carried along on the fierce tide of their passionate sincerity. But I think the only one that rises wholly above the category of illustration and is, judged unconditionally by the highest standards, a very fine drawing, is No. 15a – the young girl huddled on the bed, with the faintly sketched figure on the left, by the window – 'O! Nelly! The room is haunted! I'm afraid of being left alone!'

However, he chose another – 'Why have you that silk frock on, then?' – as the basis of a painting, 'La Toilette de Cathy', also dated 1933. Apart from the two versions of 'La Rue', it is the largest and most ambitious picture he had so far attempted, and he was not yet equipped for it. It falls to pieces. But probably it has an immovable place in his affections, as being a part of his youth, which even now would make it impossible for him to judge it with detachment. It helps nonetheless to stress the efforts he was making in these years to acquire the skills he wanted.

Along this stretch of the road there is a large number of portraits, of which only one was shown in the Pompidou exhibition – the famous 1936 one of Derain. One cannot feel any certainty about the others from the

small black and white reproductions at the end of the catalogue. But though one should never make an adverse judgment from them, one can sometimes receive a very positive and favourable impression, and from those photographs one could say that there are two good compositions of this period, 'La Leçon de Guitare' (1934) and 'Lady Abdy' (1935). Both still belong to his Quattrocento phase. The first recalls Botticelli, especially the two-figure compositions, and above all 'Pallas and the Centaur', in the beautiful linear quality of the drawing and design, the distribution of the masses, and of the light and dark parts, and the very character of the shapes and movement; even something in the young woman's head is reminiscent of the head of Pallas, whose right hand grasps the Centaur's hair, while he presses his hands together and, with head shrinking painfully sideways, seems to pray for mercy. And the picture of Lady Abdy, like a Gothic angel, is a marvellous invention, and carries through to perfection the visual idea of the rather heavy-handed 'La Fenêtre'. Then there is a photograph of a small study for 'La Montagne', consisting of the left two-thirds or so of the mountain background, with the dark, shadowed foreground and the recumbent girl. This seems entirely beautiful and shows a quite new mastery, as compared with the little early landscapes.

And now we come to the next landmark, the huge picture itself, 'La Montagne', which is much bigger even than 'La Rue'. The date is 1935 to 1937, so it was finished in the happy year of Balthus's marriage. John Russell speaks of his having challenged Courbet with it, and compares it with 'The Young Ladies of the Village' and 'Bonjour, Monsieur Courbet'. (But really it is quite unlike Courbet in handling.) Russell also says that 'the landscape . . . has a crystalline quality which is . . . pre-Romantic' and that

> the figures . . . have a note of undergraduate high spirits, as if young people with a superabundance of energy had set off with the equipment prescribed by Baedeker . . . and were acting out all the absurdities that came into their heads . . . hallooing, shamming sleep . . . and yet being genuinely carried away by the grandeur of the scene and the pleasure of one another's company.

Yes, that does, in a way, give the feeling of it; and yet, the longer one looks, the more something else seems to come through. The high spirits are of course the painter's own – there is a sense of the boundless confidence of

youth in his own ability to do great things – but, as it were, refined by a trembling excitement, for after all, one never knows – but certainly in some ways his powers have blossomed and expanded since 'La Rue'. There is a greater freedom and sweep and boldness. Looking back to 'La Rue', one could say that it dealt with life, a moment in the present, while this takes in life and death, set in eternity. For surely here there is a secret wish to paint something which really deals with the profound mysteries of existence, on the level of myth, in the Grand Manner. And possibly he has even been a little shy about it, and that is why he has hidden it under the mask of youthful play-acting. And I found this feeling somewhat confirmed on reading in Jean Leymarie's book:

> The sturdy peasant lad kneeling beside his haversack with a pipe in his mouth is the spectral portrait of a childhood friend of Balthus carried off prematurely by appendicitis. He is placed in the zone of shadow, as is the dark-haired girl lying asleep on the ground as if dead, in the pose of Poussin's 'Narcissus'.

Yes, this poor young man 'in the zone of shadow' – he too was once in Arcady; and now he kneels there, in a rather stiff, unnatural pose, disconcerting and awkward; and although, with feet still in shadow, but more than half of her in the sun, the lovely girl in the centre, with bent head and clasped hands held high above it, is all by herself performing the dance of the Graces from Botticelli's 'Primavera' – Persephone celebrating her perennial return to life – although the whole picture pulsates with the joyous return of spring and the bounding rhythms of youth, nevertheless the shadow is not that of night, which would vanish, but of afternoon, which will deepen and spread; and Hades will persist, with the uncomfortable fact of the ghostly kneeling youth, and Procris is perhaps after all irretrievably dead. But the picture, with its amazing sweep of brilliant sky and mountain, sun and shadow, and its crystallisation of the theme of death-in-life, persists and endures.

And Balthus was still not yet thirty. And now follows the most fruitful stretch of his career – the richest in masterpieces – his own High Renaissance.

In the Renaissance itself, the very masters so unjustly decried by Artaud (on page 43 of the Pompidou catalogue) were the first to achieve certain qualities of painting cultivated through the succeeding centuries by a few artists whom Balthus took as his models and teachers. The kind of pictorial

unity now required demanded a hitherto unknown fusion of all the elements of a composition, a taut interlocking and compact richness of formal relations, welded together by subtleties of tone and colour. These aims, these skills, Balthus acquired in a very few years, from studying his chosen masters. They were (though, as one is sometimes reminded, he has never forgotten Piero): Caravaggio, Poussin, the great Le Nain, Georges de la Tour, perhaps Vermeer and Velasquez, and on into the nineteenth century, David, and with especial devotion, Courbet – a noble ancestry, which he has earned the right to claim.

'La Montagne' is almost his farewell to the Quattrocento – not quite, because the portrait of Miro with his daughter (1937–8) still has something of the very clear-cut, icon-like quality of that early time. It is more subtle, profound and modest than the portrait of Derain.

And now, between 'La Montagne' and the two very large pictures, both dated 1952–4, 'La Chambre' and 'Le Passage du Commerce-Saint-André', there follows a succession of splendid paintings so numerous that one can only pick out one's favourites. And as one goes along, one can see a slow and subtle development and change.

In 1937 Balthus took another of his Brontë drawings as the basis for a painting – 'Because Cathy taught him what she learned'. By turning the boy's head he got rid of the restless, anecdotal touch, and achieved, in 'Les Enfants', one of the grandest, purest, most monumental compositions he has ever brought off. Nothing he did before this has such a simple, architectural massiveness and timeless feeling. The drawing is powerful and austere, the colour monastically sober and cool, and beautifully put on – a little reminiscent of Le Nain. And here there is a kinship with Courbet. One can see how this picture must have appealed to Picasso.

'Nature Morte', with the broken decanter, is Balthus's magnificent answer to the 'heroic' still-lifes of the seventeenth century. The two paintings of the child Thérèse and her cat are in the same style, but the 1938 one of Thérèse in the armchair, larger in the picture and turning her sulky face to the spectator, seems to belong to a higher category than those two, approaching that of 'Les Enfants'. And going back to 1937 we find 'La Jupe Blanche', which redeems the awkwardness of 'La Toilette de Cathy'. The self-contained singleness of the design, the seemingly natural flow of the pose and fall of the curtain, the restrained but rich harmony of red and green, white and gold, and the beauty of the paint itself, are all worthy of Courbet.

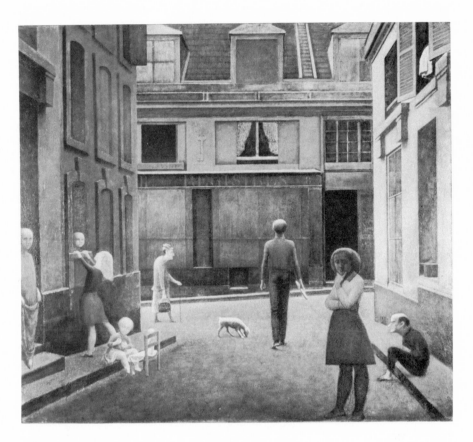

BALTHUS
Le Passage du Commerce-Saint-André 1952–4
Oil on canvas, 115¾ × 130 in
Private collection © DACS 1986

'L'Enfant Gourmand', of these years, is a picture which I know only from the coloured reproduction in Jean Leymarie's book, but which, even half-known, seems so beautiful and important that I have to linger over it. The corrections to the unfinished left arm underline Balthus's preoccupation with composition, and the child's whole figure and movement are echoed in the upper part of the picture. There is also a softness and breadth of handling which foreshadow later developments. Leymarie tells us that this was the maid's child where Balthus was staying in Savoie; perhaps the same infant might have broken the decanter of the 'Nature Morte', on finding which the painter, after a moment of anger, seeing exciting possibilities, probably arranged the whole still-life: for suggestions of any worse kind of violence seem far-fetched. 'Jeune Fille en Vert et Rouge' ('Le Chandelier') also belongs in this group. It is unfortunate that so many of those who have written about Balthus have been poets or men of letters (not students of painting) who have projected their own obsessions on to his paintings and attributed meanings and atmospheres to them which I believe are simply not there. I find very little sinister in his entire output. Whatever private fantasies may have suggested the strange red and green costume of this young girl, with the cloak over her right shoulder and her left hand holding the candlestick, while before her on the white tablecloth stands a shallow antique drinking-cup and a dish with a joint of meat into which a knife is stuck, I believe the mainspring of this picture to have been entirely concerned with painting – with a desire to paint a picture of such a girl in a way which should not be genre, but which should lift it to the more grand and solemn level of those religious paintings by Caravaggio, or Rembrandt, or de la Tour, which he clearly admired. The model herself deserved it, for she is at that age when girls look like boys and boys like girls, when their beauty seems so poignant and other-worldly that that is how the Italian painters most often portrayed angels. And her pose, her dress and the objects, suggesting a sacrificial rite vague enough to refer to almost any religion, provide a structure which enables Balthus to compete (rather successfully) with the great seventeenth-century masters – just as, in 'La Montagne', he seems to have wanted to paint a great mythological picture, like Botticelli or Signorelli. One can see very well the value of this hieratic arrangement by looking at 'Le Chapeau Bernois', beautifully painted, but not more than a portrait.

'Le Goûter', three years later, is in the same stream as the 'Nature Morte' and 'Le Chandelier'. Jean Clair writes well, and, being an art

historian, with less exaggeration than most about these pictures; even so, he writes about the imagery rather than about painting; and I cannot see the young girl here as either 'officiante ou victime'. It seems more likely that Balthus arranged the small white cloth over the dark tablecloth to look like an altar, with the bread and wine as if for a ceremony – the knife perhaps an irresistible repetition – and the fruit, so marvellously painted in its dish, for purely pictorial purposes; and then, calling in the model, asked her what she supposed all this was for?

And indeed, for the artist of today who cannot believe in any religion, but who is acutely aware of the depths and darknesses and voids which religions attempt to plumb and illuminate and fill, is it not very hard to find a way of expressing these profundities underlying the surface of life, without resorting to, or hinting at, the frameworks generally accepted when religions have prevailed? It is clear that Balthus is not content to be a painter of genre; and while continually perfecting his technique, he has gradually attained the power of presenting people and scenes without the help of such devices, with a seriousness and penetrating vision which makes his best work, if not equivalent to the old religious paintings, of a gravity which permits the question.

Parallel with his figure compositions, his painting of landscapes also advanced during these years. 'Larchant' (1939); 'Le Cerisier' (1940); 'Paysage aux Bœufs' (1941–2); 'Le Gotteron' (1943) – all four of these are very different, each from the others, and only alike in that each is a highly concentrated and memorable image of its subject in its most enduring aspect – contrary to the various modern ways of treating landscape through its evanescent surface. The 'Paysage aux Bœufs' appears to me the most personal, and the most beautiful and strangely haunting. In its sensitivity to the poetry of an antique time, which still survives in some countrysides – in mood, that is, though not in treatment – it foreshadows the landscapes of the 1950s.

But before that there is a new development in figure composition – in 'Le Salon', of which there are two versions, one dated 1942, the other 1941–3. Both were shown in London in 1968, and, if the second did not exist, almost all that words can say of it could be said of the first. Yet the second (shown at the Pompidou Centre) is the more perfect. Balthus here tackles a kind of composition often used by Titian. It can be found again and again in his pictures of the Virgin and Child with Saints, in the Entombments in the Louvre and the Prado, and in mythological pictures,

as 'Sacred and Profane Love', or the 'Diana and Actæon' in Edinburgh; a movement begins in the upper left part, travels along towards the right, descends and returns along the lower part in the opposite direction, and comes to rest, knotted up in some way – a hanging hand, a planted foot, a mass of drapery – in the bottom left corner. And within this rhythm, large masses answer one another, their curving contours echoed and balanced in endlessly surprising ways, so that the entire composition becomes a visual music; and it is fascinating to see how Balthus, alone in our time, has become absorbed in this, so to speak, 'abstract' problem. In the 1941–3 Salon one can trace his corrections, his gradual perfecting of the design.

And he now makes use more and more of four activities, which all, in their way, suspend action: sleeping, reading, card games, and gazing into a mirror – thus providing an ideal basis for this visual music to grow from a naturally held moment.

So it is in 1943, in the later 'Salon' and in 'La Patience', that Balthus has attained the mastery which enables him to dispense with the contrivances employed in 'Le Chandelier' and 'Le Goûter'. And it is these pictures which might suggest that he was a contemporary of Proust, who did the same kind of thing for the novel.

In 1944 to 1946 he produced the extraordinarily beautiful 'Les Beaux Jours'. There is an intensity, a poetical magic beyond analysis in this picture, which makes it the jewel of the whole decade-and-a-half between the second and third landmarks.

Let us pass on to 1947, in which year Balthus painted a small 'Buste de Femme', which I have seen in London – modest but perfect, an unforgettable little masterpiece. And in the same year he did the first painting (as far as I know) towards his 'Partie de Cartes' pictures – a study of the girl alone, placing the card on the table, with the candle at her left; and although I have only seen it in a photograph, it appears, like the little 'Buste de Femme', a masterpiece of such radiant clarity that there is nothing to say about it.

In the last years of the 1940s, Balthus seems torn between his persistent love of verticals, together with the sharp-cut separateness and definition of his earlier time – his Quattrocento phase – and a desire for the greater richness and softer handling, even atmospheric melting, of late Titian, together with the latter's interwoven flow of design. And he tries different ways of reconciling, in varying degrees, these contrary aims. One can see how he had learnt from Courbet to put a colour over an under-painting

without covering it everywhere, with such skill as to suggest innumerable variations and the full richness of draperies, rocks, or fruit in a dish – veering, with this, towards the Venetians; but then he is drawn back again to the plain enamel jugs and kitchen tables which insist on a primitive separateness.

In 1947 to 1948 he painted an astonishing picture, fairly large, 'La Chambre I', in which, as it were on a knife-edge, he achieves one of these reconciliations. The very young girl, massively built, dazzlingly blonde, with abundant red hair, stands as if in a dream, confronting us like an antique statue, with one arm held a little away from her side, and the hand in the same line, with fingers extended, while the other arm, covered by a white towel hanging over her shoulder, is bent horizontally from the elbow so that the hand lies flat on her body below the scarcely formed breast. The pose is beautiful, largely because one cannot attach any precise meaning to it, and also in a purely formal sense. The line of the extended arm (a typical Balthus gesture) is continued through that of the smaller, humbler girl kneeling with a book in the background, but turning her head to look up at her companion. The book on one side and the enamel jug on the other complete the pyramid; and the wooden cupboard, the chair, fireplace, and mirror-frame are all as severe and straight as can be, though more in the style of the seventeenth than of the fifteenth century; but the nude girl is painted with such Venetian breadth and softness within the contours that one scarcely notices how firm these are. The whole is quintessential Balthus, and is perhaps the finest of all his pictures of young girls at their toilet. It has a glowing splendour and an uncompromising absoluteness.

It is remarkable that during these years the Second World War came and went without leaving a trace on Balthus's pictures, apart from one, 'Le Passage du Commerce-Saint-André'. John Russell says: 'In September 1939 Balthus was called up, served for a while in the French army, and eventually was invalided out into private life.' At some point he came back to Paris, and there, from 1952 to 1954, painted the two great pictures which I have taken as the third landmark – 'La Chambre' and 'Le Passage'. The latter seems to be the only picture in which he has ever betrayed an awareness of changes wrought by the war, and then only in very subtle ways. For what a contrast there is here with that earlier picture of 'La Rue', so lively and warm and full of bustle and activity and youthful buoyancy and hope, with the confident, visionary boy coming towards us – standing, one cannot help feeling, for the painter himself.

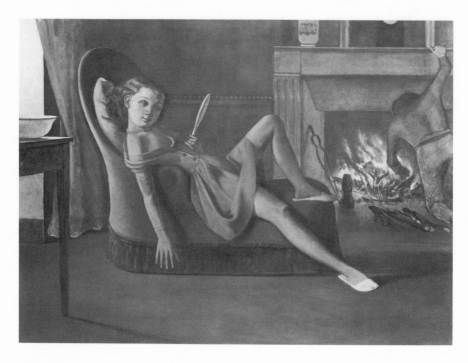

BALTHUS
Le Beaux Jours (The Golden Days) 1944–6
Oil on canvas, 58 × 79 in
Hirshhorn Museum and Sculpture Garden,
Smithsonian Institution ©DACS 1986

This is a picture of despair. The merry-go-round has almost ground to a halt. Whether because of what the war did to Paris and France, or because he is older and has now understood clearly the wretched situation of the artist and of art itself in these times, or both, the painter is disillusioned, turns his back on us and stalks away with his *baguette*.

It is one of the great modern pictures, piercingly sad, as if it were an Entombment, and this is expressed by the shapes, the great number of solemn verticals, the intervals and proportions, which are like a dead march. Mysterious melancholy of a spring evening; the warmth brings the little old man out, to sit on the kerb, and the tiny child opposite, also, to play with dolls, and the little girls to dream, and to desire companions for their games. The shapes of the tiny child, and of the girl with light hair falling back as she lifts her hands to the window-guard over which the little boy looks out, are delicate and tender, curling and climbing like wild flowers in a graveyard.

And, again, with the uncompromising severity of the design Balthus has combined the almost crumblingly soft handling of late Titian – still more so this time – which, seeming to eat away the contours, intensifies the feeling of a moist spring evening. The tones, the colours, the light, are truer than in 'La Rue', true and convincing as that is.

'La Chambre', of the same date, is Balthus's nearest approach to Velasquez. It has a grandeur, and a sense of vastness, as if this dark room continued far up beyond the edge of the picture, into still more mysterious shadow. And here the soft handling is used to express the subtleties of indoor light.

In the Pompidou catalogue there are reproductions of about half-a-dozen studies and small pictures done in the 1940s – one in 1950 – which seem to be try-outs for the girl's pose and the pictorial idea – prose notes and drafts for a great poem. Also, the pose of the lovely adolescent girl in 'Les Beaux Jours' is very similar – indeed, there is a suggestion of the later composition there too – but somehow it has got lost, and almost – dare one say it – a little cramped at the right side, where the young man kneels and feeds the marvellously glowing fire. 'La Chambre', however, is the definitive solution of all these designs, and together with the masterly management of tone, using the same little wooden table, ewer and basin, and a plain wardrobe dimly seen in the shadow, he has suggested the lofty proportions of a legendary palace. The slender yet rounded form stretched naked on the chaise-longue, with head thrown back, voluptuously dream-

ing, reminds me of Montaigne: 'Shall I bouldly speake it, and not have my throate cut for my labour? Love is not properly nor naturally in season, but in the age next unto infancy . . . no more is perfect beauty.' As for the malevolent-looking little phantasm drawing back the curtain, with the gesture of Piero's angels in the 'Madonna del Parto', this strangely shaped creature appears to have grown by pure logic out of the exigencies of the composition, which is as perfect and economical as Balthus has ever achieved. There is perhaps a dart of envy and cruelty in letting the daylight in, to disturb this little Danaë's innocent dream of paradise. (According to Frazer, Jupiter's 'golden rain' was probably the light or 'eye' of the sun, from which, in very early times, young girls were guarded in darkness, because it was thought to have the power to impregnate them.) But all that is not so important – the real problem, the pictorial one, is solved.

We may regret that he has never produced any more great pictures in the line of 'La Rue' and 'Le Passage' – has never, since the last, looked again at the outside world of men, women and children at their daily occupations. But who can blame him, seeing the way the world is going? He has become an ivory tower man; but he works extremely hard at cultivating his chosen garden.

Looking back from this point, we can see that from Balthus's precocious beginnings as a painter in 1921 there was a fairly steady ascent, an unrelenting climb, for sixteen years, to 'La Montagne'. From there, for a similar period, it was a glorious triumphal progress along a gently rising road, culminating in 'La Chambre' and 'Le Passage du Commerce-Saint-André'. Clearly, with the completion of these two great pictures at the end of his Paris period, he had reached a point where he had to break new ground and tackle new problems.

From 1954 to 1961 he lived at Chassy, in the Morvan, and this stretch of seven years shows him occupied with new ideas, different ways of painting. From the work which he at once began to produce here, one gets a wonderful feeling that he was eagerly starting a new life, and that, having absorbed the art of Italy and France since Gothic times, he was now turning his attention both forward, to nearer his own time, and further backward, to Graeco-Roman painting (as found in Italy) and classical sculpture.

In this Chassy period, of seven or eight years, there are three streams of painting.

First, there is a steady succession of beautiful landscapes, different from

those he had done previously in that, instead of being closed in by hills, rocks and trees, these stretch away to a distant horizon. And perhaps it was the character of the countryside itself, which he now had constantly before his eyes, that made him treat it in a flatter way, so that although the distance can be read and is convincing enough, it seems to rise up before us and lie, more than in his earlier work, within the plane of the picture surface.

Secondly, from the beginning of his time at Chassy, parallel with the landscapes, there is a series of paintings of girls, nude and clothed, standing, sitting, reclining, full-length, half-length, bust-length, all remarkable for their sculptural solidity. One of these strongly recalls Piero – the luminous and statuesque 'Léna aux Bras Croisés'. Another, 'Jeune Fille à la Chemise Blanche' (together with the study for it) is exceptionally monumental. Still in 1954 to 1955, there is a strangely beautiful picture (which I only know from the photograph), unlike anything else in his work, 'La Coiffure', in which the picture-space is almost filled by two three-quarter-length figures of girls, one smiling and resting her knee on a chair as she dresses the hair of the other, all in strong light and shade, boldly and powerfully modelled, or rather, carved. It has an affinity with some earlyish works of Picasso. Also in 1954 – perhaps done while he was still in Paris – there is a small painting, 'La Dormeuse', of extraordinary beauty, very solid, almost breathing – probably a study towards the pictures of 'Le Rêve'. In the same year we find three studies for 'The Three Sisters' and the first small painting of the whole composition. All these are massively solid, like the studies of Léna, Colette and Frédérique. They have a forthright strength, a quality of having been seen, which makes them more compelling than the three large pictures done in the 1960s. (In these, the obsession with composition seems to exceed the interest in the subject-matter, and so the tension has to some extent evaporated.) Then there is a starkly severe version (1954–5) of 'La Patience' of nearly a decade before; and in 1957, in the line of these 'sculptural' studies, a quite large picture, 'Jeune Fille Lisant' – a beautiful and admirable painting.

Thirdly, beginning in 1955 with three small studies of flowers and fruit, there is a stream of paintings which can be described as relatively decorative.

Balthus seems to have acquired a fondness for all kinds of *objets d'art*, for things beautiful in themselves, tiles, carpets, embroidered or pat-

terned stuffs, the detail of flowers, the litter of pretty things on tables; and we find a series of pictures which are themselves like woven carpets or large embroideries, in which the one or two figures are sunk in the all-over decoration.

One may speculate on the connection between this kind of painting and the bringing of the landscapes more flatly into the surface-plane of the picture – whether both were the parallel results of a deliberate intention, or whether one affected the other, and how it all came about – from looking at Matisse, or Oriental art, or what?

In the Pompidou catalogue there is a reproduction of a small painting of a pigeon standing by a cup, of about 1953, and of a somewhat larger one of 1958 of the same subject (facing the other way), with a climbing plant luxuriantly twisting and twining in at the window and a view of a roof and country outside, where the treatment of everything is comparatively stylised, and shows the decorative direction his work had then taken. It even seems to have affected the landscapes of that year. But, happily, they soon recovered, and in 1959 to 1960 some of the most beautiful of all appeared – among them 'Grand Paysage avec Vache', 'Cour de Ferme à Chassy', and 'Grand Paysage à l'Arbre'.

Some of the pictures in this third stream, for instance 'Nature Morte à la Lampe', 'La Tasse de Café', have a strange resemblance to certain Cubist pictures; but Cubism itself, whatever its proclaimed intentions, is in effect decorative.

In the first study for 'Le Rêve I' (1954) this tendency is barely adumbrated. In the picture itself, of the following year, there is already a flatter, all-over treatment, but the component areas are relatively large, so the design remains clear. 'Le Fruit d'Or' (1956) and 'Le Rêve II' (1956–7) are more telling as compositions in black-and-white photographs than in the actual paintings, where the colour-relations and, in the second picture, the amount of pattern, pull against the design. In 'La Tireuse de Cartes' the girl is so schematised as almost to become a playing-card herself. The most extreme of these decorative pictures is 'Golden Afternoon' (1956).

Certainly Balthus is not afraid of being inconsistent, of experimenting in different and even opposite directions. Sometimes – not often – he succeeds in fusing two of them, with marvellous results.

Apart from the latest landscapes, there are three outstanding master-pieces in the Chassy years. First, 'Jeune Fille à la Fenêtre' (1955), which

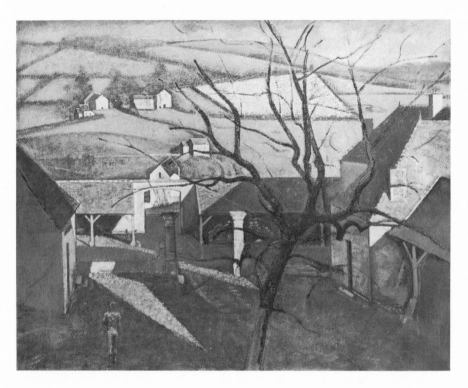

BALTHUS
Grand Paysage à l'arbre 1960
Oil on canvas, 51¼ × 63¾ in
Private collection © DACS 1986

was seen in London recently at the sale of Madame Anavi's pictures at Sotheby's. We see the back-view of the girl, sturdy and solid as a Giotto figure, her dark hair, terracotta-red blouse and greenish-blue skirt all clearly defined areas of local colour. She stands with one leg bent up on a chair, leaning far out over the window-sill, as if to drink in the full deliciousness of the radiant summer morning. Here the landscape is not distant, but close up like a garden, with only a very little sky at the top between the dark branches – as dark as the shadow where the floor meets the wall under the window; and the balance between the outdoors and indoors, with the light flooding into the room and over the forward-leaning figure, is miraculously perfect. Balthus has never yet repeated this particular kind of achievement, though a small painting of the following year (which I have only seen in a coloured reproduction) of four fruits on a window-sill, deals, in a much more limited and modest way, with a similar problem – and solves it with similar magic. Both these pictures are signed and dated, so I think Balthus must have been pleased with them, and well he might be.

In 1959 to 1960, as if to justify all those experiments with decoration, another great masterpiece appears, 'La Phalène'.

Here the human form regains its supremacy, and also suggests sculpture – half statue, half weathered relief – and yet completely living. Long-limbed, high-breasted, with bent head, the tall, slender girl, stepping lightly alongside the bed, lifts one arm to wave the moth away from the lamp, and by this gesture blurs with shadow the lower part of her face, leaving all the emphasis on the eye, which, with narrowing downward look, appears of Byzantine length and divinity. The towel hanging from her other hand echoes the tall chimney of the oil-lamp. There are only two patterned areas, the side of the bed, with draught-board squares, and the bed-cover, and the elements of the patterns are very large and simple, so that instead of cloying us with decoration they suggest the kind of grandeur accompanied by bareness that is sometimes found in old country houses. Balthus has brought everything within the shallow space of the picture-plane, and used and fused all he has learnt about decoration, about light, about composition; but for a long time one is hardly aware of any of these things – only of the beauty and reality of the picture. Whether the girl or the moth is Psyche, or what it means, does not matter. It is like enough to something the painter might have actually seen.

And lastly – not in date, for that is 1957, but because it is the supreme

masterpiece of these years – there is 'La Sortie du Bain', which was also in the Anavi sale at Sotheby's.

Imagine that you are wandering over an old country house one morning, and suddenly you come upon the wide, doorless entrance to a bathroom – an ordinary, plain bathroom, no decoration, no particular colour, greyish-green, or greenish-grey, but light and airy – and there before your eyes, quite unaware of you, so that you get the full benefit of her perfect, noble profile, a buxom Greek goddess is just bounding out of the bath, the springing arch of her foot poised on the rim, her near arm lifted and pushing her great mass of red-brown hair back, out of the way, her body pale and gleaming as sea-foam; surely in a few moments she will be ready, with the same buoyancy, to mount her chariot and ride against the giants. And indeed, the last sight, before this, that so suddenly took my breath away was in fact the sixth century BC statue of Athena, with her tasselled aegis, from the gigantomachy, in the Acropolis museum.

Of the work done by Balthus after 1960 we have not been shown many examples. A very beautiful one, 'Etude pour une Composition' (1963–6), was exhibited in London some years ago at the ICA. This carries on many of his lifelong preoccupations with subject, composition and the marrying of severe verticals with an interweaving of flowing forms, powerfully modelled and handled with breadth and grandeur. But in the Paris retrospective exhibition these twenty-three years were represented by only eight or nine pictures, and it was not enough to convey an idea of direction and development; though with the help of the more numerous small reproductions at the back of the catalogue one could begin to trace a widely zigzagging movement, towards a synthesis embracing contradictory achievements of different ages in different parts of the world: an effort to reconcile the Italian Renaissance from Giotto to Titian, with the massive world of Rome and the more delicate world surviving from antiquity in Graeco-Roman art, where colour prevails over tone; and with an interest in decorative pattern; and, most difficult of all, the effort of a European painter to assimilate and fuse with his own art the art and culture of an entirely foreign, Asiatic race – the Japanese. 'La Chambre Turque' (1963–6) seems to be the only bridge between the two civilisations; and it was a great pity that in the exhibition that bridge was left with its Orient-facing end in mid-air, unconnected to anything; the two pictures 'Japonaise à la Table Rouge' and 'Japonaise au Miroir Noir', done during the next ten years, should have been there, to make sense of the story. For

there was no thread on which to string 'Katia Lisant' (1968–76), 'Nu de Profil' (1973–7) and 'Nu Assoupi' (1981). The first is massively solid and hot in colour – very Roman; the third reconciles equally strong modelling with Balthus's recurrent interest in flat pattern; the sultry colour of 'Katia Lisant' is relieved with areas of coolness, and a richly compact design in the great European tradition is achieved; but between these two the ethereal 'Nu de Profil' appeared unrelated to anything, except perhaps the pale landscape of Monte Calvello, though from the reproductions one can see it as a fusion of Japanese and Graeco-Roman art.

One wants to see a road. But having ascertained its existence, one can almost forget it, for it is the monuments erected at the halting-places that give us pleasure. And in the very last resort, whatever problem the artist may be trying to solve, for the spectator the question is: have his efforts resulted in his becoming still more *himself*? For in the end we only care deeply about the works in which he does this.

So let us consider, finally, 'Le Peintre et son Modèle', which seemed to me at first a difficult picture to like. Many of the old 'motifs' are there, yet with a difference: the very young girl, kneeling, with one leg stretched far along the floor, looks at her book, which is propped on the chair, with the same slight sideways squint we have so often seen, but now without any hint of voluptuousness; on the contrary, she is chaste and cool as the most innocent Gothic angel; the same stark chairs and table, but the table scraped like a ruin and flattened against the wall almost to the shallowness of the frame of a fireplace, and on it (as on a mantelshelf) a packet patterned in squares, and the familiar basket of fruit, but shorn of all those decorative elements that used to recall other painters and schools of painting – reduced now to the severest bareness; and once more the back-view of the painter himself, with small, pointed feet, with lifted arm pushing back the curtain from the window, but quite free from the overtones carried by that gesture in 'The Room'. And the flat pattern of the composition, though strongly typical, is different here in that its move-ment leads out of the picture, curves, masses, and rhythm suggesting a boat, just about to move off towards the right, where the helmsman stands like a mast, looking searchingly into the bright daylight, as if to set out with his little boatload on a new adventure. For there is a feeling here that the whole picture is a soliloquy of the artist, meditating some bold new work which, not by force but simply and naturally through the ripening agency of time, would draw together all the threads that have been running their

parallel and puzzling courses for so many years, and, like a powerful beam of light turned backwards over the road he has travelled, illuminate it, setting all the seemingly contradictory works in due relation, more clearly than I have been able to do, in the landscape of his development.

And time works on us, the spectators, too. For, having long admired an artist's work, we too often expect him to pamper our laziness by repeating himself, while he, breaking new ground, moves on, always ahead, leaving us to catch up if we can. And if in, say, ten years' time we were to come unexpectedly upon any of the works by Balthus which now puzzle or fail to satisfy us completely, it is highly probable that we should recognise them with the pleasure we experience on suddenly meeting an old friend, surprised, perhaps, to find how firmly he has kept his place in our affections, even while we thought that he had somehow changed and was no longer quite the person whom we used to love. But he, after all, while still growing, had gone on *being himself*, and with delight we recognise his voice, his movements, his characteristic ways, and all the qualities that formerly drew us to him.

For it is not sufficiently noted that this kind of recognition plays a large part in what we often think is a spontaneous and instinctive liking.

8

LUCIAN FREUD

In the small front rank of painters in England today, one of the most extraordinary is Lucian Freud, born in Berlin in 1922, but settled here from the age of ten.

The 1974 Retrospective Exhibition at the Hayward Gallery provided an opportunity of studying his development over more than thirty years. One could follow the conflicts and reconciliations, the compression of opposed branches of the European tradition, the telescoping of centuries, in the evolution of one man's work, and try to discover reasons, to understand the changes, from one phase to another.

One accepted these changes as a matter of history; but there always remained the sense of a riddle, of something concealed, teasing and disturbing. A brilliant unease flickers like summer lightning over his work, and it seemed impossible to diagnose the nature of that heavily charged condition which produces it, a sort of hidden storm which never breaks.

The content of his work is sober and autobiographical. The people and things he paints are always part of his life; and little, other than what he can see from his windows, is out-of-doors. Mostly the subject is something to which he gets very close, so close that there is often a feeling of scientific study, the examination is so detailed, the statement so exact.

Sometimes he seems obsessed with the transience of everything, with a desperate desire to rescue something from decay and oblivion, to preserve the memory of it, as nearly as possible exactly as it appeared in life, in some hard, definite, imperishable image – to record, only to record; and then this seems to be the overriding motive of his work; at other times he seems to be preoccupied with the ambition simply to paint better, to enlarge his powers. It appears to be the alternation of these two impulses which drives his work forward.

A dozen or so very early pictures were exhibited at the Hayward Gallery, many of them done at Cedric Morris's school. They show a strong influence of Christopher Wood, strangely married with that of George

Grosz, and are a mixture of primitive boldness and precociously sophisticated observation of character and behaviour. There is a self-portrait and two still-lifes of 1939, and most of the rest are a year or two later – 'Hospital Ward', 'The Refugees', 'Portrait of Cedric Morris', 'The Village Boys', and so on. While the bodies are flat, soft and puppet-like, with spindly limbs, naïvely drawn (until 'Man with a Feather', 1943), attention is concentrated, as one would expect, on the heads; but these are remarkably sensitive, and developed far beyond anything usually found in immature work. This emphasis, however, is counterbalanced by an even tension of pictorial design, holding all the areas interlocked in a taut mosaic stretching across the surface like a veneer of inlaid woods. The paint is usually put on horizontally (always visually satisfying because it has the unifying effect of the fall of light), seeming to billow across the canvas or panel like the undulating floor of St Mark's in Venice – and with a similar suggestion of some dark, peaty, primal stuff underneath, out of which, with great difficulty, the artist is struggling to bring his images, and into which they might subside again. Out of this dark element the faces, and sometimes the hands, and the arms if bare, appear quite clean-cut, as if made of some nacreous material, with a strange effect of being cut round against the grain, against the movement of the brush – for the waves run through them also. Occasionally these paler shapes have a warm apricot or opaline glow, and they represent living faces with haunting power. The eyes sometimes appear to be of a yet more precious inlay, such as ivory and agate, and yet, as real eyes do, they seem as if they could allow a contact to be made with the living person within; a possibility then denied by the firmly closed, secret-looking folds of the lips.

The early pictures, in short, are real paintings, marked by an apparently natural control of the brush, a feeling for paint, for warm harmonies of colour, and for a close-knit unity of the picture-surface. With the point, on the contrary, he had at first less technical ability. The d'Offay Gallery showed pages from a 1941 sketch-book, and in these drawings the line itself is 'stroked', tentative, feathery; but there is a sense of placing, of style, much observation and grasp of character, and an understanding of what he was about. Altogether, from the outset, one would say, a talented young artist.

And yet, we are told, he felt he was hampered by 'lack of natural talent', and so for a time stopped painting, and set himself to learn to draw, from solid traditional foundations – to learn to re-create three-dimensional

forms on a flat surface, to grasp their over-all character, and control a gradually increasing complexity of relationships.

If one had not seen any of this early work, one would have thought the exact opposite, namely, that Freud was a born draughtsman and natural user of the point, and had striven with patient determination to master the art of painting. In fact he seems to have brought this situation about by a kind of perversity, jettisoning all his natural painterly equipment, and after a long discipline becoming indeed such a remarkable draughtsman with the point that that very skill eventually seemed, at times, to make painting more difficult.

His affinities were, naturally, Germanic. And although one seems to see him working back, out and round, from what he knew of contemporary art and the recent past – of the world into which he was born – exploring the wider and older world of European tradition, even (some of his work suggests) glancing at the art of China and Japan – getting his bearings and looking for some firm soil on which to build – his temperament has always remained typically Northern. And during this period when he concentrated on drawing, he produced studies – of gorse, thistles, cacti, dead birds, a rabbit, and so on – which recall the work of German and Netherlandish engravers contemporary with the Renaissance.

In general, one of the big differences between the Italian Renaissance style of drawing and that of the Northern schools seems to be rooted in the length of time the Italians were able – or trained – to hold the image in their memory before taking another look. One gets the feeling that the Northerner looked much more frequently, keeping the point on the paper while raising the eyes, which gives the drawing a 'stop–go' look of being made in segments, of a relatively stiff-jointed angularity in place of the rhythmic flow of a whole figure, and sometimes, also, little changes of scale add up to a fantastic disproportion. The Italian allows an image of the whole to form in his mind, draws it all in lightly with a free sweep – with his arm, one feels, not just with the hand – then looks again, and gradually corrects and completes it, but with an organic growth and grace. It is a more subjective image, a more free translation, and the Germanic one remains much more tightly tied to the object, but, against the more idealising and creative Mediterranean abstraction, it presents a record of specific facts.

After his abstinence, Freud began to paint again with a new clarity and decisiveness. And a sort of optimistic openness to the unknown, even a

Surrealist element, can be felt in the two pictures with the stuffed zebra's head, especially the later one, 'The Painter's Room' (1944). The potted palm – perhaps the first appearance of that in the 1951 'Interior in Paddington' – seems wonderfully fresh and exotic, and by its presence changes the light blue background to a distant sky; the zebra's head and neck, gaily painted in red and yellow, thrusts gigantic into the room, and all that is real becomes magically tiny and toy-like; the two arms of the settee, with the covering worn off in patches, and the earlike shapes of the back, repeat in little the zebra's head, and turn the whole settee into a two-headed beast of fantasy, while the red scarf and dark top-hat abandoned on the floor suggest that the artist has been whisked away – vanished on some hilarious adventure.

The two little paintings, 'Woman with a Tulip' and 'Woman with a Daffodil', done in the following year, are clear and brilliant as mediaeval enamels, and reminiscent of many exquisite small portraits done in the sixteenth century; and while they retain some of the idiosyncrasies of the early pictures ('The Refugees', for example), as in the drawing of the wide, almond eyes, and lips modelled like rolled petals, they have come out into a clear daylight, the decisions and handling are confident and bold, and they are among the first paintings which made Freud famous for a certain kind of portrait, meticulously executed, and of a peculiarly harrowing intensity.

In these two paintings any variations of tone are slight, and contained within unbroken areas of local colour, which are more than descriptive: they sing together. Freud still had a kind of painterly innocence, a single-mindedness, which in a few years he lost.

After the war, following a visit to Paris, he stayed for several months in Greece, and the effect on his work was dramatic, as if a modern Faust, long cramped over his laborious and myopic studies up there in his Northern tower, suddenly transported to the blinding brilliance of the Mediterranean, were straightening his back and lengthening his focus to take in all the beauty and splendour of that light and of the classical world.

And indeed he captured something of that light and beauty in a few very small pictures, 'Unripe Tangerine', 'Lemon Sprig', 'Still-life with Green Lemon', using cast shadows and strong light and shade without losing the local colour. But the whole problem of reconciling effects of light satisfactorily with local colour in more elaborate and ambitious pictures is one that has tormented painters for centuries, even in the relatively veiled and

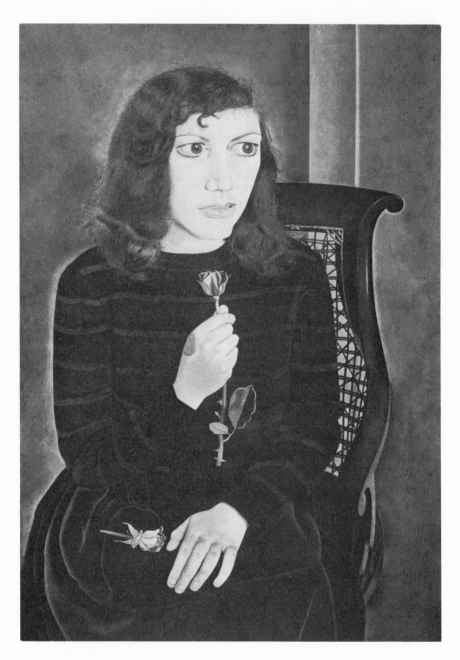

LUCIAN FREUD
Girl with Roses 1947–8
Oil on canvas, 41¾ × 29½ in
The British Council

misty light of the North. For a little while Freud shelved it, but he had to face it eventually.

At about this time also, he must have acquainted himself fairly extensively with the whole field of European art, its styles and masterpieces. The series of portraits done after his return from Greece shows a new desire for the monumental, and the power to achieve it. The work of these few years, until 1949, is full of a quite extraordinary sense of the excitement of a young man feeling his powers unfolding towards capacities the limits of which he cannot yet see, eagerly turning in many directions, and still undecided which to pursue.

'Girl with Roses', the amazing and unforgettable portrait of his first wife, is, both in immediate effect and technically – especially in its style of drawing – Germanic, closer to Cranach, Hans Baldung Grien, and Holbein than to any of their Italian contemporaries; but it has what those German masters had learnt from the Italians: simplification and grandeur. The proportions are strange, but convincing. The head is larger than life, seen in a three-quarter view, and the upper part is opened out, bringing the far side forward almost frontally, so that the already exceptionally large eyes appear enormous. The vertical centre of the face is severely in line with the stem of the upright rose and the pale hands (one with a small scar); had it been curved to make the form of the head in perspective, the architecture of the design would have been weakened, the solidity would have rendered the discrepancies of scale intolerable, and the realism would have degraded the Oriental remoteness and destroyed the profounder reality of the image, which makes a sensational impact and yet has a continuing power to haunt. And one has the impression that Freud achieved this miracle like a somnambulist walking a tightrope, instinctively, unselfconsciously, tense and concentrated but entirely positive and unaware of the abyss into which a false step would have thrown him.

The huge eyes have tiny reflections of a window in the pupils. The ashen lips are slightly parted, showing the teeth. Only that look of frozen anxiety, of life suddenly arrested, marks it as modern. It is monumental as an ancient Egyptian figure, designed for eternity.

In a few small portraits of about the same time the Asiatic element is more marked. There is something Chinese in the 'Girl with Kitten', not only in the treatment of the animal but in the delicacy and stylised sweep of the drawing of the eyes and brows, and in the matt colours, as of magnolia

petals and celadon. 'Girl in a Dark Jacket' is even more Chinese in feeling, drawn throughout with a wiry beauty, a sort of sharp, dragonish sting.

In all these portraits the pure local colours are almost undisturbed by tone. But soon Freud veers in another direction, seen in the pastel and conté drawing on grey paper, 'Girl with Leaves', which has the weight of a painting and gives a sense of full colour and light with strictly limited means. There is green in the leaves, the stripes of the collar are blue and white, there is some muted brown in the dark hair and eyes, and a little brownish-pink in the lips; but the face, which is more fully modelled than hitherto, appears as live and luminous as that of a real girl in the open air against a pale blue sky, cool and bright as if above a river, and all this, the flesh and sky, are, most astonishingly, done entirely in grey and white. There is suddenly a feeling of today in this pastel, of living, changing light. A little breeze seems to turn the leaves over. This new feeling also comes across in a pen-and-ink self-portrait, 'Man at Night', which uses old, engraver-like techniques for stating tone, but in conjunction with a strong contrast of dark hair and light face. Both the pastel and drawing, in their bold simplification and brilliant luminosity, recall Derain.

There begins indeed to be a suggestion of Paris in some of the works of this period – nothing startlingly modern, more a quality of the light and colour of the city itself, a silvery, blue-grey coolness; and a feeling of growing sureness, not exactly of direction, but of what it means to be a painter – of standing in the present and knowing how to make use of the past – a sense of the living continuity of tradition more often found and felt in Paris than in London.

In these years Freud produced a succession of masterpieces, but with a sense of restless searching and experiment. A number of small works, still-lifes and heads, shows the mastery acquired during the years of disciplined drawing, and used now with a new freedom – even an appearance, almost certainly deceptive, of ease. The superb head of Christian Bérard, in black and white conté, can only be compared with Holbein's Munich drawing of Henry VIII. It is the casual informality of the pose, in dressing-gown, head resting on pillows and mouth slightly open, which gives it a modern look. The same is true of the etching 'Ill in Paris'. Only one other etching was exhibited, but several small paintings were done on copper in the next few years, suggesting discarded etching-plates.

1949 appears to mark the beginning of a new period, of Freud's submitting himself to the discipline of the classical Mediterranean schools

in general, and of Florentine draughtsmanship in particular. This is the year of the beautiful painting 'Father and Daughter', which is unlike anything else in his work. It picks up a thread abandoned since those quite early paintings, 'The Village Boys', 'Man with a Feather', and so on, in the way that every area of the canvas plays a vital part in a complex, tautly interwoven surface design. The bead-curtains, with their large zigzag pattern, echoed by the shapes of the man's hat and hand, give a sweep to the composition, reminiscent of fourteenth- and fifteenth-century altar-pieces – for instance, of the strongly patterned angels' wings in Lorenzo Monaco's 'Coronation of the Virgin', which make such surprising spaces through which bits of bodies appear; so, between these curtains, partly concealed, the seated man gazes out, sad and attentive, while the little girl who stands between his knees is painted with the velvet gentleness of Renoir. But the picture as a whole recalls its golden Italian ancestry, and, among modern painters, Derain – himself so firmly rooted in the Old Masters – and Balthus in his painting of Miro and his daughter.

Up to this time Freud had, on the whole, almost forgone the use of tone in favour of local colour; but now he began to study form with a stronger sense of the solid mass, following every change of plane, and using a full range of light and shadow. In 1951 he completed his largest picture yet, 'Interior in Paddington'. This work is carried out completely in terms of tone, with sculptural thoroughness, as if it were a monochrome representation of an actual scene. The colour is so muted that it plays a quite secondary part. The shapes build up a composition both monumental and elegant. There is an equal balance of Mediterranean grandeur with Northern exactness, of Italianate grace and Florentine clarity of form with Germanic accuracy of observation. And while the eye can rest anywhere with pleasure, or travel endlessly over all the relations, one is also conscious that here is an instant of ordinary daily life, out of the millions continually vanishing, rescued and preserved as under a glass bell.

In the 'Girl with a White Dog', finished in the following year, 1952, Freud has dealt with the problem of tone and colour in a different way. The light is diffused, and the whole picture is, so to speak, carved within the limits of a shallow depth, as opposed to the fully three-dimensional effect – as of free-standing sculpture – of the 'Interior in Paddington'. Here, by renouncing the full range of tone, he allows the colours, in spite of their subtlety, to register locally. Girl and dog, in pale, gleaming colours against the darker curtain and settee, make a mass like a thick, reversed

capital 'L', and this figure is repeated, with variations, within itself. The dog, stretched beside the girl, underlined by her leg and foot trailing in front of it, its head resting in the crook of her knee, is as marvellously painted as Oudry's 'White Duck', and modelled to fuller roundness and weight than any part of the girl herself except her bare breast. With this, the animal repeats the same figure, and, in terms of colour, with the cold bluish-white moulding on the right. The girl's face is studied with moving precision and sensitivity, still as if carved within the limits of a relief, and is more a portrait and less a monumental image than in the 'Girl with Roses'. We see again the little scar on the right hand; and while the whole picture has this exact and particular element of portraiture, it is, even more than the 'Interior in Paddington', the work into which Freud has put every-thing which it suited him to assimilate from the Mediterranean tradition. He has for once allowed himself, with a hint of melancholy and a sense of luxury, the flowing grace of the Florentines, though there is even more, here, of France – the coolest, most Northerly of the Mediterranean countries. And both girl and dog live and breathe. They are not simply recorded, preserved, rigid under a glass bell, but are re-created.

In addition, the picture has a valedictory quality, as if the painter had arrived at a turning-point. This was indeed Freud's situation. But we must not follow him into his next phase without lingering over the beautiful small heads, a highly important part of his work, done in those last two years (1950–2), such as 'Head of a Woman', 'A Writer', 'John Minton', 'Francis Bacon', and the tiny unfinished self-portrait.

Probably no one else, in the middle of the twentieth century, was doing portrait heads so meticulously searched out according to the fifteenth-century Florentine conception of form. But however astonishing it may be to find them being done in our time, they bear the stamp of it more than at first appears.

Technically, these heads are modern in being done directly from life, every touch stating something seen, discovered in that instant, with an effect of freshness and immediacy. They are full of observed colour in the shadows, and even in the subtly varied lights, with a preference for pale iron-blue, a washed-out brown-violet with a little pink, olives, and strange yellows (the colours of bruises), exceedingly beautiful seen close, though at even a short distance much is lost. The Florentine portraits on the other hand were done from preliminary drawings, and the painting proceeded confidently according to a method, the light parts usually the golden

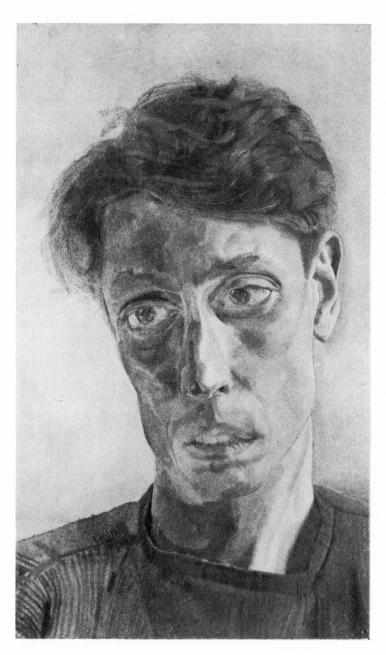

LUCIAN FREUD
John Minton 1952
Oil on canvas, $15\frac{3}{4} \times 10$ in
Royal College of Art

colour of the Italian skin, the shadows merely darkened with a single variation of it, or with grey, and all built up to a final condition of substantial completeness. The results are so forceful, solid, and clear-cut, that in a gallery they appear like enduring monuments among the wash of unsettled human beings moving past them. And that was the intention. They are more formally posed and composed, wearing even as they sat the look of monuments, the aspect considered most seemly for transmission to posterity; and so, in spite of physical peculiarities being noted, they approximate to types and ideals. If they meet your eye, it is with that slightly veiled look which defies entry, and shows them in command of themselves and the situation. Freud's little heads, by comparison, are like shimmering reflections in a mirror – not less real, but like captive, naked souls. Here it is the painter who is, temporarily, master of the situation, for he has penetrated the armour of his sitters, and they are poignantly revealed, always as vulnerable and usually as suffering. If the fifteenth-century Italians represented a person as suffering or emotionally tense, it was as a character in a story; but Freud paints John Minton with his mouth half-open, his head a little inclined, not as some martyred saint but as his own tormented self, nakedly at grips with his destiny.

In spirit these heads are completely modern. Among them perhaps the most remarkable and most beautiful of all is the little portrait of Francis Bacon. The most purely Florentine in effect is the tiny unfinished 'Self-portrait' of 1952; but this too expresses a painfully intense anxiety.

By this time Freud must have realised that no further development was possible for him as long as he retained all the technical elements he was then using, because beyond a certain point they were irreconcilable and cancelled each other out. The last series of heads shows how the increase of subtlety, the modelling of every change of plane, threatened the power of making strikingly clear images, which he had achieved in the portraits of 1945 to 1948. The subtleties of colour, too, negated colour at a distance. Three pictures, all masterpieces, which were hung together in the Retrospective Exhibition, summed up his position. They were 'Father and Daughter' (1949), 'Interior in Paddington' (1951) and 'Girl with a White Dog' (1952). They show that he could draw with a point as well as most of the Northern masters and most of the fifteenth-century Florentines, and could put on paint as exquisitely, with gradations as fine, as Holbein or Ingres. He could organise a picture in shapes defined by clear local colour, as in the 'Father and Daughter', but then it remained (though only when

compared with certain others) rather flat; or he could compose in depth, as in 'Interior in Paddington', but then the colour remained very muted; or, as in 'Girl with a White Dog', he could organise a composition in both colour and form, by restricting both and giving the painting something of the character of a carved relief. This third picture is perfect; but it is the end of a road. He could go no further that way. And really, the crux of the matter was, that whatever the actual procedure, in effect and fundamentally these pictures were linear drawings, coloured – as with the Florentines. They were not *made with colour*, made with *paint*. Freud may have felt that in his artistic evolution he was going through centuries of European painting, and now it was time to pass quite beyond this stage: hence, probably, the elegiac quality of 'Girl with a White Dog'. Something must now be sacrificed, and big decisions taken. And no doubt these conflicts, this uncertainty of direction, are mirrored in that little 'Self-portrait'. It may well have appeared to him as if, in order to go forward, he must risk his whole identity.

He began to do larger heads. Perhaps the best in the first phase of this experiment (in 1954) are 'A Woman Painter' and 'Man in a Head-scarf'. They are lit from in front, so that there is hardly any shadow, but the entire surface of the face, every little formation and change of plane, is explored to the last detail, and this is done without any tone, by changes of colour, pinkish and greenish. Seen close, the paint looks thin, almost like water-colour, and is no longer applied with enamel-like smoothness, but left rough-edged and blotchy. Yet at only a little distance the colours of the flesh merge into a general opalescent or nacreous effect, surprisingly similar to that of his early heads, although the forms are now more fully understood, and carved as clearly as if in marble.

In the late 1950s he was doing heads much over life-size, seen at such close range that they are like topographical surveys, every lump and hollow being rendered with equal emphasis, and all somewhat exaggerated. The eye is as it were compelled to make its way over a rocky terrain of raw, reddish clay, strewn with green, mossy boulders, veined and weathered, and only with difficulty finds it adding up to a head. Seen and done bit by bit, they give the feeling of Gulliver looking at a Brobdingnagian. They are still very thinly painted, often with overlapping brush-marks. Sometimes the backgrounds are painted as if quilted or faceted, probably to relate and unite them more closely to the forms of the heads in a shallow space – rather in the way that Kokoschka dealt with his back-

grounds in 1911 to 1912, after the quite differently handled early portraits. Both Kokoschka and Freud, in these phases, appear to have been thinking about Cézanne, to have suddenly felt drawn to his basic conception of creating form and pictorial unity by means of a continuous modulation of colour. But at this stage Freud was still groping towards this goal. The best head of this kind is 'Woman Smiling', which, in a strange way, as one grows used to it over the years, seems to become beautiful.

From 1960 to 1962 there is another change, completing the metamorphosis. The paint is no longer like water-colour. It is mixed with an oily medium, and becomes thicker – not a stain, but a substance; and instead of building the form by placing smallish patches of colour with great deliberation in the right place, the brush-strokes, which have become bold, vigorous, and sweeping, now create the form by their movements. They remain visible and constitute a vital part of the painting. They did this, but only in the painting of hair, in the linear Florentine tradition, even as far back as the 1940s, the brush always moving in the direction of its growth, making every strand with a springing rhythm. But now, with a new confidence, the broad, powerful strokes move over the canvas, leaving as their trace a jaw, a neck-muscle, a collar-bone, a shoulder-knob. The scale is still much larger than life, and the colour too becomes, in the same proportion, stronger than life. A glowing, terracotta-pink, veering sometimes to orange, sometimes to a rosy or meaty red, makes its appearance in his palette for flesh, and with it a clear, cool ivory, and still cooler, dove-like, pearl-like grey; and with the greenish-blacks and dark slate of his sofa, browns of hair and rugs and so on, Freud has made his breakthrough, and discovered how to create form through modulations of colour, in such a way that the form appears satisfyingly full, and the colour, even through its changes, retains its local character with vivid freshness. At the same time the forms themselves, without losing any of their representational qualities, acquire a massiveness new to his work. 'Pregnant Girl' (1960–1) is, I think, the best painting of this series, but 'Baby on a Green Sofa' (1951) and 'Sleeping Head' (1962) come very close.

In 1963 he was master of his new language, and able to employ it on any scale, even quite a small one, as in 'Naked Child Laughing'. Having worked it out, he did not need to do any more huge heads. The next ten years are full of the rewards of the last ten. Having put himself through a succession of disciplines, he emerges equally master of the point and of the brush, of form and colour. And having taken what he needed from the

Mediterranean side of the tradition, he has returned to the North, and shows – for a few years only – an affinity with Hals.

This is evident in the 1963–4 painting 'A Man and his Daughter'; it is compared with such a painting as this that that other 'Father and Daughter', of fourteen years earlier, looks flat. Yet that early one is real, poignant and beautiful; but of a different world – the world of an earlier historical period, or of a younger man. This later one has a massive heaviness, a solid grandeur and severity. As a relief from the intensity of the human presences, one's eye dwells on the way the physical forms are made, on the deft strokes of paint, so accurately judged that in one operation they create form, colour, and light. The paint becomes the scarred flesh of the man's face, the child's thick plait of hair, the white bow that ties it, the ivory gleam of bone close under the skin, the salmon flush across the cheeks, the soft, sullen lips, the liquid of eyes. If ever thoughts moving through the mind cast visible shadows across the eyes, they do so here, and bring one back to the immaterial side of the mystery.

The head of John Deakin was done about the same time. What is most extraordinary about this portrait is its quality of absoluteness. It appears, as far as such a thing is possible, lifted out of conditions of place and light – almost of time. It could have had a gold background, like the old pictures of saints. We are confronted by a clear image of the head of a human being, much battered by life, and we feel that every physical detail has been shaped, over the years, by the kindly, humorous, but tragic being whose visible form it has become. And by some miracle of sympathy these forces seem to have passed into the brush of the painter, which has somehow repeated this shaping process without reference to accidents of light. The general colour is a meaty red. It is true, without being naturalistic. Freud has never done anything more profound.

There can be no doubt that the work of Francis Bacon counted for something in the changes through which Freud's work had been passing, in his attitude to the potentialities of paint itself, and the importance of the brush-stroke, as well as in a new freedom and vigour of style, though it was seldom that this influence appeared in the composition of a picture. An exception is 'Reflection with Two Children' (1965) which shows the artist, cut off at the beginning of the thighs, seen in a backward-tilted mirror, so that he leans away in steep foreshortening as in a baroque ceiling, or those violent sketches of sacred subjects by Rubens. Without the advantage of compliant draperies, simply with a short modern jacket, and bent arm

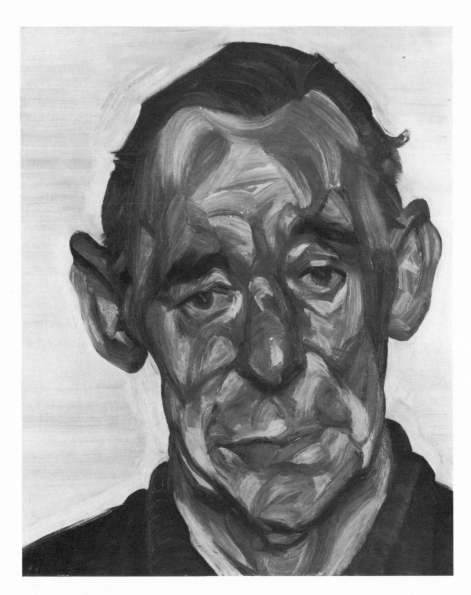

LUCIAN FREUD
John Deakin 1963–4
Oil on canvas, 11⅞ × 9¾ in
Private collection

loosely resting across his body, Freud carries off this bold invention with breadth and bravura. The head is as it were folded back each side of the centre-line, as often in Cézanne and always in Giacometti, giving a more acute sense of the third dimension, still further heightened by being seen from below. This head, superbly drawn, with a flourish of conscious power, looks down proudly, as well it may, from its pinnacle in this extraordinary and slightly swaggering composition. The two tiny children in the bottom left corner, cut off above the elbows, are on a much smaller scale, and their pictorial function is similar to that of the child angels at the bottom of Renaissance altarpieces. One, indeed, seems to gaze upward in sweet piety, but the other laughs diabolically. Both together, but the gentle one particularly, are reminiscent of the cherubs in Raphael's Sistine Madonna – of which the entire picture can be read as a parody, with Lucifer in place of the Virgin. The two circular ceiling lights, necessary elements in the spiralling pyramid, stand in for swirling draperies. This painting – smaller than it feels, a yard square in fact – comes closer than anything else of Freud's to Francis Bacon in its bold sweep and spacious design, and also in its element of parody; but with Bacon, when there is parody it is savage and burning, while here it is rather a spirit of wit and mockery – cooler, more Mephistophelean.

The double portrait of 'Michael Andrews and June' is a less spectacular *tour de force*, but it succeeds without the prop of irony. Kokoschka, a year or two before the First World War, painted an impressive double portrait of himself and Alma Mahler, for which he must surely have taken Rembrandt's 'Jewish Bride' as a model. The 'Jewish Bride' is not only portraits of two people, but a picture of a universal relationship, endowed with tenderness and sanctity, in the tradition of van Eyck's 'Jan Arnolfini and his Wife'. Kokoschka has retained, translated into his new painter's language, the solemnity and formality, suggesting the religious ceremony of betrothal; and the memory of the Rembrandt embedded in it ennobles it, and seems to hold it together against the threat of disruption from the cruel, unidealised head of the woman. The Freud double portrait has jettisoned everything but the feeling of the man's serious acceptance of responsibility. The woman leans back relaxed in the protective shelter of his arm. Yet it reminds us of those earlier pictures, in the way that children, rebelling against their parents, demonstrate their involvement with their ancestry. The sense of ceremony, of occasion, is quite gone, and seems actively denied. We see an enduring situation between two particu-

lar people, in all its everydayness, stripped of ideals, summed up in the kind of pose they might adopt for a snapshot.

But there is a sort of compact, landscape grandeur in the composition, compressed like a volcanically formed mountain; the influence of Giacometti contributes to this emphatically solid appearance, in the way that the forms are crushed together, folded back, and elongated.

Three paintings of a naked girl, twice asleep and once nearly so, are similarly particular. The light shines on her from in front, at about the same level as that on which she lies, or a little lower, so that it falls on the planes which would more often be in shadow, and this, because we are not so used to it, always heightens the effect of solidity and seems pleasing in itself. The naked body is presented without preconceptions, as objectively observed as if it were a rabbit or a bird. The flesh gleams and glows against the sheet. Two head-and-shoulder lengths of the same girl, once holding a towel and once in a fur coat, are painted with equal brilliance.

It is hard to pinpoint exactly where it happens, but about this time, in the later 1960s, Freud's painting changes again, becoming gradually tighter. One would have expected the painter of 'A Man and his Daughter', 'John Deakin', 'Reflection with Two Children', 'Girl in a Fur Coat' and 'Girl Holding a Towel' to have gone still further in that direction; and I cannot think of any other painter who, having once acquired such power, has deliberately relinquished it – and not proceeded to even greater breadth and freedom. But what characterises this change is the feeling that the whole question of *how* he paints seems at this stage less important to Freud than *what* he paints. It is a subtle shift of emphasis, as if he had satisfied himself that he had stretched his powers, and could do this and that, but that, after all, it was only to enable him to say whatever he wanted to, and there were things he cared about which could not be handled in that way. For instance, he loves plants, and all their intricate detail. Why should he sacrifice their actuality, their particularity, for an idea – for considerations of 'good painting'? The shapes of a cyclamen are in fact expressible in the language he had recently evolved; those of thistles and buttercups less so. 'Interior with Plant, Reflection Listening' is a still more refractory subject. For this large picture is almost filled by the plant's principal fountain of leaves, long, narrow, shiny, and curved, thrusting out beyond the canvas on all four sides, seeming to sweep round and round with the perpetual motion of a swastika. Appearing in a space among them, the little reflection, in the dark glass of the window at night, of the

artist's head and shoulders and lifted arm, completing the rhythm of the leaves, is handled in his broader idiom. And this relatively tiny area of paint dominates the whole picture. Half-concealed, he crouches like a great spider in its web, watching for its nourishment, intent on this challenging adventure. And when one remembers that, even while his results were broadest and freest, Freud never proceeded like those painters under whose hand the whole picture grows as a unity from beginning to end, but always bit by bit, finishing as he went along, the return to a sharp, linear approach is less puzzling.

And, in returning, he has retained some of his conquests. His language is richer than it used to be, as the 'Large Interior in Paddington' (1968–9) clearly shows.

This is the biggest picture he has ever painted, 6 by 4 ft. In the foreground a small child, naked but for a short vest, lies on the bare floor-boards under an indoor linden, which rises up like a forest tree, spreading its stems and aerial roots and green leaves across the window. This goes down to the floor, letting the pale light stream through it full on to the little body, not much bigger than the flower-pot, lying in a twisted pose like one of Correggio's, lost in some incommunicable daydream. The child is painted with the breadth of 'Girl Holding a Towel', the head, in its juicy fullness, even recalling Rubens. At the same time, without any feeling of inconsistency, every leaf of the plant is painted individually; and throughout this picture the tone really becomes colour: the luminous green of the leaves, the colour of the flesh, of the floor, all tell at a distance; but nothing is forced, nor is the Impressionist range used, nor anyone else's; it is entirely Freud's, but appears unselfconscious, arrived at from sheer observation and fineness of judgment.

Behind the child's head, on the floor, there is a glass marble, and straight above this, in the top left corner, the knob of the shutter, from which hangs the painter's jacket. It seems to have hung there for years – a lifetime – like Faust's old cloak. And though it would be too heavy-handed to attribute to Freud any ideas beyond visual ones, the whole pictorial conception is itself mysterious, and seems full of echoes and memories, as if the magician of former days, who once flew to Greece, really did bring back some magic seeds of classical Mediterranean beauty, which from time to time, if he ever so slightly loosens the tight rein on which he keeps himself, can still flower, even in this austere climate, in strange, unforeseeable ways.

In the last few years, Freud appears to have accepted that, after all, it is the subject, the particular experience, which is of the first importance for him; and if it is something which rebels against breadth of handling or simplification, then he will let it dictate the treatment itself. Thus, for instance, there are three pictures, two of waste ground with houses, one of a factory in north London, painted with extraordinary tightness, and with an equal emphasis on every detail. A few big shapes, scarcely more stressed than they would be in a photograph, hold everything just sufficiently together; but they are surprising at this late point in his long Odyssey. Two little night interiors, one with a naked girl and one with Harry Diamond, have a similar Dutch exactness, but a more fluid and, for want of a better word, 'painterly' quality. Then, in 'Portrait on a Brown Blanket' and 'Naked Portrait', of 1972 and '73, he has turned quite away from the broader treatment of the 1966–8 'Naked Girls', and returned to the clear line and sharply silhouetted forms of the fifteenth-century Italians.

The four small recent heads of his mother combine the painterly skills of his later years with something of the 'absolute' quality of his portrait of John Deakin; but they are tighter. And the same may be said of the most recent picture of all, the 'Large Interior, W9', which also, in an odd way, takes us back to the quite early paintings.

This picture presents an impenetrable front. It is composed of starkly few elements, so clearly defined and tightly interlocked that it is as if they linked arms to screen the mystery behind them – as with 'The Refugees'; and there is the same astringent yet resonant colour. His mother sits in the studio chair, hands resting on its arms, looking down and lost in her own thoughts, while a girl, naked to the waist, reclines on a bed in the background, her equally unseeing gaze directed towards the ceiling. Her raised knees, under a dark brown blanket, make a pyramid exactly over the older woman's head, and together with the chair-back this gives a strange effect of a Gothic throne. The two women look entirely real, but they do not see each other and they have nothing to do with each other, waiting in this bleak room; and so, with all its reality, the effect is dreamlike, as of the irrational, interior world of the artist's mind, and of 'figure composition'.

It was not until the Hayward Exhibition was over that, musing on a fragment of John Russell's catalogue introduction – 'Freud at that time was conscious – and in fact had been conscious since he was fifteen – that he had an almost total lack of natural talent. He determined to make up for

this by observation, and by working in a graphic tradition' – I wondered: why did Freud come to this consciousness and this decision precisely at the age of fifteen? And then I thought that, on the contrary, his early work showed marked talent; it also, I remembered, showed a strong influence of Christopher Wood. And suddenly a spark seemed to flash from one to the other, and illuminate the mystery of his development. Correct or not, it offers a way of seeing and grasping it as a whole.

Freud was fifteen in 1938; and in that year, in March, the big Christopher Wood exhibition was held, in the New Burlington Galleries. And the beauty and vitality of that work must have been a revelation and a spur to any sensitive young man with kindred ambitions. Almost certainly Freud would have seen it, and probably knew at once that something of that kind was what he himself wanted to do, and in the same instant knew that he could not – or at least, not then. And this inability he would have felt as a 'lack of natural talent', not allowing for sheer difference of gifts. Determining to work 'in a graphic tradition' no doubt refers to 'at that time' – a few years later; for at first there followed those early paintings, in which Christopher Wood's influence is evident – a time of hopeful hard work; then the period of disciplined drawing; and the influence reappears in the pictures with the stuffed zebra's head, especially the second one, where there was surely a memory – even if unconscious – of Wood's 'Zebra and Parachute'. The red and yellow of the parachute are transferred to the animal's head, and there is the same airy blueness, and feeling of a strange, other world. And there is a note of buoyancy, of eager hopefulness, an unrepressed response to beauty, a love of clear colour and strong light, running through his work for another four or five years.

In 1948 he finished his first big, ambitious picture, 'Girl with Roses', in subject, in treatment, from every point of view, unashamedly beautiful. Did he compare it, afterwards, with Wood's 'The Blue Necklace'? He may even have done it in rivalry, as young painters do, feeling the challenge of something they admire – and then, comparing it, was he depressed? He was still only twenty-five, and Wood was about twenty-seven when he painted 'The Blue Necklace'. It is more accomplished and mature. It is classical, sculpturally solid, a flowing unity, and both model and painting are poised and regally confident, while with Freud both are strung to an extreme pitch of nervous tension, and his painting, against the noble Mediterranean conception of the other, is relatively unsophisticated – a Germanic, romantic work. And yet it is as great a masterpiece, and, I

would say, the more memorable, personal, and moving of the two. But the genius, the facility, of Wood may well have disheartened Freud and changed the whole course of his development. For that 'Girl with Roses' was the last 'innocent' picture he painted, the last in which any 'academic' shortcoming can be found.

We may feel that Freud was mistaken in interpreting difference as inferiority. And of course all this is only a guess. But however that may be, after this, as suddenly as such things can happen, he became completely adult; and the effect was as if he were wilfully, deliberately, turning his back on his youth and rejecting all the wild, poetic, irrational side of his genius. Most people who cared about his work regretted the change of style in the early 1950s, when he began to do very large heads; but I think the decisive change occurred earlier, about 1949, for between then and 1952 or 1953 something characteristic of the bold flights of his youth was already lost.

The beautiful picture 'Father and Daughter', painted in 1949, stands at the cross-roads. It is truly inspired and original, and he has not yet given up clear colour. The drawing, however, is much more sophisticated than in the 'Girl with Roses'. 'Still-life with Sea-urchin' and 'Still-life with Aloe' and the bold little drawing 'Mother and Baby' are on the early side of the line, and 'Still-life with Apricots and Shell' on the other. Up to this time he had followed his inspiration, but from now on it appears as if his will took over, and he had determined to become unassailable. He had indeed learnt to draw in one graphic tradition – but there was a greater one: the Italian. In a surprisingly short time he became a master in that too. Was it the spectacle of Christopher Wood's genius that shook him so profoundly, and made him decide that the only possibility of succeeding in his ambition (for he was clearly ambitious) lay in observation and draughtsmanship, in keeping his feet, Antaeus-like, firmly on the ground, and renouncing the vision of his youth?

Whatever the cause, a sadness hangs over the work that followed, giving a strong feeling that he was doing himself a violence, twisting himself away from his natural direction, driving himself mercilessly, perversely.

And then his friendship with Francis Bacon, and recognition of his genius, was probably to some extent a repetition of the illuminating but painful experience Christopher Wood's work had given him, of realising his own limitations. For Bacon, though completely different from Wood, was like him in being much more liberated than Freud, and able to create

large forms directly with the brush, with the paint itself. And Freud, having in a sense surrendered his early self in exchange for mastery (was this the fearful pact, the smouldering secret, that flickered about him?), would know that, to be a painter, what he had already learnt was not enough; that this power with brush and paint was something he had also got to learn, and *could* learn; and though not following Bacon into the realms of imagination, he completely transformed his own handling of the medium.

All this is not meant to suggest that, if Freud had continued in the line of his early direction, the results would have had any resemblance to the work of Christopher Wood, only that he might have been different from that which he is; and indeed, the whole speculation adds nothing to the story of his development; but it offers a possible clue, a shaping force to that story. The thought of Wood may have been partly, even largely, responsible for Freud's abandoning his early style, for a decision against being that kind of artist – because he thought he could not do it well enough – for the direction of his whole subsequent development, and for, as he said to John Russell, his 'horror of the idyllic'. For there has been, for more than twenty years, a quality in his work suggesting that he was holding down with an iron hand something that he feared might emerge and embarrass him if he ever relaxed his control. And then, in the last few years, there has been a feeling that he was sufficiently sure of himself to permit a reconciliation between the two sides – gaoler and prisoner. And so the captive seems to have been allowed out, in 1968 to 1969, to play a part in the 'Large Interior, Paddington'. But perhaps it was too late; perhaps this other, or half, self, whose disappearance was mourned by so many, never having been allowed fresh air and exercise during its long captivity, had lost the strength to survive in freedom, and breathed its last in that large picture.

But this may all be too fanciful. Still, whatever the truth, one cannot fail to recognise that Freud's early work had a beauty, something we call 'poetry', and that then the Muse left him. But this often happens as a man grows older. It happened, for instance, to Stanley Spencer, with whose later work Freud's has developed a surprising affinity. Yet, through all the phases of his development, all his efforts to stretch himself in different directions, one can also see that the personality has remained unmistakable, the work is of one weave throughout.

9

LEON KOSSOFF

Leon Kossoff was born in London in 1926 of Russian–Jewish parents, and the Eastern element in his work has always been strong.

Most of the models for his numerous drawings and paintings of single figures have been Jewish, and many have had hard lives, which have shaped both their physical and mental attitudes. As they sit, they often fall asleep; otherwise they settle into a variety of poses, rather oriental in character, their broad, patient shoulders expressing resignation, but also stubborn endurance. But if there is no victory, there is no defeat either. In the end, endurance and survival in themselves become a form of victory.

This is the world in which Kossoff grew up, through which he has had to find his way, with which he has had to come to terms, and out of which he has created himself and his art.

Among these figures one exception stands out: an early portrait (1953) of Frank Auerbach. Broadly painted, and simple in effect, it is nevertheless profoundly like the sitter; and what sets it apart from all Kossoff's other portraits is this: it is a picture of someone young, upright, and full of confidence. The typical curved rhythms are there, but adapted to a sturdy, self-reliant system; the head is slightly tilted, with an easy grace; the neck has a columnar strength and roundness, the pose a settled, comfortable weight. The colour is a mossy green, the green of a young oak growing in a forest, with black shadows and sparkles of orange. There is a reminiscence of Rembrandt in the pose – the slightest suspicion of swagger – which in Rembrandt himself was probably an Italian echo, and this too has found its way into this portrait of Auerbach, which is unique in Kossoff's work.

The two painters were friends. Kossoff, five years older, had already done his military service before they were students together at St Martin's School of Art, and concurrently at evening classes with David Bomberg, who had a profound and lasting influence on him; and following that, at the Royal College. This friendship played a great part in the lives of both artists; their early work had many features in common, and their names

continued to be linked long after their styles had diverged widely, though for many years they drew and painted similar subjects – notably, building sites. For Kossoff, however, these building sites seemed to hold a meaning in addition to their visual excitement, to be warmed by a spirit akin to that of his sitters. For if there is demolition and destruction, there is also survival, rebuilding, and renewal. In a series of pictures of a building site with St Paul's, done during the 1950s, the cathedral towers above the excavations and construction works, its dome swelling and rising like the triumphant crowning phrases of a prophecy. And almost certainly Kossoff's love of bridges and railways must be connected with this same spirit of overcoming, for these link the separated, cut roads through obstacles, and reach into new worlds.

Perhaps the most dramatic picture of these early years is 'City Landscape, Early Morning', which was begun in 1953 but took six years to finish. It is a scene in the heart of London, devastated by bombing; the walls stand up like black fortresses, or great battlements, against the ashen sky, their stripped sides supported by struts, and a little right of centre the pale sky floods down into a wide rectangular gap, like water filling a cistern. These walls encircle a vast, deep hole that fills all the foreground; it is marked with trenches and cuts and seems to be full of workmen; and though it is impossible to read a single figure with certainty, there is a sense of life and movement and continuous activity. There always seems to be a man just to the left or right of where one is looking. This picture is black and grey as burnt-out cinders, and looks as if it had been made by a flow of molten lava descending with the rhythms of a waterfall and spreading out into the circular bottom – and then, as if it had been literally translated into the metaphor of a cataract, whitish streaks, as of foam, appear on the surface. It is more abstract (but only a little) than most of Kossoff's work, yet it is clearly a picture of a great city struck by a disaster, and an ant-like swarm of inhabitants getting to work to rebuild it. In a strange way it recalls those terrifying drawings of Leonardo's of the Deluge, some of which have a Chinese quality in the squareness of the rocks and the stylised scrolls of water issuing as from the mouths of dragons. In the square shapes at the top and the central cataract there is a Chinese character in this extraordinary picture of Kossoff's too; but the three-dimensional power of the European tradition remains dominant, with the diagonals straining against each other and resolved in the centre.

In the later 1950s, while he was working on this picture, he did a series

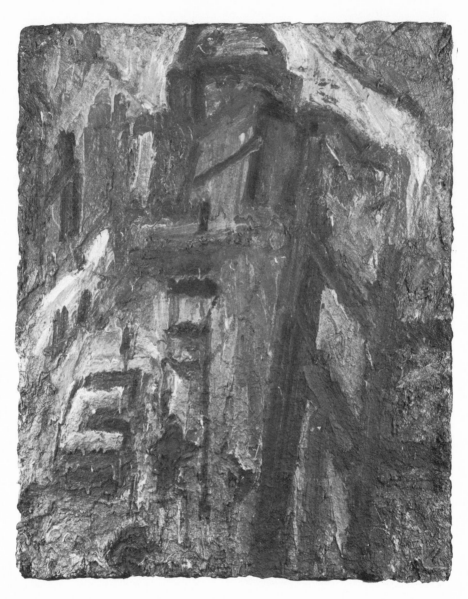

LEON KOSSOFF
St Paul's building site 1954
Oil on board, 60 × 48 in
The Artist

of horizontal building sites with St Paul's, both large and small. In these everything is becoming more fluid. Within each picture an entirely continuous world is created. They are in the baroque tradition, especially as seen in Rubens, created with great strokes that sweep curvingly over the whole width of the landscape, giving the sense of its being a little piece of the curved surface of the earth. And also they are growing lighter, more silvery. (The earlier ones were made of the warmer earth-colours, with ochre and red.) The air and light seem to be almost eating things away – embracing, encircling, drawing everything into a single rhythmic unity. Turner has become a powerful influence.

When one speaks of pictures taking Kossoff several years, it does not mean that he continues to pile paint on paint. At the end of each day, if the picture has not come right, he scrapes it down as far as possible to the board, and starts fresh the next time over this scraped-down ghost. Each picture is preceded and accompanied by scores of drawings, so that he gets to know his subject thoroughly – even by heart. And the effect of each painting having been produced at a single session is true, for at last the day comes when, in a few hours, in one unbroken series of movements, it comes right. The surface is one continuous field of paint, in a single skin, and the image is there.

'Making something out of nothing' is one of his favourite phrases; and one can see why, for, unlike most painters, who, as Gombrich says, begin from some traditional, accepted 'schema' and proceed by modifying it, Kossoff begins absolutely from the bare ground, from the cold hearth. He stands alone in the Here and Now, as if, like Prometheus, with none to help him, he were making his images out of primeval clay, lifting his heavy arms in sweeping, curving movements, obeying the force that works in and through him, creating from the inside, from the core outwards, as if he did not even know what shapes, what appearances, would finally result. And one feels that what determines the shapes of his figures is even more real and mysterious than bone and muscle, that it is the elemental force by which bone and muscle are themselves shaped.

Looking at Kossoff's work of the first ten years or so is like watching a fire kindling in a vast, shadowy fireplace, its first smouldering beginnings creeping through the dark foundation layers, then the flames beginning to shoot up intermittently, and at last the golden tongues leaping into a clear blaze.

The fire runs back and forth through the early 'Riverside' landscapes,

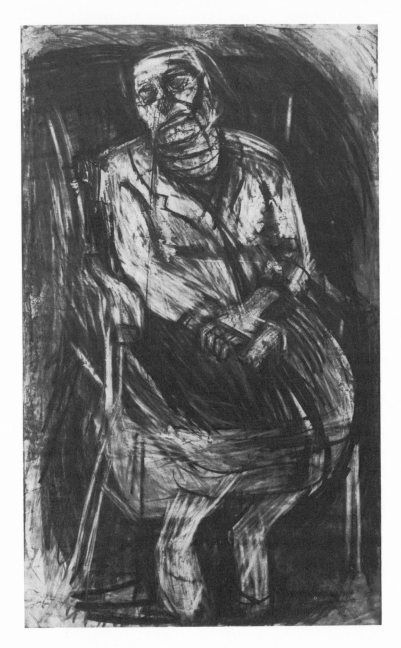

LEON KOSSOFF
Seated Woman I 1959
Drawing, charcoal and black conté on paper,
59¾ × 31½ in *Present whereabouts unknown*

the wide horizontal 'Building Site, Mornington Crescent', gathering power in such pictures as the 'Railway Bridge, Mornington Crescent', burning up with occasional flashes of brightness, as in the 'Portrait of Frank Auerbach' and the large upright 'St Paul's' picture of 1954. And though the quality is always high, the feeling of a fire struggling upward with difficulty, fighting against something dark and tragic, continues for a long time.

For instance, during these years, besides the many pictures of building sites, there were several series of drawings and paintings of seated figures – of a woman called 'Seedo', of Kossoff's father, and of a young man in a wheel-chair, all of whom sometimes fell asleep and are thus portrayed; and if one happened to see a whole row of these life-size charcoal drawings of seated, sleeping figures, glimmering blackly through the glass, leaning against a wall, it was as if one had come upon a row of effigies in the underground darkness of a tomb of kings.

The 'breakthrough' seems to have occurred about 1960 to 1961. After a succession of seated half-lengths of Seedo, somnolently brooding like an Eastern idol, there is one in which the colour, though still sombre, begins to glitter darkly, the pose no longer has that settled calm, and the whole figure appears to be uneasily twitching into life, like a Tibetan devil-dancer; a flame even seems to be issuing from the mouth.

But then comes a picture of her which reaches a new height. The parts of the body, although it is still possible to read them, are telescoped one into another, so that the head and hunched-up torso make a simple, egg-like form, out of which the tilted face half smiles, almost grotesquely and yet sweetly, above the folded arms. The colour too is new – pale ivories and mauves, and streaks of deeper violet with a ruby stain, and the brown of dead leaves – the colours of the resurrection of spring in a winter wood.

Among the cityscapes the change appeared the year before, in a large, horizontal painting, 'Railway, Bethnal Green', which is like the breaking of a hopeful dawn. Confidence and power stream from the long lines sweeping away to the horizon, and the landscape is punctuated by vertical structures as by a recurring musical motif. The colour is springlike, an opalescent shimmer of silver-greens, greenish-blues, lavender and dove-grey.

Though not finished until 1963, 'Mother Asleep' really belongs here. She sits sideways, resting her head on her hand, her elbow on the arm of the chair; and though she has fallen asleep, the effect is different from that

of the earlier, darker paintings. The brush-strokes seem to have followed one another easily, softly, like snowflakes falling, like the clothes of a dancer billowing and settling around her as she sinks down in a pale, iridescent heap.

Kossoff's colour now gets brighter. It is neither local colour, nor local colour modified by light and atmosphere in the Impressionist sense, nor so simple that the terms 'emotional' or 'Expressionist' would cover it. It has something of all these uses. But one feels that each pictorial conception itself dictated from the beginning the few necessary colours from which it would take shape, and that these having been placed ready to hand, the artist seized upon them with the swiftness of a sculptor picking up clay, making instantaneous, instinctive decisions which have resulted in an intensity similar to that of van Gogh's strokes of pure colour.

There are in fact many affinities of character with van Gogh: unlimited compassion for all suffering, struggling humanity; the capacity for maintaining the intensity of his work through exceptionally long hours day after day, and of producing an almost unbelievable amount in some very keyed-up periods; and the general direction of his development. During these years, 1960 to 1963, Kossoff's work suggests the exertions of a bound spirit struggling to break free. His movement is from dark to light – like that of van Gogh from the dark North to the bright South. Today many people find the latter's dark early pictures, such as 'The Potato-eaters', as beautiful as the later bright ones, and may feel the same about some of the dark early Kossoffs; but in both cases the artist himself seems to have equated light with liberation and advance. In the big 'Willesden Junction, Early Morning' of 1962 there is an unmistakable mood of exultation and jubilation. The curved horizon, the glittering railway lines sweeping up to it, the radiance pouring down on to it – this is not realistic, that is to say, imitative painting, but a convincing equivalent image. It has all the exhilaration of one of those brilliant mornings of sun and wind when the ground gives back the brightness of the sky, and one feels the painter's joy equally in this and in the making of the work.

One of the most important pictures of this time was the large 'Two Seated Figures'. It shows Kossoff's father and mother seated side by side, like a king and queen: a picture of interdependence and faithfulness, perhaps embodying some feelings about the parental and filial relationship; and while it recognisably portrays two individuals, it lifts them into the universal situation of ancestors, almost of primitive idols. It was

Kossoff's first large composition of two figures, later developed in different variations.

In the same year he did some portraits of his brother Philip. The best is over life-size, and though the figure still sits with folded arms and bent head, the ample design, the huge strokes of brilliant colour with their rushing movement, make him appear to have suddenly descended among us with lightning speed, out of a glorious sunrise, and taken his seat like some Biblical judge or prophet.

In 1963, the last year of this phase, there were two large female nudes. One could not possibly think of them as women seated in armchairs. Torrents of ivory and vermilion, running over river-beds of brown and purple, have been whirled about to coalesce into these huge forms, creating as it were the actual river-goddesses.

Schiller divided artists into 'strivers' and those whose inspiration simply welled up and flowed forth like a natural phenomenon. He would have been thinking of poets, but to the extent that the distinction is valid, it is so for all artists. And Kossoff is certainly a 'striver'. But from time to time his efforts bring him to a point, or rather to a plateau, where he can consolidate his achievement, where he seems refreshed by breathing a clearer air, and although he works as hard as ever, there is a feeling that the work pours out of him with greater ease and abundance, and even with joy rather than pain. This effect appeared for the first time in his exhibition at the Marlborough in the spring of 1968. And in spite of the fact that there were twenty-five paintings of people and only nine of landscapes, the overall impression was of a landscape exhibition. This was partly because all but a few of the paintings of people were small, partly because the nine landscapes were so magnificent that they dominated the exhibition, and partly because his approach to landscape, now fully developed, with a power like that of Soutine to grasp, twist, and bend the whole subject into a single strongly rhythmic image, together with his now brightly glowing colour, had become, for the time, his approach to painting altogether, whatever the subject. So, in the paintings of heads and figures, he had arrived at a treatment which fused them more completely with their settings than formerly, making them at first glance more like landscapes. One of the largest pictures of people was a new composition of 'Two Seated Figures'. Here his parents no longer sit side by side, but appear engulfed in an emotional situation – stressed by this unified, landscape handling. The father, seated nearer the front, hunched over, seems to

cower, or rest, Oedipus-like, half-child, half-consort, while the mother, though seated, towers over him, maternally, consolingly, enfolding and supporting him. Perhaps the earlier composition was a picture of parents, of ancestors, and this a picture of marriage.

In the same exhibition there was also a large picture of 'A Woman Ill in Bed Surrounded by Family'. In its abstract design it has much of the early, upright St Paul's, even more of the 'City Landscape' of 1953 to 1959, with its suggestion of lava streaming down from the top and spreading out below. It is compact and intense, expressing close family relationships, and the tribal quality of immemorial lamentation.

Without taking over any formulas, entirely through the study of life itself, Kossoff has arrived by a new road at some of the basic pictorial structures, the monumental poses and rhythms, of the Grand Manner. In his tilted heads we find again the great foreshortening curves that give such weight and power to the works of the High Renaissance and Baroque. His work is distinguished by a surprising number of those qualities listed in my short introductory essay as Mediterranean – yet without any Mediterranean appearance. It also has almost all the Northern characteristics. It re-creates the actual, the individual, particular, accidental, even everyday and domestic, yet elevates them to the typical, universal, monumental, and grand. But there is a total absence of any idealising in the classic sense. These often over-life-size figures refer back through a long history to an oriental antiquity. By the waters of Babylon they have sat down and wept. This Jewish tradition, which produced no visual art, fills the place occupied in most European art by the Greek and Roman, and later the Italian. The idealising is in the direction of moral qualities, above all of endurance; the figures, more often than not, are ungainly and worn, as we have already seen, and often one feels a heroic spirit almost bursting out of its inadequate or hampering body. And the heads are tilted, not in elegance but weariness.

In all the art of Europe, Old Testament characters were presented as if of the artist's country. Only Rembrandt painted real Jews, the Jews of Amsterdam, with sympathy and grandeur, whether as themselves or as Biblical personages. But the sympathy and grandeur were the same that he lavished on everyone; they were not his people. Kossoff has painted his own people, giving them something approaching mythological status.

But in that same Marlborough exhibition of 1968 there was one picture which heralded a further development; it was of his mother, called 'Rachel

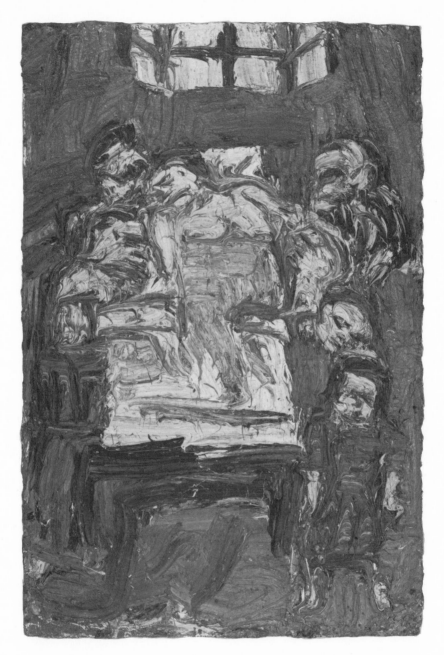

LEON KOSSOFF
Woman Ill in Bed Surrounded by Family 1965
Oil on board, 73 × 49 in
Tate Gallery, London

Seated in an Armchair'. It had a new clearness, with well-marked dif-
ferences of local colour; the figure was more self-contained, more calmly
and objectively seen than any hitherto, and probably for this reason the
most memorable single figure in the show. And in the big exhibition of
'Recent Work' at Whitechapel in 1972 there were many pictures of the
artist's family, and of a nude woman on a bed, which were similarly clear in
conception, and relatively calm, contrasting with the turbulent cityscapes.

Also at Whitechapel, a new subject made its appearance, in four
pictures of a 'Children's Swimming Pool'. It was not the first time Kossoff
had painted scenes of crowded activity, but here an entirely new note
was struck. At the far end of the gallery, they faced one on coming in from
the street, and the impression was of shimmering light literally in motion,
of moving ripples of light reflected from the silvery and pale greenish water
in which myriads of little figures were splashing about – in no way
idealised; when you got close to them they were as robust as Breughel's
people, and no prettier. But the paint was thin, the touch quick and
summary, the effect delicate as Chinese porcelain; the gaiety and laughter
seemed audible.

If one thinks back to that 'City Landscape, Early Morning' started
twenty years before, in all its black grandeur it was like a vision of spirits
working in an inferno to bring about redemption, while these were at least
the outskirts of paradise. And even portrait heads and figures, individually
sad when seen close, rode on the tide of buoyancy, vitality, and confidence
that vibrated through the whole of that large gallery.

The 'Swimming Pool' pictures were a true development of the original
Impressionism – before it degenerated. Monet, returning day after day to
his subjects at the same moment, sought and found and remade something
solid and grand underlying all that appearance of intangible, evanescent,
dissolving atmosphere, and even went on for years in his studio with
paintings started elsewhere. And Kossoff, who has always felt the impor-
tance of light, studied these scenes, noting the season and time of day, and
going on and on in the studio, in the true spirit of Monet.

Since then, in large double portraits of his parents, in drawings of his
wife's head, and paintings of seated nude girls, as well as some exceedingly
beautiful free copies of pictures by Poussin and Rubens, Kossoff appears
to be moving gradually closer to the Mediterranean side of the European
Tradition, enriching his work and giving it a valuable balance; and in this
way he extends the Tradition itself.

10

EVERT LUNDQUIST

Evert Lundquist is Sweden's greatest painter. Behind his work one feels very clearly a thinking man, formed not by chance but by choice, and this not arbitrary, but dictated by his most profound necessities. He is a man who has gradually become more and more conscious of his deepest drives, and at the same time penetrated further and further into the nature and principles of the art of painting, and in whom these two pursuits have become so intertwined that one hesitates to say whether he travelled and studied to find out more about painting, or about himself.

Looking round a gallery of Lundquist's paintings, it is impossible not to feel his greatness. The natural originality of his vision and his way of coming to his own conclusions and stating them with confidence and authority mark him as one who, though he might be pleased by recognition, does not need it, and would accept it merely as his due.

This comes across, not as a feeling of arrogance, but as the stamp of a somewhat withdrawn personality, working in solitude. And in fact Lundquist has his studio, not far from his home, at the edge of the great royal park of Drottningholm; and there he stays, sometimes for a fortnight at a stretch, though his house is so near, in order not to break his train of thought; for his painting is a kind of philosophy.

Modern life, especially in cities, is destructive of the conditions favourable to contemplation. Lundquist, needing these conditions, has found – or made – them. One feels in his work a great effort to get close to those fundamental but not uncivilised realities of life on this planet which have been so frighteningly overlaid, hidden, and crushed. His paintings are not a romantic escape, but he strips away what is superficial, temporary, fashionable, and lays bare what does not change.

Of course, through the centuries, this has been done many times; but each time the result is different and unexpected, because a great artist's vision, response, and style are as mysteriously personal as his voice, physical form, and movements. This is why it is so sad to see a great man's followers imitate those external characteristics, which can have no truth,

no inevitability, for them, instead of applying the underlying principles, which would always result in something new. The only justification for this kind of following was the demand, in earlier times, for more works than the master could produce, as nearly as possible in his style; but no one can pretend that such a demand – for serious painting – exists today.

But it is just those external features, and their development, which are almost all there is to discuss.

In the case of Lundquist, as far as I know, there is not a great deal to tell about his development.

Born in Stockholm in 1904, he grew up enjoying the advantages of a capital city, the achievements of civilisation, yet just remote enough, up there in the cool North, from the heat and violence and speed of the centres of modern European movements, for him to retain a degree of detachment, and also never so far from the countryside as to lose the sense of the living surface of the earth.

But the leisurely tempo of his development should not deceive us into supposing a lack of urgency. His is a very controlled temperament, but the fire within burns no less strongly for that.

He spent about eight years studying in art schools – the first in Stockholm, the second in Paris, the remaining six again in Stockholm, where, at the age of thirty, he held his first one-man exhibition.

He had begun in the Impressionist tradition, but was soon attracted by the vigorous forms of Lautrec and van Gogh, and the strongly silhouetted shapes of Munch. And it was, he says, when he was about thirty that suddenly, without knowing why, he felt a compulsion to work with thick paint.

Other painters, both before and since, have felt a similar urge, but in the case of earlier ones it is less often noticed, because over a long period paint shrinks surprisingly, and also many older paintings, once thick, have in the course of restoration and relining been much pressed and flattened. Among others, Rembrandt, Courbet and van Gogh often painted thick, but not always, nor uniformly. Probably the practice springs from a love of the material, combined with the craftsman's pleasure in actually, physically, making a real thing, and also the satisfaction of giving force and emphasis by a muscular gesture which leaves its trace: energy transformed into enduring shapes.

At first one could say that, in Lundquist's work, this or that object was seen very clearly against a background; then, gradually, all the parts,

nearer or more distant, solid or airy, became not so much interlocked as fused into a single new entity – the picture itself – emphatically made of paint.

At what point exactly Lundquist's work passed from simple representation to pure creation, it is not possible to say. His pictures remain in the studio for years, taking shape slowly, several going on together, like fruit ripening in an orchard. This was also the practice of Titian, and it was he who, with his late work, broke open the road which Lundquist has taken.

In those late paintings of Titian, the forms become ever grander, more ample and massive, magnificent in their own right as well as representational, and just as weather crumbles stone to a ruin and makes it one with the landscape, so the light and atmosphere eat away the edges and details of these great forms and weld them into a perfect unity.

From time to time one can see traces of this influence, in the other great Venetians, in Rubens, and other baroque painters, sometimes in Velasquez; but, so far, these characteristics are nowhere so marked as in Titian himself. With Turner, however, though the subjects are different, the application of the principle is still more extreme: light and atmosphere play an even more dominant role in dissolving, melting down, and remoulding form. Late Gainsborough and Constable and the whole of French Impressionism descend from this Venetian ancestry, and it is the thread of this tradition that Lundquist has taken up and woven into something new. One might even say, into a new tapestry; for the material, the paint itself, has acquired such importance, not here and there but equally all over, that his pictures do indeed resemble sumptuous tapestries, in keeping the whole world they present very much within the plane of their own surface. One is immediately conscious that these images are made of paint, and although they can be read as three-dimensional and even give a feeling of massive forms within the over-all weight of the texture, they hang on the walls with a wonderful evenness.

Although, just occasionally, there is some difficulty or uncertainty in reading them, on the whole the world of Lundquist's paintings is clear: men and women, either nude or in the simplest of rough country clothes, that change so little through the centuries as to seem dateless; animals, rocks, water, trees; haystacks and barns; pots, spades, and brooms; a ladder, a chair, an easel; fruit, bread, meat, an antique torso; ruined columns; often just one of these things, but at the most two or three, large in the picture.

There are no dramas or stories in these pictures, not even the basic ones of birth and death. Any actions shown are such as occur in the natural cycles of maintaining existence, indoors and out; that is to say, the subject-matter is the same as that treated in the medieval miniatures of the Books of Hours. But whereas those are crammed with complication, incident, and bustling activity, each picture of Lundquist's presents a single isolated image on a large scale. And they give a feeling of immense patience, suggesting slow, organic growth: as if, when he takes up his brush before a clean canvas, a sort of visual equivalent of a musical idea takes possession of him – a theme of one or two shapes, with a feeling of the character of its development; and then, out of the wealth of his experience – for he no longer paints in front of the subject – a subject comes to meet this embryonic beginning, to inform it with life and direction, like a child in the womb, and, also like that, sometimes even turning right round before it is born. As the picture grows, the successive layers of paint are not obliterated, but by some wizardry the earlier ones still show and glow through the later, like bones through flesh, or blood through skin, or the sun's fire through an evening cloud; or like the line and colour of the cello lying under the sound of the viola and violins in a quartet, weaving one thing with them.

I remember very vividly the look of galleries hung entirely with Lundquist's work. Nothing like it was ever seen in painting before. When I think of it I am reminded of a passage in Stevie Smith's *Novel on Yellow Paper*, describing a wild landscape and a lonely house, which she habitually imagined to comfort herself when wretched for lack of sleep:

> . . . it is quite deserted, and the countryside either side is a flat plain, like it might be stretching out to the sea over saltings and samphire, and the road is dyked up, and there is a white stone wall banking it back and running alongside.
>
> And so you go on and on . . .
>
> And presently you know to turn to the right across the saltings, and there sure enough is the house. It is a high square white house, and has outbuildings and barns lying low, and a stone wall going round it to keep the wind away . . . and you go in through the gate of the wall, and you shut it behind you, and you go up the pathway that is bordered by trees all blown one way in spite of the wall, and so you come to the heavy door that has a stone porch, that has stone steps

leading up to it, and you unlock the door and you go in and shut the door behind you, and bolt it, and inside there is a wide stone hall and lights hanging down perfectly steady. Though the wind is now roaring round the house it cannot get under the door. And you go up the stone staircase that has shallow steps, and up and round, and there is a long oblong dining-room with food set out on the dining-table. And the food is, first there is grouse *en casserole* and potatoes baked in their jackets, very hot and fresh. And then there is beer to drink, and then there is mushrooms on toast, and then there is figs fresh picked, and then there is this cool beer to drink. And there is a little fire burning in a basket in a large stone fireplace. . . . And so by and by you go to the bathroom, that is a large square bathroom flagged with stones, and the bath is a large stone bath, and the water comes crashing into the stone bath hot and foaming because of the salt in it. . . . And the bed is a high bed, it has no foot board and no head board, it is high and flat and there is only one pillow and the sheets are turned back, and the bed is standing in the middle of the room. It is a large square flat high straight hard bed, and the sheets are white and dry and fine as dust.

This fragment, so concretely and marvellously imagined, recalling one of those enchanted castles found by travellers in fairy tales, or some old château in France of the time of Rabelais, has an amplitude, a rugged hugeness, a suggestion of splendid proportions and uncluttered grandeur which lifts it towards the heights of the antique world – or what we have come to think of as the antique world – and seems to me to embody the ideals that inspire Lundquist's work.

The 'antique world' of course means many different things, for artists, poets, historians, archaeologists, and so on. But the ideas of it which have helped to inspire great works of visual or literary art of later times, to create a tradition still effective today, really sprang only from the art which survives: frescoes, sculpture, architecture – most often damaged and incomplete, and possibly all the better for that; and Homer and the Greek dramatists, poets, and builders of philosophical systems; in any case from works, and fragments of works, of art. It is these which have formed our ideals of heroic grandeur.

These ideals ought to be separated as far as possible from associations which blunt and obscure them. For the fascination exerted by classical antiquity has fostered a kind of romanticism arising from a confusion of art

with archaeology and with life. The confusion with archaeology produced many of the lesser, drier works of the Renaissance, and countless works of the eighteenth, nineteenth and even twentieth centuries. And yet out of all that ferment, the true ideals of the great art of that past found and fertilised some artists of later times, which might not otherwise have happened – above all, Michelangelo.

The confusion with life led to the idea that things really *looked* better in ancient times, and thus provided better subject-matter for art. And this is partly because the further back in time a period recedes, the more details are lost, the more simplified it stands in our imagination, and the relatively bare and scattered facts, by a kind of inverse perspective, appear greater from such a distance, and so the more we come to think of the life of the period as approaching, in actuality, the grandest works of ancient art. And there is this grain of truth: that when there were few people, cultivating the ground by simple means, living in roughly built houses – but of good proportions – using hand-carved furniture and hand-made pots and other objects, the effect – though doubtless quite unlike the art – must have had a certain grandeur. But similar conditions can still be found today, in the deep country, in many lands (Sweden, for instance), and probably, when found, they fall somewhat short of the mythical Golden Age; while even in ancient times, as soon as there were cities, and wealth, and crowds, there must inevitably have been corruption, ugliness, and meanness, of all kinds, including the visual. Sometimes it has occurred to me, walking through the ruins of Rome or Pompeii, that if we could see them as they were when new, swarming with the life of the time, the sight would be as garish, as meaningless and painful to the eye, as Oxford Street today. And just as in Oxford Street today, there would be sudden, very rare and always fleeting moments, when the fall of sunlight and shadow would sweep everything into a magical unity, as beautiful as a Turner.

And yet I think we do all tend to dream of an ideal world, and some of us imagine it in unspoilt country now, some in the far future, some in remote antiquity. But artists transfer their ideals to the qualities they require in a work, and, accepting life as it is, ennoble what they find by the forms they create to present it.

The characteristics, above all others, by virtue of which the surviving great works of antiquity still exert their spell and retain their place as the highest ideals we know, are: simplification, uncluttered largeness and

unbroken rhythm, and perfect balance. And these ideals require great sacrifices.

As Matisse discovered, the most refreshing, restoring, bracing quality – the quality most deeply pleasing to the tired eye – is simplicity. It flatters the spectator with an illusory and tonic sense of his own power to grasp and understand, and makes the least possible demands on him, but all the more on the artist, for the fewer the elements of a picture, the more exactly right they have to be, and the more full of subtlety, if the satisfying effect is to continue for any length of time.

So I come back to that passage from Stevie Smith, itself imagined and created as a restorative for her own weariness, which had already struck me, in its gargantuan scale and antique simplicity, as suggestive of late Titians. Such a setting might be supposed enfolding the little room where Tarquin attacks Lucrece, or awaiting Diana after her revenge on Actaeon, or in the distance beyond the Nymph and Shepherd. And it seemed to me a more vivid evocation of the spirit of Lundquist's work than might be achieved by an attempt to describe the pictures.

The first quick glance round the room brings back an impression of something idyllic and pastoral – almost of the scent of hay. Within their narrow ranges, the colour harmonies are dense and full, and the paint seems to give out light. A kind of eighteenth-century grace shimmers along the walls, perhaps assisted by there being one or two oval pictures, yet the forms are rough, massive, and heavy. It is no Rousseauesque Arcadia, but the genuinely rustic, even uncouth world which Lundquist finds at his doorstep. And everything is seen through a highly sophisticated temperament impregnated with the heroic ideals of ancient Greece, and of the Mediterranean tradition – so that here and there even a Mediterranean subject, from his travels, hangs among the rest as part of the same world.

But these ideals are balanced by that astringent acceptance of the actual and the everyday which is characteristic of the North. Rembrandt has been very important for him. There is even a painting of a 'Girl Asleep' based on Rembrandt's study in the British Museum – immediately recognisable, though in a quite personal transformation.

His simplifications are entirely his own. To simplify is to discard everything but the profoundly essential, but only a master can do it in such a way that we feel no regrets. Lundquist does it, creating an image that seems alive, so full of subtleties within its simplicity that it baffles analysis,

EVERT LUNDQUIST
The Tree 1961
Oil on canvas, oval, 42½ × 80¾ in
Private collection

so mysterious that one never tires of looking at it.

His strokes are made with a wide, full brush – like Bacon's, though the tempo, rhythm, and consistency of paint are different – and this allows the continual flicker of the unexpected variation, which gives a feeling of the whole surface being shot through with little, hardly perceptible movements, like a creature breathing, or a calm sea that is yet broken all over by the tiniest waves, or a tree seen as a simple mass, within which we sense the movement of a million leaves.

Those great trees in the painting 'At the Edge of the Forest', or the single one with its twisted, powerful trunk, in the oval picture 'Tree' – who would have believed it possible to sacrifice so much and then win it back again in such an unforeseeable way by the creation of a new reality, absolutely as if Nature had found a different way of making trees? And that shallow triangle, the avenue, seen 'From the Garden', of fruit trees covered with spring blossom – how do we know it is blossom? Only from the colour, the warm, creamy whiteness of the cloudlike masses that finally merge, like true clouds, with the tender colour of the sky; for if the whiteness were cooler, more silvery, they might be the same trees at the beginning of autumn, glittering in the morning sun, when the sky is so like that of spring, and the ground the same pale, dead-leaf gold. The exactness of the colour in these broad sweeps of thick paint gives us this kind of information by its immediate sensuous impact, as opposed to a quantity of detail which would have to be read. All Lundquist's paintings make this immediate impact, and yet, as one goes on looking, one becomes aware that each one was a long meditation – an active meditation, so to speak – which slowly ripened to a final statement. 'The Glass', for instance, is a painting of a wine-glass, a bowl supported by a stem, which rises from a circular base. All that the painter has ever observed about such a glass – the form, and how it is both sturdy and delicate; the substance, how it holds the light, gathering it into concentrated brilliance, but also transparently lets it through, and also reflects the gathered brilliance on to the whiteness behind and round it, and yet at the same time casts a shadow, so that it makes an intangible but perceptible extension of itself into the surrounding space – so much has gone into this painting that one feels Lundquist has said his last painting word on that subject, and the glass, while remaining itself, stands for all glasses. It is the same with 'The Torch', so magnificently flaring and streaming out, and with many paintings of objects. In the first place they strike one as pictures by

Lundquist – original, different from anything one has seen before; then, while one is looking at them, one is gradually persuaded that it is not possible to uncover more nakedly the character, the essence, of the thing presented.

With the human figure of course it is different: he can paint any number because people themselves are all so different. And yet, in spite of the often-repeated assertion that no two are exactly alike, they do undeniably fall into types. And most of the great artists of the past produced types. In fact everyone who paints 'compositions' produces them; and the slightly scornful tone in which that word is sometimes pronounced today, together with the present emphasis on the fragment, the study, and the absolutely particular, probably has some connection with the present rarity of compositional powers and of the ability to create types of any real interest.

But Lundquist does create types. His paintings of the nude (all women, I think) are 'nudes' in Kenneth Clark's sense: we do not think of them under any other conditions. They are like ripe, heavy fruits, and their heads are turned away into the shadow. The clothed figures are more individualised, but not completely. The 'Harvesting Woman', for example: almost incredibly burdened, and yet not more so than peasant women often are, she moves slowly through the cornfields, with bent, brooding, heavy-featured head. There have been so many repaintings that no 'first-time' painting could equal that miraculous fullness and opalescence of sun-soaked autumn colour, and the decisions of the last great strokes that carve out the final form have the force and boldness of an audacious first sketch. Or the 'Street Sweeper', smoky black against the pale grey-blue of the open – a steeply vanishing street, perhaps – he towers gigantic in the doorway, seen probably from a low seat within, his right arm going downward as it grips the broomstick and the left raised high as if to push it with all his might: these figures are not individually studied portraits, as Rembrandt, Hals, or Velasquez would have made them, although they have that Northern stamp of finding character more interesting than ideal beauty, preferring the actual – even, as some might think, the ugly – bodies, deformed and disfigured by heavy work, hardship, accident. But they have grown larger than individuals, larger than life, this 'Harvesting Woman' and 'Street Sweeper', and become types; not types to be used again in other pictures, arrived at through repetition, or generalisation, or formalisation; but each figure is a monumental summary, distilled from countless observations and memories. I

EVERT LUNDQUIST
The Torch 1961
Oil on canvas, 45¾ × 35 in
Private collection

EVERT LUNDQUIST
The Street Sweeper 1958
Oil on canvas, $45\frac{3}{4} \times 35$ in
Private collection

do not think there is any other painter living today able to do exactly this. Like all great art, it balances on a tightrope. The images are full; less full, they would not move and convince us; but fuller, that is to say, holding any more information, they would become diminished, tight, squeezing out the possibilities which circulate through them. Excess of detail destroys mystery, and hence the illusion of life.

There is an analogy, in art which creates types of this kind, with the arts which require the collaboration of performers – music and drama. The words and notes are written down, and are exact. Yet, though they seem in themselves finished and perfect, they have an openness which allows variety of interpretation. And so we have many versions of, say, Shakespeare's or Verdi's characters, and of musical compositions. Even in works we read in solitude, we find that the greatest writers sometimes describe their characters by a few bold strokes, sometimes not at all, but never minutely, and therefore each reader completes them in imagination – just as the Greek Helen was said actually to appear to each man as his ideal of beauty. So, in the visual arts, the role of interpreter is filled by every spectator.

Many a countryman might find his grandmother in Lundquist's 'Harvesting Woman', yet she is grand enough to play some sorrowing old woman's part in an Italian opera or Greek tragedy. Similarly, the 'Street Sweeper' might be recognised in the next street, or he might sweep the steps of some temple or palace, without breaking the spell, in a heroic drama.

Lundquist has achieved the elevation of the everyday to the level of the grand and monumental, tying the Northern and Mediterranean strands together in an entirely new way, and of course, as always, it will in time be what is new and personal that comes to be most loved; but meanwhile his modernity, and above all, his originality, are such that, in spite of his standing so clearly as a landmark in the Great Tradition, recognition, which was delayed for a very long time, is still inadequate.

RAYMOND MASON

The sculptor Raymond Mason has lived almost all his working life in France, but remains in some ways profoundly English.

He was born in Birmingham in 1922, studied at the local art school, and later, in London, at the Royal College of Art and the Slade. Very early, while still a student, he understood that an artist can only acquire technique and style through ceaseless efforts to re-present, to re-create, the real, visible world. The academic ideals of the art schools, their attachment to formulae superficially copied from the Old Masters, disgusted him. The art of Picasso inspired him, by its deeper understanding, its vitality and freshness.

Paris pleased him when he visited it in 1946, and he has remained there ever since. He found the intellectual climate stimulating, and quickly fell in love with the city itself – the architecture and life of its streets.

Fortunate in his friendships, Mason acknowledges two influences: Giacometti and Balthus. Giacometti affected him first, and very strongly, because of a certain affinity of temperament – the obsession of trying to represent what he saw, the fascination of the unknown passer-by – and because of the inspiring example of his single-minded drive, his rare integrity; the influence of Balthus appears only in a few particulars, rather than in any general principles.

Some traces of the influence of Giacometti, though transformed, remained in Mason's work for a long time, in a curious stiffness and straightness of his standing or walking figures (though this also occurs in Balthus). But whereas what fascinated Giacometti was the single, solitary figure, for Mason it was – and is – the crowd: the crowd itself, the sense of multitude, and the actual movement of the crowd; and then again, similar large rhythms – the flowing of tides, the rolling and breaking of waves (he has done beautiful drawings of these), the huge undulations of panoramic landscapes, masses of trees and processions of clouds – sometimes bent and driven by winds and storms. And whereas Balthus's art, in spite of its scope, remains very private, Mason's, though equally personal, is compa-

ratively selfless and public, with no sense of a private life at all. His gaze is directed outwards. He is forever drawing in the street. Like Sterne, who, in his 'dusty black coat' stood at the window of his hotel in Paris 'and looking through the glass, saw all the world in yellow, blue, and green, running at the ring of pleasure', Raymond Mason also looks out, as from a solitary tower – a kind of modern Faust – hungry for the whole spectacle of life. It is comparatively seldom that he works from a model in his studio. Mostly he draws in streets and public places, enthralled by the variety, the continuous change.

He must have done hundreds, perhaps thousands, of these drawings; and the least thing he does with his Indian ink and dip pen has fire, elegance, and style. He has an inborn feeling for the 'abstract' beauty of black and white, or, if not inborn, it certainly goes back to his childhood, when Birmingham appeared to him as if etched in black. And although he does not engrave, all his drawings have a marvellously incisive, bitten quality. They also have that mark of the true draughtsman, that by virtue of a line on the paper, the white paper itself becomes form – on this side of a line, the mass of a shoulder, on that, the distant flatness of the pavement. He draws with lightning swiftness, and with sureness and authority, and has such a knowledge and grasp of architecture that no subject baffles him – vast panoramas, complex views from roof-tops, the intricacy of a market. And he has a sense of drama, a love of story-telling, an interest in particular objects and individual character; and a romantic longing for the vast, the stormy, the grand, the infinite – very well seen in some illustrations for 'Les Contemplations' of Victor Hugo. In fact, his natural orientation is almost entirely Northern. Probably some deep instinct led him to settle in a Mediterranean country, so that his art should become balanced by being continually reminded of the great classical qualities.

His sculptures, which are nearly all a kind of very high reliefs, are cast, not from clay but from plaster originals, which, though to some extent modelled, that is, built up, are finally worked and cut (but not carved, for nothing is taken away), while the plaster is still wet, and the surface has a highly nervous effect.

The first that brought him fame, 'The Barcelona Tram' of 1953, is a conception of extraordinary boldness, combining tradition and novelty. The sculpture is made all in one with its deep, containing frame – a box without the front – which set the pattern for all his future reliefs. It is possible that he got the idea of this form from some of the antique Roman

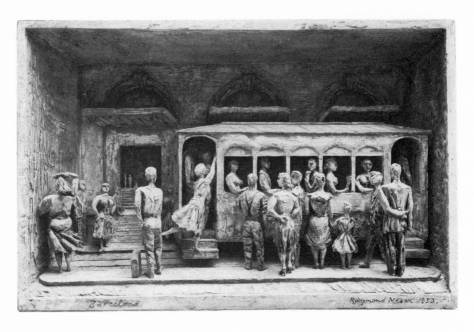

RAYMOND MASON
Barcelona Tram 1953
Bronze, 30¾ × 49¼ × 9¾ in
Tate Gallery, London

funeral reliefs, which are also as it were in open boxes, and very deeply carved. But in the general conception, the design, and the use of architectural features – even the shapes of the doors and windows of the tram, as well as in the building behind – it recalls Donatello; and this firm traditional basis gives it a striking grandeur and authority, which become more remarkable the more one examines it and perceives the freshness and newness of every element, and realises that the flesh, so to speak, is worthy of the bones.

The scene is an everyday one, of modern life, and the people standing in the street waiting for a different tram, the running girl with flying skirt who has just got on to the step of this one, the seated people seen through the windows, the smaller figures coming down the steps from the background on the left, the tram itself, all are observed from life, drawn in the street.

Where else can one find in sculpture today a scene of everyday life, with people in modern dress, and nothing extraordinary happening, which, quite without pretentiousness, by the sheer quality of design and originality of vision, impresses itself on the memory – not as 'genre', but as something in the Grand Manner?

The figures are sculpted with a certain rough force which leaves the artist's personal feeling for planes, rhythms, and movement, clearly marked; and when this sculpture made its first appearance, it was perhaps this roughness which, leaving the gestures of the figures starkly seen – and yet, essentially, truly and feelingly drawn – gave rise to so much uncomprehending criticism in the press: comparisons with peepshows, 'a type of decoration sometimes found on cigarette-boxes sold as souvenirs', 'quite alarming lack of facility in representing in the round the human head or figure'. However, *The Times* critic – the same who wrote of cigarette-boxes – did grant that 'The Barcelona Tram', 'in spite of the crudity with which the figures are realised, conveys, through its disposition of forms and masterly use of illusionistic perspective, a quite haunting sense of reality'. And he also recognised that 'of all the young British sculptors who have lately emerged into the public eye, none has confronted us with a more individual artistic personality'. Perhaps this was really quite perceptive, for, in general, sculpture is even less appreciated, today, than painting.

In fact, 'The Barcelona Tram' made a lasting impression on all who saw it at that time in London. It is perhaps not so much the 'use of illusionistic

perspective' as the 'disposition of forms' which is truly masterly, and which, without any subject so obviously exciting as, for instance, the Dance of Salome, or the Miracles in the life of St Anthony of Padua, succeeds in suggesting – in representing – the mystery and excitement of life itself.

The year before (1952) Mason had done a small relief, 'Man in the Street', which is so modest that by itself it might easily have been overlooked. Yet it is already highly personal, and contains the germ of most of his later work, though it has no movement, and is of an almost primitive simplicity. On the left, we see a quite plain doorway, with two steps on to the street, and above, a window, both as close as possible to the corner of the building. At right angles, the uniform façade of all the houses runs sharply away to a faintly indicated distant view. All this is reduced to a simplicity suggesting a row of workmen's dwellings in ancient Pompeii. In the foreground is a large head, and barely even the top of the shoulders, of a youngish man, staring darkly out towards us. Here are the few basic elements – the house, the street, the anonymous passer-by, whose hollow eyes echo the dark cavities of door and window, but with an intent, anxious, searching gaze, thrusting forward out of the mystery behind and seeking to probe the mystery ahead – the basic elements of almost all his work since then.

In the same year as 'The Barcelona Tram', Mason produced a small and much less ambitious relief, the 'Place Saint-Germain-des-Prés'. In this he begins – but only begins – to tackle the problem of movement at right angles to the picture-plane. (In 'The Barcelona Tram' the over-all direction is parallel to it.) The buildings with their many windows are in three masses, the central one presenting the apex of a block frontally, closing off, as it were, the main field of the design and holding it to the surface, while the streets run away either side. But the vanishing of the street between this central block and the tall, balconied buildings framing the scene on the right, is checked by the transverse projection of a café awning and the minute, barely descried figures seated under it. On the other side, however, the perspective of the long street runs away almost to infinity, only saved from draining out of the scene by the row of parked cars which cuts across its near end, linking up with all the awnings to enclose, pictorially speaking, the square. In the foreground, right of centre, appears, very large, the head and bust of a young man coming obliquely forward to the right, but the head and gaze turned full to the front – less

strained and anguished, however, than that of the 1952 'Man in Street' – younger, more graceful, dreamy, and hopeful. Diminished by the distance to not much more than the height of this large head and neck, and right up against it on the left, a cyclist rides directly away towards the background. On the same scale, a little dog on the right pavement moves in the same direction. In this relief there is almost as much sky as horizontal ground. The whole effect is extraordinary in its combination of a sense of reality – the unmistakable character of Paris – with the feeling of a dream. And it is absolutely unlike anyone else's work.

A few years after the 'Place Saint-Germain-des-Prés' Mason produced the large horizontal relief of the 'Place de l'Opéra', in which again he uses movement into and out of the picture-plane, but now much more elaborately and with greater mastery, using numbers of figures going up and down the steps, controlled in large rhythms, and again combining the flavour of Paris with a quite personal poetry, a sort of twilit dream. In almost all his work one feels the complication – or, let us say, the enrichment – of a sculptural conception by a pictorial one (indeed, he began his studies as a painter). But in the Opéra relief, which has a beauty quite of its own, the enriching conception is of a more linear kind, more like a wood-engraving.

The following year he made the 'Boulevard Saint Germain', a somewhat smaller, upright relief, in some ways more characteristic than the 'Opéra'. It recalls, in a curious way, a strange, stark little terracotta relief of 1953, composed (like the early 'Man in Street') of very few elements: a line of people – of whom the nearest stands flush with the frame – curves away and up some steps, where the first in the queue – not much bigger than the head of the man in front – waits outside a blankly shut door, which, with its massive frame and pediment, occupies a large part of the whole design. But in the 'Boulevard Saint Germain' these basic elements have burst into luxuriant life. We no longer find a door shut in our faces: the diagonals that run in from the corners of the rectangle vanish away into the infinite openness of the street, the tall houses on the left side running steeply down as in a magnificent Renaissance perspective, and the architectural elements being much more freely and fluidly created than ever before, while trees enrich the lower-built right side, and the irregularly shaped space which runs away like a funnel into the far distance, but opens towards us like a cornucopia overflowing with fruit, is filled with a lively stream of figures coming, going, stopping, turning, facing different ways. The head

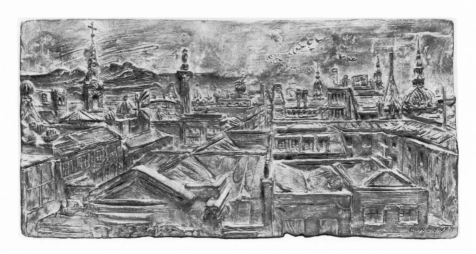

RAYMOND MASON
London 1956
Painted plaster 8 × 16½ in
Private collection

and bust of a figure much nearer to us is again cut off by the lower edge of the relief – this time a young woman, and in profile. Above, the sky, alive with rolling clouds, runs down to meet the ascending perspective of the avenue filled with people, echoing in reverse both its shape and its fullness with the space of its hollow funnel. In spite of the general effect of fluency and abundance, however, some of the larger figures retain, from Mason's earlier work, a strange, sleep-walking posture, holding themselves very erect and placing one foot exactly in front of the other. This adds something to the dreamlike quality of the whole, yet without lessening its reality. It is, in fact, how Balthus represents himself in the pictures where he walks away from us, beginning with 'The Quays', most notably in the 'Passage du Commerce-Saint-André', and in landscapes; and the boy coming towards us in 'La Rue' walks in the same statuesque way. I think that, although Giacometti was older, this attitude appeared first in the work of Balthus, through which (especially in view of its context) it may well have found its way into Mason's. It is curious that no one likes owning to a source – and yet it is no disgrace; and indeed was once a vital element in the functioning of tradition. However, it is often unconscious. Here it is possible that in all three artists there is a memory of an archaic Apollo; and also, it is something seen in many Surrealist works – possibly because of the connection with dreams, and hence sleep-walking.

This series culminated in the big 'Carrefour de l'Odéon' of the same year (1958). Here we find, in a new combination, many of the elements which Mason had already made his own, but used even more fluidly, diversely, and eloquently. The development that has taken place in a mere six years is impressive. Naturally, during these years, he produced many other works, both large and small, and not all in his main direction. One such exploration of a path not pursued further was a large relief, 'Les Épouvan-tées', showing three half-length figures of women hiding their eyes in various gestures of terror and grief, while a curtain blows inward from an open window, seeming to suggest that they have seen some appalling happening in the street. This has a strange quality, as of the antique world imagined by Racine. Then came a massive upright relief, 'The Idyll', showing two lovers embracing on a seat in front of an avenue of horse-chestnut trees, studied from the Luxembourg Gardens. This too has a strong feeling of theatre. There were also small reliefs – roof-top views – of London and Paris, and a small sculpture in the round, though with a definite front view, of three girls on a seat.

From 1960 to 1963 he made an important series of wide landscape reliefs of the Lubéron mountain in the south of France, two showing the rock-formations like great petrified waves, and the tree-dotted plain in the foreground, and another showing the sun shining on the mountain. These vast, majestic landscapes turn out to be as much Raymond Mason's 'subject' as the crowded city streets; and perhaps the reason is that they are an enveloping ambience, for this, or, occasionally, a small section of it, is what he always represents most successfully. And these immense panoramas, their grandeur and solitude undisturbed by a single creature, are the opposite extreme, and therefore the natural refreshment, in which he immerses himself after long periods in the man-made and man-filled metropolis.

The 'Big Midi Landscape' is a sculptural invention, immediately convincing as a mountainscape transfigured by a blaze of light which, spreading sideways from the circle of the sun through the heavens, as if breaking through dissolving clouds, floods down over all the ridges and channels of the mountainside in a burst of apocalyptic splendour.

At the time (1960) when he began to work on these landscapes he did a sculpture of his own hand, erect and spread, which one would think a difficult subject to treat with much originality. Yet, as Patrick Waldberg has remarked, it is itself like an aspect of the Lubéron, with ravines, declivities, and the dry channels of mountain torrents. But it also has the upward thrust of aspiring architecture; and yet again the three middle fingers seem to become three statues supported on the jutting ledge of a cathedral.

The landscape series continued throughout the 1960s – 'Landscape with Storm-cloud', 'Procession of Clouds', 'Le Roucas', the language modulating at last into the surprising treatment of the 'Mois de Mai à Paris' of 1968. The rectangle is nearly filled by the pyramidal tree; in the centre we see the bare, severe architecture of its trunk and branches, which then become covered all round with clusters of blossom or foliage or both. Each side and below we glimpse the many-windowed avenue, thronged by a moving crowd, in which we see only the upper parts of people, and, in front, mostly heads and shoulders. All is fluid. This language has been evolved from studying the clouds and trees in the Midi, and now the same forms, the same melodies, express the fruit-like lumps of heads and breasts, mother and baby, lovers embracing, meeting, greeting, promenaders enjoying the spring (hard to make out, for they seem to move and

change before our eyes), and the exuberant masses clothing the branches – in which we can also discover, if we like, heads and torsos, all the excitement, the flowering, the promise, of the month of May in Paris.

And this experience of the landscapes, and of the Month of May, has at last flowed together with that of the earlier street scenes, deepening and enriching the language of the 'Boulevard Saint Germain' into a new sculptural idiom, still more fluid and free, as in the small, later relief of the 'Boul' Mich".

Mason had in fact begun to evolve this broad and vigorous language for the expression of street scenes in 1963 and 1964, in an upright relief, 'The Street', and numerous small groups in the round, which he made as studies towards his huge sculpture, 'The Crowd', which was first exhibited in plaster in 1965 and later cast in bronze.

Before attempting to appreciate this work we ought to pause for a moment to consider some of the problems that face a sculptor today.

Sculpture used to be either cast or carved, or modelled in clay and fired – terracotta. If it was cast, that implied a technique of *pouring* molten metal into a mould, formed by various processes from a *modelled* original. We have grown used to the idea – which has not been seriously disputed – that the form of a work of art should be influenced by its material. Bronze, however, has been much misused, in order to multiply copies of carved works. Its true character is to appear to be, or at least to have been, fluid, though now set hard. But it is not uncommon now to work, as Mason does, direct in plaster, which, during the short time that it is very wet, can be modelled like clay, but as it rapidly dries and hardens, can be cut, though not so cleanly as wood or stone. So this is a new process, for which, as a technique, there is no tradition. It is half-modelling and half-carving, and the truth is that, but for the material, it would be better painted than cast, as carved wood sculptures used to be painted, or as terracotta reliefs were sometimes glazed in colours – as with the della Robbias. This last, with its semi-pictorial approach, is certainly closest to the spirit of Mason's work. But plaster being in itself neither pleasing nor durable, nearly all of it has been cast in bronze. From the point of view of sheer form, it has not been unsuitable, but he has never felt it ideal because of the pictorial element in his conceptions, and he has taken such pains in patinating it, to bring it nearer to his dream, that sometimes one would hardly know it was bronze.

Added to this problem, there is the collapse of the whole European

tradition of the art, even more than in the case of painting, for since Bernini there has been far less great sculpture than great painting – indeed, very little at all. Rodin rises like an astonishing mountain out of the flatness, thrust up by the sheer force of genius. It is true that he had good technical teaching, from Carpeau and Barye, but he had to go back to the Renaissance to base his art firmly. And, like all the great ones, he drew his strength from both streams of the tradition – from the antique-based, heroic, ideal art of Michelangelo, and from that of Donatello, to whom in some ways he was closer; for Rodin was not, fundamentally, a carver, but supreme as a modeller, and Donatello too was a master of bronze, and also in spirit more Northern, more modern, than Michelangelo, caring more for the flesh and blood individual, observing character and particularity, and actual humanity.

Had Rodin been less utterly and gigantically alone, he might have opened a path for modern sculpture, as Cézanne did for painting. Or one could say, he opened a path, with his great Balzac monument – but who has followed it?

Some of the best modern sculpture has been done by painters – Degas, Renoir, Matisse, Picasso – but done so unpretentiously that it is not studied as it should be. Brancusi's vision was only for himself, and, in sculpture, so was Giacometti's.

This apparent digression was necessary to lead up to the fact that Mason, having had to find his way in the wilderness, with no clear road, only, somewhere behind, a free choice of a few signposts, can now be seen, in his work of the 1960s, to have taken the direction indicated by Rodin. In his relief 'The Street', in the four 'Elements of the Crowd', the four 'Small Crowds', and 'The Crowd' itself, he takes up the clue given in Rodin's work of the 1880s and 1890s – above all, in the colossal 'Head of Iris' of 1891. In these works Mason has pushed as far as he could – and that is a long way – in the direction of fluidity, of the true nature of bronze; of abstraction; of the generalised, simplified, heroic side of the Great Tradition: of public, monumental art and the Grand Manner.

'The Crowd' is not a particular crowd, but symbolic of all crowds. An undulating, fugal movement ascends and descends continually from the large figures in front to the little ones gradually rising up and vanishing in artificial perspective at the back. This is the only one of Mason's large sculptures unenclosed by any frame. It consists entirely of the mass of human bodies, flowing along like a great river. And yet it is more like a

troop of disembodied souls, such as Dante describes, thronging towards the river Acheron, innumerable and terrifying, because they appear to be swept along, driven, by some overpowering force – not at all masters of their own fate. Here and there, it is true, some struggle in the opposite direction, but then the movement returns for ever upon itself, there is no escape, the tide flows relentlessly, irresistibly onward.

They seem like spirits because they are reduced to their barest, basic, human elements – in a way quite the contrary of Giacometti's, where each individual, however eroded, remains firmly on his own significantly enlarged feet; but in Mason's 'Crowd', not only the figures retain the bulk of people in everyday clothes, but – as in any true crowd – we do not see the feet; it is as if there is some single fluid, pushed up into a thousand temporary forms, which break and dissolve and re-form again like clouds – the fluid is Life itself, the river of forms pouring on into the universal ocean.

The physiognomies are rugged and elemental – lumps and gashes and cavities – but just behind the striding figure in the centre, we glimpse a beautiful woman-face, with half-open mouth, turning in tragic profile to the left; yet even she seems strangely fluid, partly by reason of the form itself, and partly because just behind her, a little lower, this one lovely face is echoed by a hollow, shrunken one, a toothless crone, yet still resembling her – a sort of 'belle heaulmière' – and 'Où sont les neiges d'antan?' Indeed, the one jarring note is the central figure itself, precisely because, in this context, he is over-particularised, not great and grand and fluid enough.

But who else in our time – who else since Rodin – has even attempted such a subject? And Rodin, for 'La Porte de l'Enfer', used the nude – like Michelangelo. Yet for 'The Crowd' the nude would have been a false solution, for however strongly it gives the feeling of being a crowd of souls, it is nevertheless a crowd of people still living in this world, in a city of today, but seen with the penetrating vision of a true 'seer'. And have we sufficiently admired the way Mason has dealt with the practical, professional, technical problem of modern dress – of which so many sculptors have complained? We are just conscious, if we think about it, that his people are wearing clothes, but – except for the man on the left with his back to us, in hat and short bulky jacket (the man from the centre of the 'Opéra' relief, grown old and wintry, like a polar bear) – we really have not noticed what kind of clothes. And this is a triumph for the artist; for the

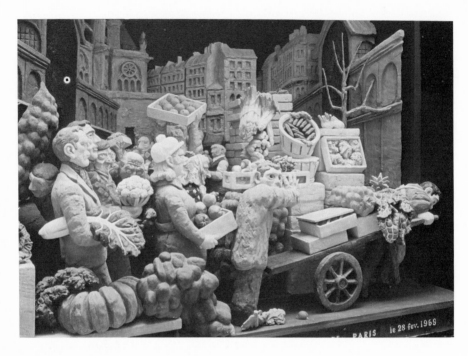

RAYMOND MASON
**Le Départ des Fruits et Légumes du
Coeur de Paris, le 28 février 1969** 1969–71
Epoxy resin and acrylic paint,
121¼ × 124 × 53¼ in incl. base and frame
Fonds National d'Art Contemporain, Paris

beauty of antique garments was, that they gracefully and unobtrusively moulded themselves close upon the body, neither hindering nor obscuring movement or individual character; and fundamentally, this is almost all that is required of clothes by art. Contemporary garments – especially male ones – are not quite equal, on the score of dignity, to the representation of the heroic, tragic, or monumental. Even in real life, in regal and ecclesiastical ceremonies, robes are still worn. We may smile at Tischbein's wrapping Goethe in a white travelling-cloak – but even Rodin wrapped Balzac in a dressing-gown, and could never have achieved such sublimity with a jacket and trousers. All honour, then, to Raymond Mason, who, without resorting to either the nude or the toga, and without offering the guidance of any significant title, has given us a 'Crowd' which we who see it feel to be at once contemporary and 'in the light of eternity'.

His next work, 'Le Départ des Fruits et Légumes du Coeur de Paris, le 28 février 1969', is so audaciously different that no one could possibly have foreseen or guessed his treatment of the subject. It is only after the event that we can recognise it as an aspect of the same personality; for indeed he has here pushed as far as possible towards the opposite, and complementary, extreme to that manifested in 'The Crowd'.

The subject itself is absolutely specific, and he has handled it with the sharpest definition of which he was capable, emphasising – not to say exaggerating – every particular. To achieve this fierce definition he has, naturally enough, approached his theme as a carver, as far as he possibly could. He has also found a material more obedient to his aims than anything else he has tried so far: the work is cast in epoxy resin, which is not only as a substance in keeping with the character of the plaster original, but, being white, allows of being painted.

The dimensions of this work are: height: 10 ft 2 in; width: 10 ft 4 in; depth: 4 ft 5 in, and though it is now sculpture in the round, it is once more partly enclosed, and in an architectural setting – already represented in perspective, as in Borromini – so that it relates again to his earlier reliefs in their open box-frames. On the left we see the beautiful church of St Eustache, houses along the back, and, on both sides, the market pavilions. The movement of the procession once again runs parallel to the imagined picture-plane, as in 'The Barcelona Tram'.

Mason himself has written in the catalogue: 'The Halles Centrales Market was the last image of the Natural in the City. It is now a Paradise Lost.' The men and women who handled all this country produce had, he

says, grown up from the soil like their own vegetables – even into kindred shapes. 'It is the man of the Middle Ages who is leaving, the "little vegetable" of our own species.' And now they are packing up for the last time, and moving off, carrying fruits, vegetables, boxes, crates, the procession headed by a young man bent almost double as he pulls his loaded barrow. But it is 'the heart of Paris' that suffers the loss, the artist and the spectators who mourn; the men and women are tough and gay – one can almost hear their earthy jokes and tart repartee – they will start again somewhere else. And even the artist, although he grieves over their departure, has, in the course of working, fallen ever more deeply in love with the scene, in its entirety and in every detail, so that it has become a celebration as much as a farewell. His Englishness comes out here at its most extreme, his passionate interest in individual character, in the particular, the detailed, the everyday homeliness, in the incisive drawing which, like Hogarth's, stresses every characteristic until the person or thing becomes more than itself, a type, a symbol – and this not through generalisation, but through the intensification of the specific – the still rounder eyes, still deeper wrinkles, still more pouting lips, and so on. The effect approaches caricature, yet if we look about we can see how true all these renderings are. And there is not a grain of malice, but on the contrary the most abundant warm-heartedness, and Mason's perennial love of 'theatre'. It is remarkable that he has escaped being carried away by his interest in the accidental, detailed actuality of the everyday into a degree of 'genre' destructive of good sculpture; but all great art walks a tightrope. In the event, while all these characteristics remain strongly marked, they are nevertheless balanced by a powerful sense of form and design which has welded the whole cortège into a monumental work of art. Large rhythms run through it, and a myriad formal echoes and relationships bind it harmoniously together, even while the whole scene is so complex and rich that, as one moves a little to the left or right, different figures are revealed.

The many beautiful drawings Mason made for this work are themselves masterpieces. And having made the studies, and once planned the whole, it seems as if, while he worked on each section, each figure or group, or box or basket, or cabbage or pumpkin, he did it with such intense concentration that he no longer worried, but simply trusted, that the shapes and rhythms would work together in unity, by a kind of necessary logic. And he continually found himself surprised by confirmations of this belief – by such things as the correspondence between the veins of a cabbage leaf and

the late Gothic of the church. The same principle must have been at work in many Gothic and Renaissance works, too large and elaborate for a continual consciousness of formal relations throughout the whole. It is a principle which seems related to that expounded by Kleist in his piece on the Marionette Theatre, where he says that the operator must imagine himself in the centre of gravity of the marionette, and need only control that part, and the resulting movements of all the limbs (which are 'only pendulums') will then be right and express what they should; but the line traced by this centre of gravity represents nothing less than 'the path of the dancer's soul'. In a similar way, the sculptor's ardent identification with each person and thing in turn has ensured the rightness of the whole.

It is painted in acrylic gouache, in vivid and glowing colours – lilac and gold, orange and scarlet, green and violet; the architecture sober brown and grey, and the night sky black. At last he has found a technique that suits him. We can see the roots of this work further back than Donatello, in polychromed medieval wood-carvings, in Gothic representations of the Nativity with shepherds bringing their rustic offerings, and the procession of the Three Kings with their rich gifts. Also it is like peasant celebrations, harvest festivals blazing with colour, or a brilliantly lit crowd scene in an opera, perfectly planned, moving, shuffling along (again, we do not see the feet) to music, a heightening of actual life. Finally, however, it is unlike anything but its extraordinary self.

If it were possible to see 'The Crowd' and 'Le Départ' together, and look quickly from one to the other, I think one would see a similarity in their abstract, formal qualities – the character and relations of lumps and hollows. This is the mysterious thing that defines a physical identity – by which we recognise our friends at a distance, or a work of art too far away to see what it represents. But apart from this most basic thing, they are as different as can be. It seems as if the two streams of the European tradition, which for a time Mason had succeeded in combining in his work, have here divided, to flow separately. In 'The Crowd' he went as far as he could along the Mediterranean way; 'Le Départ' perhaps marks a return to his Northern origins, and it is this direction that he has since followed.

12

EUAN UGLOW

Euan Uglow, unlike most of his contemporaries, seems to have looked at the glories of the great European tradition, particularly of Renaissance Italy and nineteenth-century France, not as if they were sealed off in the past, a lost paradise to which there can be no return, but as if re-entry might still be possible to the devoted and persevering pilgrim.

He was born in 1932, and from his student days onward appears to have continued firm in his faith, in spite of the doubts and confusion all round him. Partly by being taught, and partly through a personal development of what he had learnt, he evolved a method of painting whatever was in front of him – figure, still-life or landscape – and so developed a way of painting, unpretentious, down-to-earth, rather as if he believed, like van Gogh, that a painter should be able to do a job as reliably as a shoemaker can make a pair of shoes, or as if he were an apprentice in a Renaissance studio, never doubting that the craft could be mastered. And of course, crafts, considered simply as such, can be mastered. But since the continuity of the tradition has been broken, and the achievements of every time and place lie open like a map all round the bewildered youth of today, it is rare for a young painter to feel so convinced that any one approach will include all the possibilities he may need that he is willing to choose it, and submit himself to the discipline of acquiring a technique, humbly, patiently, and long enough to become a master-craftsman.

Uglow has certainly become a master of his craft; and yet his method is permeated by the doubting, questioning spirit of today, and is less assured, less clearly envisages a conclusion, than the methods of the past. It has in it a quality of infinity, a kind of openness, which allows it to keep pace with the growth and perfecting of his vision, even obliging him to leave the final word unsaid. For in fact he never does say that he has finished a picture, but that – for some reason connected with the subject – he has stopped working on it. Partly it is also because of his slowness. He has to leave the landscapes and go back to London; flowers in any case would fade in a matter of days, so he is apt to start with them shrivelled,

but in the end they dry beyond recognition; the fruit shrinks, the women
get married and go away.

Bound up with the slowness, his method has two severe limitations:
one, that it cannot cope with movement, or at the most only with a halted
movement, as of a figure interrupted in an action; and the other, that it
cannot be applied to groups of figures, or complicated subjects impossible
to preserve indefinitely in their exact relationships. But these limitations
appear to be in harmony with Uglow's temperament, and within them his
achievements are of a high order.

His way of working involves the continual taking of measurements,
checking and cross-checking. It is an extreme development of an attitude
traditional in the Slade School, and he learnt it there, and before that at
Camberwell, from Coldstream, and, like him, he leaves his canvases
peppered with little ticks and crosses, but apart from this there is not much
resemblance. This peppering of little measuring-marks has its own charm,
like the prickings of a cartoon. If we ask ourselves why we experience it as a
charm, I think it is that it seems to allow us the privilege of a glimpse into a
highly skilled and specialised procedure. When we are confronted with an
'Old Master', finished, in the old sense of that word, whether illusionistic
or in a quite unrealistic convention, it is a *fait accompli*, and appears to us
like a work of magic; we cannot imagine how it was done, how begun; we
are excluded from the secrets, amazed spectators. But these little marks
seem to take us behind the scenes – although far from being made for that
purpose, it is part of their effect – allowing us, like tourists being taken
over a factory, a slight – very slight – insight into the way the thing is
made. Not only that, but it also makes quite clear that what we are looking
at is not a copy of an appearance but a translation. Squaring-up lines have a
similar effect. They make us more conscious of the surface, and of the
step-by-step process of seeing, of drawing, of painting – which indeed
adds up to a double translation. It is as if we were shown the facts of
perspective and optics at work, first translating our flat retinal image
into three dimensions, then transforming that back into a more clearly
understood flat image, and this intensifies our feeling of the solidity of the
form – giving us that sensation described by Berenson as 'life-
enhancing' – at the same time that our increased awareness of the flatness
tugs exhilaratingly against it.

It seems to be Uglow's practice to begin by taking his measurements on
something parallel to the picture-plane and as near it as possible, such as

EUAN UGLOW
**Nude, from twelve regular vertical
positions from the eye** 1967
Oil on board, 96 × 36 in
University of Liverpool

the near edge of a table or platform, or of a window framing a distant scene, and from there to proceed inwards, as if excavating a space until he reaches the surfaces of his principal subject. In a sense, of course, all that appears on the canvas is the subject, but in another sense we feel as if, within the space he has made, he were pointing up a block of marble. But whereas that is done in order to copy an existing sculpture as exactly as possible, or to make an enlargement of a small model in the correct proportions, Uglow is searching for points which will enable him to discover facts about forms still, so to speak, in the raw in the physical world, to create an image not yet in existence.

One feels the influence of Giacometti, probably transmitted through Coldstream; an influence, not superficial or stylistic, but profound and ethical, characterised by a firm belief in representation, and an almost ritualistic attitude to the activity of art – working long hours, day after day, with devoted regularity, alone in the studio with the subject, trying to see it without prejudice; a belief that discovery is preferable to preconception – because it is assumed to be truer. From this influence and attitude there has developed, in some painters, a faith that, if this way of life is patiently followed, something will happen, probably quite suddenly, which will make sense of the work and be a sort of revelation for the artist; but Uglow has adopted the discipline and the way of life without the expectation, or even hope, of any such event, revelation, or miracle. 'Adopted' is perhaps too suggestive of a deliberate decision; for the feeling one gets is that it is the only way in which he can function at all. And without looking for any sensational development from one day to the next, he has faith in his method, and trusts it, as a good workman would, to produce a work of quality, of which he need not be ashamed, at whatever stage it might be interrupted. And he is conscious that his utmost striving towards objective truth must still, inevitably, produce a subjective image; that his method, as far as 'truth' is concerned, can at best produce only approximations and compromises.

If he is painting a standing figure, it is clear that he lifts his eyes to the head and lowers them to the feet, and between these extremes there is an infinite number of focal points, the perspective changing at each, and similarly from side to side. If his own eyes – of which there are two, which is in itself a complication – are situated at a level halfway up the model, the parts above and below are further from his eyes the closer they are to the head and feet, so that all the measuring in the world cannot prevent a

considerable degree of distortion, greater in proportion as the model is
nearer to him. The part of the model nearest to his eyes will be seen on a
larger scale than all the rest. He became so acutely aware of this distortion
when doing a large painting of a nude female model with one foot back,
toes just touching the ground, as if walking, that after this he decided on a
curious experiment. He built an elaborate construction, on which he was
able to sit at twelve levels, and the model was posed standing on something
against the wall, which was marked at corresponding levels. The work that
followed became the famous painting 'Nude from Twelve Eye-levels'.
One result of this cancelling of perspective by moving his observing eye
itself up the whole height of the figure was that the girl, already tall and
slender, became in the painting about 7 ft high. Another result was that the
twelve horizontal sectional lines drawn along (or round) any part of her
would appear to curve up at the sides receding from the eye when viewed
from above, and down when viewed from below; so that every time he
changed his level, his measuring points caused gaps to appear (on the
painting) across the more distant parts of her body, for the upper and
lower limits of each gap both represented the same line, and they gradually
tapered to a point as they approached the part nearest the painter's eye.
But although they can be read as gaps, the painted figure more easily
registers as complete, but pierced by a number of horizontal arrows,
suggesting a female St Sebastian, and added to her exaggerated height and
quiet pose, with arms folded behind her back and hands holding the
elbows, this has produced a quite extraordinarily remote and solemn
effect, as of a virgin immolated in the sacrificial rites of some antique
religion; but in fact the religion was that of art.

In this painting Uglow seemed to be testing his method by pushing it to
its extreme limits – indeed almost beyond them. It was an experiment:
what happens if –? And it gave the answer: this is what happens. There
was no point in doing it more than once. And partly because elongation is
always fascinating, but still more because of its hieratic effect, and because
of the intense degree of seriousness, exalting art to the level of a religion,
and because of a cool purity and delicacy of form, and factors half-abstract
and half-evocative, as mysterious and indefinable as those which consti-
tute the appeal of a Botticelli Venus, this painting is profoundly and
hauntingly beautiful.

After this he returned, as it were, to the realm of Practical Reason,
always giving a great deal of thought to the arrangement of the subjects, so

that each is a unique problem, but painting them in accordance with his usual procedure, from a single viewpoint, taking infinite pains over measuring.

Although the process is like pointing up marble, the actual appearance of his images is closer to that of carved and painted wood. The way the paint is put on, so cleanly and deliberately, leaves every plane defined at its junction with the surrounding ones, so that we seem to see the very strokes of the chisel. The edges are never smoothed off, the carving is never polished, and this is one of the beauties of Uglow's work. And it is largely in this that the open, infinite quality of his work consists, for although the definition is always clear, one feels how it would always be possible for him to make a further cut, to place another plane across two adjoining ones, or break down a large one, refining the definition with additional subtleties.

There is a quite astonishing early painting, already unmistakably his, done when he was twenty and a Slade student, 'Nude with a White Skirt' – a dark-haired, middle-aged, foreign-looking woman, sitting squarely in a wooden armchair, with a background of closed shutters and brick wall. She sits there like a figure carved in wood and painted in local colours, monumental, with a sort of peasant dignity. Here and there, at the edges of her skirt and turned-down bodice, it is as if the wood had split because of being undercut to such thinness, making a square-toothed edge. No doubt his time on this painting was limited by the availability of the model, and the carving remains rough; but this gives the forms a sharp clarity, and the rough-hewn look seems in keeping with her vigorous type. However boldly done, nothing is generalised: the fingers, the breasts, the nipples, the head with every feature distinct, all are observed and exact; she is that particular individual, unforgettable; and in spite of the cool, deliberate technique, the painting has a fiery vitality reminiscent of some early Kokoschkas.

This deliberate technique owes a great deal to Cézanne, but nothing at all to the Impressionists. Uglow rejects their whole science of colour in favour of local colour; but he takes note of subtle variations of this, more than the Florentines and Flemish painters did; for instance, of how the flesh of one person is here more mauve and there more pink, here yellowish and there whiter, and so on; but the over-all effect of the local colour retains the strength of impact that it has in actuality, when we feel we know what colour a thing is. And thus he comes closer than most modern painters to Friedländer's 'absolute idea'. He really does attempt to create

EUAN UGLOW
Large Oval Still Life 1968
Oil on canvas, 28 × 23 in
Dr Bethel Solomons

something approaching as nearly as possible to an absolute idea of the form and colour of his subject – but an idea derived from observation, not a concept or a memory – by means of scrupulously measured drawing and the maximum of logic in the use of light, as well as cleanly mixed and applied paint, eliminating accidents which explain or contribute nothing, rendering as much as possible what is permanent and as little as possible what Friedländer calls 'the appearance of form and colour in which the idea presents itself casually, modified by place and condition'.

But Uglow follows Cézanne more closely than he does any other painter of the same or a later date in the supreme importance he gives to form itself and to rendering it as exactly and fully as possible, making it even more solid, massive, and clear-cut than it appears in nature, minutely observed but without loss of bigness and over-all character. And though he does not use colour in Cézanne's way, he has learnt from him how to make form principally by modulations of colour, dictated by the interaction of observation and personal feeling, and laid on the canvas deliberately, touch by meticulous touch. Thus, like Cézanne, he has a method but not a formula, so that as he works he continues to discover.

But Cézanne's method arose out of a profoundly original vision, feeling, and theory, and while he applied it indefatigably to studies from nature, he could and did adapt it to serve a loftier ambition, embracing works of imagination and compositions in the Grand Manner; whereas Uglow's method appears to have grown out of some inhibition or necessity, to serve him as a crutch he cannot throw away. Whether this is really so, or whether it is from deep and quite involuntary personal preferences and characteristics, or due to a moral, even puritanical conviction shared by many of his contemporaries and from which, born in another age, he might have been free – from whatever cause, he certainly has renounced what is usually understood by 'imagination' and 'composition', restricting himself to a single figure, or limited subject, which can be studied in its entirety – that is, to the study, or fragment, firmly based on absolutely definite and particular experience.

There is, indeed, an early figure composition, a sort of Arcadian scene, which actually includes figures in movement; it already shows several characteristics of his mature style, but is clearly a student's exercise, and although it has many good things in it, he may possibly have felt discouraged by what he thought were his limitations, and decided then that with narrower aims he could reach a higher level of performance. If

this was so, it was a premature decision, for there are two or three early studies of girls walking which have more life and subtlety than that composition, besides a large, more recent painting of a walking nude, studied over a very long period, which show that, had he wished, he could have painted imagined groups. And so I think we should conclude that his restricted aims are due to choice rather than limitation of powers. Certainly, for one so evidently in love with the great art of the past, Uglow's art has a remarkably stoic flavour.

Accepting as he does the limitations of working only from something literally before his eyes, he channels the whole of his imaginative and compositional powers into the setting-up of his subject. And this is true not only when it is a strange invention, as for instance the little still-life in which three small drooping roses, faded to purple-black, with much greenery, are tied up into a sort of column, in a pot almost hidden by leaves, standing off-centre on an up-ended white cube. The whole arrangement suggests something on a much larger scale – an architectural fantasy; and perhaps it holds a memory of the spiral core of movement of some heroic statue. But one cannot deny the term 'imaginative' to the many simpler still-lifes, in which an object, or the principal object, is usually centrally placed: an oval painting of a single pear; pictures of a blue and white cylindrical Delft vase holding a few dark evergreen leaves; a white, lidded jar, solitary in the centre of an expanse of table with a coloured cube at each corner, entitled 'Passionate Perspective'; all kinds of little jars and vases with single sprigs of flowers and varied backgrounds, sometimes geometrically patterned – all are imaginatively seen, and monumentally presented.

And then there is a comparatively recent painting, which took the artist four years to complete, of a nude girl seated, seen from the side, clasping her knees, her head drooping forward between her arms, in a pose very like that of the girl in van Gogh's drawing 'Sorrow', but facing the other way, and with a few crucial differences. First, van Gogh's girl sits on a step, which multiplies the dejected, falling note, while Uglow's girl is on a single level, so that, the knees being higher, the arms are nearly horizontal, making the pose much calmer. Second, in Uglow's painting the girl is younger, the whole figure more slender, and quite firm. She sits on a white-painted slab, which projects like a drip-stone over a golden-brown wooden structure, and reflects its brilliance into the delicate shadows of her body, almost cancelling them. She is strongly lit from above, and so

casts small sharp shadows on to the white slab. The two sides of this, slanting inwards towards their vanishing-point, would find it on her shoulder, exactly below the crown of her head, implying an almost symmetrical pyramid. Her golden-brown hair is close in tone to the background, which is an intense blue, painted by Uglow with a special pigment which he went to some trouble to obtain. Her pose is enigmatic. One feels that for the artist its interest was so supremely formal that any suggestion of grief or weariness is all but lost in pure serenity. Firmly curved and carved like the framework of some strange musical instrument, she sits like a sunlit monument in the desert against an African or Mediterranean sky, striking, grand, and unforgettable.

A more recent painting, also extending over years, is of a girl half-reclining on a couch, with one hand resting on its arm and the other on her thigh, in the attitude of some of Titian's Venuses. Notwithstanding this reminiscence, and although her short tunic-dress clearly reveals her form, the effect is not voluptuous, but muted and cool, both in colour and mood. There is something extraordinary, even startling, in the way that her horizontal thighs sweep out of the picture, cut off before the knees; but the whole design is satisfying, weighty, and perfectly balanced; and not less grand than the more brilliant one with the blue background.

One feels the unseen exemplary presence of heroic figures from the best period of Greek sculpture behind Uglow's best paintings of figures. But almost certainly the greatest single influence on him has been that of Piero della Francesca, himself, as Kenneth Clark has noted, closer in spirit than any other painter to 'the highest style of antiquity'. Those characteristics of Piero which must have been fostered by the influence of Brunelleschi and Alberti – the mathematically calculated proportions of his composi-tions, the geometry underlying these and their component parts, even to the measured diagrams of heads, the contours carefully pricked through, the love of perspective – have clearly held a special appeal for Uglow, whether for their intrinsic fascination, or as elements contributing to the total effect. The deep human feeling in Piero's painting is contained by these processes in a formality, which exalts and translates it to a plane of perfect dignity, so that the total effect is of pure abstraction, of a degree of detachment and serenity, unsurpassed, if not unique, in Western art. By its solidity and stillness and the calm proportions of flat or unbroken areas to the rest, his painting seems to take to itself much of the nature of sculpture and architecture. This static quality appears not only in single

figures, but even in large compositions which ostensibly portray move-
ment, the most extreme and extraordinary example being the victory of
Constantine over Maxentius, in which men and horses and floating
banners are frozen in mid-action to such an enchanted immobility that
every detail of form, even to a soldier's open mouth, which in the normal
flow of movement would change too quickly to be precisely noted, is
presented as clearly and calmly as if all time or even eternity had been
available for the contemplation of the instant itself and for its re-creation in
a purer air, a purer language, than those of actuality.

Uglow, the most static painter of our time, has fallen under this spell. It
is apparent even in that early figure composition. Since then, among much
else, he has learnt from Piero how to simplify figures without resorting to a
formula (such as merging minor variations into two inclusive tones of light
and shadow). Piero, making great use of reflected light, reduces changes of
plane to gradations too subtle to disturb the most permanent possible
unconditioned idea of each figure, but without sacrificing the studious
carving out of the form in its completeness, so that the end is the simplicity
of fullness, not of emptiness or omission. By these means he also contains
each figure, building, or object, as well as each part that has its own local
colour, within its own silhouette, and reconciles clear sculptural definition
with an enveloping luminosity greater than any in Impressionism. This
approach, however, serves Piero in the creation of a few ideal types,
whereas Uglow, true to the age and latitude in which he lives, applies it to
the representation of individuals with all their peculiarities. Yet in his
handling of light and colour he seems to move in an opposite direction,
towards more Mediterranean and classical ideals; for while, in his early
work, as with most, if not all, students trained at that time at Camberwell
and the Slade, the tone is low and the colour heavy, gradually over the
years his pictures have become blonde and luminous, the colours clear,
and the paint, never thick, has acquired just enough consistency to
become beautiful in itself.

Other painters who have left some mark on his style have all, in different
ways, had some affinity with Piero: Poussin, Georges de la Tour, Ver-
meer, Chardin, Cézanne, Seurat – all have a strikingly monumental
character, a deliberate economy which excludes the accidental, a strong
feeling for light and a logical way of using it to create their forms, which are
mostly massive and blocky, with a suggestion of being carved; but
probably the most fundamental characteristic which links them to Piero

EUAN UGLOW
**The Massacre of the Innocents
(after Poussin)** 1979–81
Oil on canvas laid on panel, 16¼ × 19¼ in
Private collection

and each other, and Uglow to them, is their static quality.

Among many possible oppositions, one can divide painting into the static kind, and that in which everything seems to flow in perpetual motion. There has always been a tendency to regard the most fluent, the most cursive kind of painting as the most accomplished, probably on the principle that one learns to do something slowly first and then more and more quickly as facility increases – to walk first, and then to run, dance, skate, and even fly. And thus the great masters of the High Renaissance became positively airborne. A sort of boiling-point was reached at which everything melted to fluidity, the baroque masters had such control that the whole of creation seemed to flow in willing obedience from their brushes, following out the original rhythmic impulse down to the last leaf, the furthest fingertip.

Yet we should beware of being dazzled by these brilliant achievements, and so, unjust to their opposites. For there is not necessarily any continuous progress in art. Tradition can be seen as a rope of many strands, each formed by a sequence of related temperaments and preferences, developing in accordance with the character of the artist and of his time.

In the most fluid kind of painting, the movement of the painter's hand and arm leaves its vivid trace – the trace of the personal gesture, to which we today attach excessive importance, due perhaps to the difficulty of preserving an identity against the odds of the modern world. But the precise, considered touch (which still involves a slight movement on the canvas as the brush meets it, and again as it leaves it) expresses a different temperament and is not necessarily a less personal gesture than the swift fluid one. The most fluid of all moves the full brush some distance along the canvas, and in the course of this movement the paint thins, the colour is modified, and fusions and subtleties occur which the painter himself can never repeat, so that with every correction, though something may be gained, something is also lost. The opposite extreme is to place a dab of colour as deliberately as a brick, leaving it clean and undisturbed, and final from the beginning, so that whatever may be added it will continue to play a visible part in the fabric of the whole work. This is Uglow's way; and in this respect he is as extreme as Cézanne, and even much slower.

This certainly contributes to the feeling of the form in his paintings being carved – with the suggestion that a false cut might be irreparable. And yet, as already noted, the process itself returns us continually to the surface, which is never broken illusionistically; and also the point of view,

from which whatever is being painted is seen, is in fact an integral part of the subject, all the shapes making a two-dimensional harmony, even though less completely interwoven than in the works of those great painters just named, through whom runs the line of his artistic ancestry. All of these wove the elements of their compositions more mysteriously into a single new entity, which affected and slightly changed all the component parts, while in Uglow's there is less give-and-take between all the elements: the objects, or figures, retain their identity, distinct from the background, to a greater degree.

This characteristic can be seen not only as personal, but as a reaction against preceding schools of painting, just as the static, architectural quality of Poussin's work can be seen as a reaction against the excess of movement and fluidity in baroque art. For the great confusion which has bedevilled all the arts for the last 150 years or so is the idea that they should realistically imitate and record. Uglow has never been side-tracked by this fallacy. He seems to have always known that the business of art was to make images. Thus, although he loves the Italian light and landscape, he has never attempted to capture and record any transient effects, because he has no faculty for such swift translation as would turn them into art. The small paintings of the Medici Gardens by Velasquez, of 'Raphael's House' by Ingres, the clear-cut, sunlit Italian landscapes of Corot's early years – such things as these are outside his range. But against them he can set slowly wrought images which are a different kind of summary. It is as if he held some equally blissful vision permanently before his mind's eye – not an idea of what he is representing, but an ideal quality of the image itself, which can sustain him for years through the patient making of it.

His studio indeed suggests a medieval or Renaissance workshop, as if he were a craftsman in wood and ivory and fine gilding, as well as a painter; and this is not so far from the truth. There are many tools and utensils, and a feeling of monastic austerity curiously combined with pleasure in all material things. He cooks fish, game, and meat memorably, with rare sauces; makes elderflower wine, unusual preserves, 'And such sweet jams, meticulously jarred, As God's own prophet eats in Paradise'. One might almost expect to see Vasari drop in, and the two go out together and disappear down a couple of steps into some green-shuttered, modest but excellent eating-place, known only to the local inhabitants, in a narrow back-street in Florence.

Yet he lives in the world of today, and has adapted himself to it, taking advantage of whatever it offers that suits him, and showing in his work the inescapable trace of its thinking and questioning. As the line of his ancestry, the chain of the tradition of which he is a link, moves down through the centuries, the 'everydayness' of the subject-matter increases. When we come to Uglow himself, if we look round a roomful of his works, the way that he spans the tradition is astonishing. His noblest paintings of female figures still recall their ancient classical origins; and as the eye passes from them, perhaps to a still-life of a Delft jar with the end of a golden-crusted loaf near it against a whitened brick wall, to a view of the Imperial War Museum seen through a window, to a single pear on a table, to a sprig of ivy in a small white jar, and so on – the whole effect is one of timeless serenity, of clear, blonde light like that of Vermeer, of the irregular fragments of a modest existence isolated and presented with antique dignity. In short, here are all the peculiarly Northern and modern qualities – the individual, the particular, the detailed, the actual, the domestic, the everyday, the private – but raised to the plane of the classical. 'Playing a game of the profoundest seriousness,' as Thomas Mann said of art (in 1952), Uglow pursues as nearly as possible an absolute idea of his subject, but this idea includes its quite particular traits and peculiarities. That is to say, his subject is not, in the antique or Mediterranean way, idealised, but he aims at perfection in the image of something in itself imperfect.

DEVELOPMENT OF THE THEME OF
THE GREAT TRADITION

CLASSIC AND ROMANTIC

If the reader will cast his mind back to the short opening chapter 'The Great Tradition', he will remember that a distinction was drawn there between the Mediterranean and Northern streams which, flowing together, form the Great European Tradition, and the possibility of assigning the term Classic to the first and Romantic to the second was glanced at.

I have heard classical art defined (I forget by whom) as 'art in which the form contains the content exactly, so that nothing spills over'. Heine says something similar, to the effect that classic art accepts its limitations, does what it knows can be done, portrays only the finite, so that the result is serene, while romantic art strives to express the infinite, the spiritual, the all but inexpressible, and so gives a feeling of unsatisfied longing and aspiration, of something mystical, and of personal emotions and desires.

Classical art imposes itself with comparatively simple power, while romantic art, because of its 'overspill', depends to a greater extent on the sympathy and imagination of the spectator.

One may say that the best romantic art aspires to the condition of the classical, to complete expression; and, curiously enough, with the passage of time, it appears to approach it more nearly than seemed at first to be the case, because the subject-matter gradually becomes more familiar and acceptable, and so seems to lie more clearly and simply within the form. This process seems connected with the use of the term 'classic' to denote an acknowledged and established masterpiece, and so we accord it to those, even romantic, which through quality of form have survived with a force and reality overshadowing all reveries and interpretations. Nevertheless, this is a secondary and slightly confusing use, and in general one can call the antique and the Mediterranean spirit classical, and the modern, Northern one, especially in its more painfully striving aspects, romantic.

Mediterranean art is, on the whole, more sensuous than the Northern, and what we call 'beauty', being equally in its content and form, strikes the

eye more easily and completely. The Northern character tends to discover beauty where it was hitherto unnoticed, or considered ugly, and so the spectator usually finds it first in the quality of expression, and workmanship, and perhaps later in the content.

From time to time influences from other civilizations have beneficially affected the art of Europe, and many strands have been woven into its fabric, at first Oriental, through Christianity, and later, Chinese, Japanese, Indian, African, and others; but all great European art has maintained a balance between representational and abstract qualities. Throughout both branches of the double stream, good painting has been concerned with making images which represent, but do not superficially imitate, solid forms, and, in varying degrees, mass and space, on a flat surface, without losing sight of the aim of turning that surface into something satisfying to the eye apart from its interpreted meaning. Similarly, good sculpture has been concerned with representation and formal qualities, but not with imitation of appearances.

THE DECLINE AFTER THE RENAISSANCE

With increase of skill, the clear intentions of earlier art were gradually lost, confused by facility, the seduction of imitation, and even illusionism.

Consider, for instance, the device of foreshortening. The more a figure is foreshortened, the stronger is the impression of energy, power, and mastery, because the drawing relies less on reminding us by accepted symbolic marks, and more on surprising us by suggesting the actual three-dimensional form in an aspect which is less familiar, but which, with some degree of shock, we recognise as true, and this gives the sense of the artist's discovery and understanding; the sense of his energy and power, which seems to awaken an echo of delight in our own nerves and muscles, comes from the feeling that the artist has somehow taken stuff in his hands and bent it into shape according to his will, literally creating the form. For example: a head seen from below, so that one is shown the underside of the jaw running back and down each side from the chin, the convexity of the muzzle accentuated, the triangular base of the nose emphasised, the cheek-bones running down and back to the ears, the arches of eye-sockets and brow curving down still more steeply – all this gives an impression of greater solidity and energy than a strictly frontal view at eye-level; and if,

in addition to being seen from below, the head is tilted over and seen partly from the side, the impression of the artist's understanding and grasp of the structure, of his power and mastery, is stronger still. Some of the clearest examples of this can be found in Michelangelo's drawings, for instance: in that for the Virgin's head in the Doni Madonna, and the head of the study for Haman on the Sistine ceiling.

This kind of drawing was brought to perfection by the Italians, mostly in the sixteenth century, and by Rubens in the seventeenth, but all the excitement, the life and energy of it, were lost when it came to be reduced to a coarsened academic formula, no longer fed by observation. This decadence of the once noble Mediterranean side was further debased by tonal realism in painting, ignoring the qualities and relations of colour and destroying the unity and, in the best sense of the word, decorative, character of the surface; the Northern contribution towards the general decadence was the pointless copying of accidental appearances in a welter of insignificance, an abyss of triviality.

So, while for a few hundred years the path of European art, for the first time since the great age of Greece, seemed set towards continual ascent, through international Gothic to the heights of the Renaissance in Italy, and in the North, through a rather thinner but still bright star-cluster to Rubens, Rembrandt, and Hals, yet, after reaching these high points, the road descended as it struggled on towards the modern age.

For a brief moment Velasquez tied both branches together, but then they divided again. From time to time, on both sides, flashes of genius occurred. On the classical side Poussin, Giambattista Tiepolo, David, Ingres, Delacroix, made a chain of beacons blazing from peak to peak across the dark valleys, keeping the Great Tradition alive. But this classical, Mediterranean line is the older branch, and it often seemed as if it were sinking, debilitated and doomed, while the younger branch, more lusty, enquiring, and rebellious, was master of the future. Even so, and notwithstanding Vermeer and Chardin, Watteau and Goya, Turner and Gainsborough, Géricault and Courbet, who raised the more modern spirit to heights as glorious as those of the older line, sometimes, like Velasquez, uniting both – notwithstanding all this, the younger branch too sank for a time to as low a level as the elder.

Of course this whole metaphor is an over-simplification. A rendering of the accidental appearance of a modest subject is not of necessity trivial. The ancient Greek and Roman artists painted genre, domestic scenes,

exquisite still-lifes, birds in gardens, and so on, as 'private' art, for the decoration of houses, and on vases and other objects. Even long before this, the ancient Egyptians, while producing the noblest conceivable monumental sculptures, decorated the walls of tombs with charming, unpretentious, bright-coloured paintings showing how the deceased spent his time in this life. And in fact there is nothing wrong with genre painting until it breaks loose from its moorings and drifts about without any sense of direction or urgent purpose, or memory of standards. While it remains rooted in the Great Tradition, as with Vermeer and Chardin, it can rise to the highest levels. And at all times some good, perhaps even great, art can be found. But without some over-simplification no large view is possible; and it remains broadly true that the visual arts have suffered a long decline, from the Renaissance well into the nineteenth century, manifest in the Mediterranean branch as empty pomposity and pretty decoration – debased form with scarcely any content – and in the Northern branch as realistic description devoid of abstract qualities – trivial content with scarcely any form.

The cause of the decline is certainly more complicated than the simple seductions of facile illusionism and uninspired reporting. These perhaps merely occupied the void left by the vanishing of great inspiration.

Kenneth Clark, in his essay 'The Blot and the Diagram' (*Encounter*, January 1963) says: 'It is an incontrovertible fact of history that the greatest art has always been *about* something, a means of communicating some truth which is assumed to be more important than the art itself' – 'ultimate truths, stated symbolically.' That is to say, the greatest art has been employed in the service of profound beliefs. It was true in the time of Phidias, and it was true of the greatest Italians. But the fact that the best artists were chosen for such commissions indicates that great importance was attached to the form, the speciality of their skill, and that it was appreciated by those who commissioned them; and we can see that the artists themselves were as concerned with the perfection of the image as with its meaning. In the very last resort, what distinguishes the great from the commonplace is the quality of the form. But it may well be that the power to create great forms needs to be sparked off by great thoughts.

It is certainly true that, since the Renaissance, the gradual weakening of religious faith, closely involved with the growth of scientific and philosophic enquiry, ran parallel with the diminishing quality of art. Yet it was not only a matter of clearly defined religion; it was a question of belief in

non-material values. Humanism provided an impetus for art almost, if not quite, as powerful as that of religion. Some of Titian's very great paintings illustrate legends which, on the literal plane, no one then believed, but the subjects were so familiar, at least to educated people, that they could carry general human meaning, at the profound level of eternal mysteries; they were humanist art.

Bertrand Russell thought that

the political conditions of the Renaissance favoured individual development, but were unstable; the instability and the individualism were closely connected, as in Ancient Greece. A stable social system is necessary, but every stable system hitherto devised has hampered the development of exceptional artistic or intellectual merit.

One could add that the development of individual genius in the Renaissance was encouraged because wealth and power were united with the highest culture, so that patronage was intelligent and inspiring; and unfortunately no way has been found of ensuring a high degree of culture in democratically elected representatives of the people. The sad thing is that the continuous (even though not invariable) trend towards democracy – with an increasing tendency to socialism – appears now to be inseparable from the domination of materialistic values, although, long ago, it seemed to spring from idealistic and even spiritual ones. And a divorce has occurred between the intellectual aristocracy and those in positions of power.

Geniuses will probably continue to appear as long as the world lasts, since their birth is unpredictable and seems to occur without the cooperation of peculiarly propitious circumstances. In every department of human effort, certain ideas kindle the enthusiasm of like-minded men, who pursue and develop them through a few generations; and though geniuses are few, when conditions were favourable (that is, when the right sort of patronage existed) they almost certainly achieved more than they would otherwise have done, and also attracted great numbers of followers to work in the same field, whose labours depended very much more on demand and encouragement, and all these stars of lesser magnitude clustering round the few great luminaries produced the effect of a great period. Thus a few supremely gifted men, in happy conjunction with intelligent patronage, could cast a glory over a whole age.

During the long decline, the Northern spirit became the dominant one

of Western civilisation. It expressed itself in philosophical enquiry, scientific experiment and social and political changes; and though one may describe this spirit as forward-looking, energetic, and even – for what that is worth – the life-blood of the modern age, it is fundamentally not favourable to art at all. The creative spirit is, however, always at work, and perhaps, there being so little powerful impulse from within or enlightened demand from without in the fields of painting and sculpture, the greater part of this creativity was for a long time concentrated and poured into music, for which, since it entertains, and consoles, the demand never fails; and then, in response to a heightened demand, into science.

During this period the spirit of the visual arts may be thought of as having lost its way, and for the most part flowing underground, searching in the darkness for true directions, gushing up occasionally in isolated, irrepressible fountains, just enough to maintain, very thinly, the line of the Great Tradition.

THE SECOND REBIRTH

And then once more it blazed up magnificently, in what may be called the French Renaissance, in the second half of the nineteenth century.

Since France, more than any other country, combines in itself the Mediterranean and Northern elements, it was natural that it should be there, if anywhere, that the Great Tradition should find enough strength to flower again profusely. It should be emphasised that it had never completely died: Corot and Daumier, Delacroix and Courbet, had kept it alive. But in this new rebirth, just as in the Italian Renaissance, a tremendous upheaval was taking place, the new art of a whole period was being born. After the event, it is easy to see how the great painting and sculpture of that period takes its place in the mainstream of European art; but at the time it appeared disconcertingly new, strange, shocking – in short, revolutionary.

There were two crucial differences between this manifestation and the Italian Renaissance: its lack of immediate acceptance, and the general character of the new art. Neither of these factors caused the other, but they interacted.

Not only were Renaissance patrons highly cultivated people, but

Renaissance art was accessible enough to please without being fully understood, and, when commissioned by an élite for churches and public places, could be relied upon to satisfy the masses. The demand was so great that it called forth an army of inferior artists to supply it. These inferior artists were put through a severe enough apprenticeship to ensure a reasonably high professional standard, and thus the 'schools' came into being – 'school of' this or that great painter, work 'from the studio of', and so on. But it should not be forgotten that in those times the great original spirits were recognised, and those who could afford it wanted the work done by the hand of the master. The rich patrons were also those who knew the difference.

In the nineteenth century neither art nor artists occupied positions of such importance as formerly. There was no longer any demand at all for religious art, and very little for secular decoration. 'Schools' were no longer bodies called into being to supply a demand, they were academies – the very word 'academic' has become associated with questions of theory divorced from practical application and concrete reality – they were academies run by second-rate artists who genuinely believed themselves to be handing on the traditional theory and craft of great art, but who had failed to understand the real principles and clung to empty, worn-out forms. In these institutions the stream of the Great Tradition had become muddied, and in this debased condition seeped out and covered the walls of officially recognised exhibiting bodies.

Pictures had become a movable commodity, produced in a void for no particular destination, and the painters were thankful if someone bought them, from exhibitions or dealers' shops. This was sadly different from the times when commissioned work provided the artist with a living and absorbed him into society. With the changing social structure, and the advance of democracy, wealth was passing into philistine hands, and the intellectual aristocracy were no longer in a position to commission such public works as were still required. These changes were already taking place in seventeenth-century Holland, and Rembrandt, in the latter part of his career, is an early example of the isolation and neglect they caused. During the nineteenth century the artist became a completely discon-nected character. Patronage by the philistines, however insufficient, favours the muddy stream issuing from the academies, and artists thus reared could, and can, still hope for a tolerable living, the more adroit even for worldly success; but all the great French painters of the nineteenth

century, in whose guardianship the pure fountain of the Great Tradition still sparkled, found themselves in Rembrandt's situation – though his worsened with the changing times as he grew older, while theirs improved a little as recognition was gradually accorded. They worked to satisfy themselves, encouraged by a small circle of friends. Art became almost a religion, to be practised without compromise whatever the cost, which was often poverty and hardship, sometimes near-starvation. And these conditions still prevail today, and are likely to continue. For the general character of good modern art was and is such that it has become necessary to take a little time and trouble, to acquire a little special knowledge, in order to understand and appreciate it. Recognition therefore comes slowly. The artist no longer hopes to please, but to be understood.

It may be remarked that the French Renaissance was characterised by even more individualism than the Italian – a Northern, modern feature – calling for more and more effort on the part of the spectator. In a sense the whole movement was driven forward by the momentum of the Northern approach. The spirit of critical enquiry was strong enough to rediscover forgotten principles, evolve new theories and put them into experimental practice. The newness of the new art was its most immediately striking aspect, but its classical and Mediterranean qualities, though not so obvious, were nonetheless profoundly there, giving stability and grandeur, and establishing its connection with the great art of the past. The artists themselves were fully aware that they were continuing and extending the Tradition; it was indeed their aim. Their sense of form was often as strong as that of the great Italians, their feeling for colour often more developed. But the great change was the shifting of emphasis from preconception to discovery, and it was this which demanded real attention from the spectator.

The scene at the time appeared confused, in the same way that, when one goes right into a landscape, the features, clear and striking enough from a distance, dissolve and flow imperceptibly into one another and the surrounding countryside. And as an advancing army feeds off the land that it invades and at the same time conquers it, and the soldiers – who at the actual moment of the campaign are far from knowing what is in the minds of the generals, and at all times even further from grasping the underlying strategy directing the whole – sometimes make friends with the people in whose homes they are billeted, and, at higher levels also, sympathies between the opposing sides are discovered, and yet out of all

this confusion a historical change, a great event, takes place: so, and with such complicated interactions, the Modern Movement, whose leaders had studied in the schools, and which at first seemed to the academies and official bodies an alarming rebellion, destructive of what they understood by 'tradition' – this Movement, having at length acquired a following, gradually overwhelmed the resistance of the institutions and eventually was even absorbed into them; and yet, although that same Movement, which knew itself to be rescuing and developing the genuine Great Tradition, did indeed effect a great historical change, as always happens, the very process of its being accepted by the academies involved a considerable measure of misunderstanding: its outward manifestations had become acceptable through familiarity; and its profound principles were too difficult to be grasped and transmitted in that way; and so, in a similarly debased and superficial form, it joined the rest of the Tradition in the forever-to-be-muddied stream of the schools. But without thinking or seeing so far, most of those French painters would have been glad of recognition and acceptance by the official bodies; it would have seemed a kind of victory, and made their lives less bitterly difficult.

Unsatisfactory as this situation is, the schools nevertheless provide almost the only opportunity for the few gifted and original spirits to learn the basic elements of the craft they want to practise, and to meet each other and have fruitful exchanges, with a breathing-space in which to search for their right paths. And there seems to be no other solution to the predicament, in the absence of such a demand for the work of the best artists as would induce them to take assistants into their studios and thus create small schools in the old way; by this method some assistants would remain all their lives as honourable craftsmen, with no pretensions to originality, while one or two would take wing. But apart from the unlikelihood of such a demand, modern art is of such an exploratory nature that it would be difficult to make use of assistants.

This, however, is by the way. To return to that first phase of the French Renaissance, which, as it recedes into history, enveloped in a single glory, appears a simpler whole than it was: looked at more closely, it can be seen to have embraced not only widely differing but completely contradictory tendencies. Monet moved so far in the direction indicated by Friedländer, in which the 'idea' is 'modified by place and condition', that the modifications themselves became the idea; and while he himself was an original genius, whose work remained poised just this side of dissolution, the

Impressionism for which he opened the way degenerated into triviality, and probably contributed to some areas of twentieth-century chaos and disintegration. Seurat, however, absorbed the science of Impressionism while resisting its destructive propensities, pressing it into the service of a new classicism, a return to simple and grand monumentality. Manet, Degas, and Renoir also went a little way with Impressionism, but, while their work was clearly part of the new Movement, it remained equally clearly rooted in the past, and though they were undoubtedly strung to the highest pitch of attention, all three were, in their different ways, so brilliant, so gifted, so balanced, that their painting reveals little trace of problems or doubts. Like the others, they took their subject-matter from everyday life, but in their case it seemed easily lifted to the level of the universal and typical, while retaining a magical particularity. And in spite of differences, disagreements, even occasional hostilities, the painters of this Movement had, on the whole, a kind of solidarity among themselves which helped to sustain them in their difficult situation.

Slightly later, the Northern, Expressionist movement also contributed a revivifying influence, in so far as it relied on the immediate impact of form and colour; and it boasted some great painters; but as a direction it is as dangerous as Impressionism, for excess of expression destroys the effect of permanence in form, tending to draw painting and sculpture into the world of drama and the stage.

THE IMPORTANCE OF CEZANNE

It was only gradually that it became apparent that, in all that half-century, the most important figure for the new age of art was Cézanne. It was not, necessarily, that his paintings were better than anyone else's – they were on the level of the highest, but so were some others – nor that he was often tormented and despairing – so were Gauguin and van Gogh; but he was like an Old Testament prophet, a representative figure, illuminated by the full consciousness of the crisis through which art was passing, and of what was required for its survival. He himself felt that he was like Moses, and sometimes, having seen the Promised Land, feared to die before reaching it. The spirit of a whole epoch of art was concentrated in him. He saw and formulated the task of painting in terms which, while in detail particular to himself, were in principle universally valid.

The language which had once been a living one, transmitted from master to pupil, varied and added to by each user of it – the language in which the three-dimensional world used to be expressed on a flat surface, creating in the course of that expression a work of art, of an art which had its own laws, its own internal logic, like music or mathematics – this once noble language had become debased beyond the possibility of repair for general use. That is to say, in principle, it had to be renewed from its very foundations. To paint well was never easy, but while the language was new and vigorous and growing daily, the way was much clearer. Now that it is worn-out and vulgarised, and we are surrounded by so much that is worthless and misleading, a greater degree of conscious critical understanding is required, and the practice of the art has become an almost incredibly strenuous and demanding exercise. What Cézanne's work and life make clear is, that the battle is never won *once* and *for all*, but has to be fought *continually*, and *by each*.

His life sets a standard which ought to show us the way through the wilderness; but unfortunately, as always happens in the wake of a great original genius, a host of disciples imitated, as far as they could, the very things which they ought to have regarded as forbidden and sacred, and refrained from touching. They took the same subjects and coarsely aped the master's very idiom. Needless to say, their productions do not merit a glance; but for a time they did Cézanne a real disservice.

As for his own achievements, moving in a direction the exact contrary of Monet's, he brought painting back to a very pure expression of 'the absolute idea', taking little account of the modifying variations of condition. He re-created his native Provençal landscape in a newly created language as noble as itself, inspired partly by the proportions and articulations – themselves like phrases and sentences – of the rocks, partly by a penetrating study of the great masters. Delacroix had pursued the idea of reconciling the purity and strength of local colour with its modification by light and atmosphere; Cézanne, following this clue further, used local colours in the old, almost forgotten meaning of the term: the colours of the place, the earths, the very countryside itself, and used them, not necessarily on the objects which actually were those colours, but employing them as his range, like a craftsman limited by the available materials. In fact, with results even literally resembling certain Limoges enamels, in the use of dark blues, emerald-green, clear orange-reds and radiant ivory, he re-created his whole world in its typical light – his beloved mountain, the

vivid trees, the rocky terrain and clear, reflecting water, serious men and women, still-lifes with apples and earthen crocks. Nothing so grand, heroic, massively monumental and purely classical, had been done for a very long time, nor has it, yet, been equalled since. And just as Poussin, 250 years before, had brought painting back to a proper understanding of itself when it had begun to be confused amid the dangers of excessive tonal differences and illusionism, so now Cézanne, while remaking his world with sculptural clarity and weight, restored to the canvas its rightful flatness, with an evenness of emphasis, a severe abstract music, which miraculously transposed and held this world encompassed in the limits of a shallow, tapestry-like space.

He stood at the end of one age and the beginning of another. His relevance, his immense importance for the modern age, consists in his clear and profound understanding (which he even expressed in words, as far as possible) of the very nature of painting, of the problems that face the modern painter, of the need to start afresh from basic principles. No one before him seems to have felt that drawing and painting, in themselves, were so elusively difficult. Before him – and occasionally even after – they were looked upon, by both great and minor masters, as techniques, as crafts, which could to a great extent be taught and learnt. Even van Gogh thought that a painter should be able to produce a picture like anyone else doing a job – like making a pair of shoes. But Cézanne shook up the modern artistic conscience by his own acute consciousness of the whole painful process of artistic creation, his subtle questioning and breaking down of the process of his own seeing and feeling, responses, 'sensations' before nature, and by his persistence in working out a method of expressing those uniquely personal sensations in accordance with the severest traditional disciplines of representation and pictorial creation. His modernity consists in this heightened consciousness, and his almost religious pursuit of those aims, his obsession with them, sometimes to the point of despair.

Or so we think; perhaps, from that point of view, the ageing Michelangelo was just as modern. And in a sense, Cézanne still belonged to that great past, to the age of almost unbounded artistic confidence.

Cézanne's modernity was one thing, but his greatness was another. His greatness was, that he did not remain imprisoned in his torments; that he achieved not only analysis but synthesis, and beyond that, creation of the highest order. For he not only worked out his theory of expressing form by

modulations of colour, his new, pure language of painting, in what were, for him, exercises, fragments, studies – though they, rightly, strike us as marvellous and satisfying in themselves – but carried major paintings through to a triumphant conclusion. He did not doubt that it should still be possible to do great compositions 'like the art of the museums'; and he did them; not only monumental still-lifes, landscapes, portraits, even groups studied from life – 'Card-players' – all in the Grand Manner, but, with still higher flights of ambition, he produced his great pictures of 'Bathers' – for he did not deny the imagination. And after all his dissatis-factions, his sufferings and strivings, his pictures now appear calm and perfect classics in the Great Tradition, falling easily into relation with the great art of the past.

But at that period it was not only Cézanne who felt such confidence; it radiates from the work of many of his contemporaries. Some (including Cézanne himself) were truly religious; others were sustained by a vigorous humanism. In 1894, at the end of *The Venetian Painters*, the young Berenson wrote: 'We, too, have an almost intoxicating sense of human capacity. We, too, believe in a great future for humanity, and nothing has yet happened to check our delight in discovery or our faith in life.'

THE BREAK

Since then, as everybody knows, everything has happened. But, as far as art is concerned, there were two artists who perhaps justified Berenson's optimism: Matisse and Picasso. Even their achievements could not pre-vent, nor heal the effects of, the shattering of faith which has ravaged art to its foundations, or even further.

Yet, in the genius of those two, the Great European Tradition did survive two World Wars, digesting all the influences, of all civilisations and periods, to which the twentieth century exposed it, reappearing, in the case of Matisse, with Apollonian serenity, in that of Picasso, with the cathartic effect of tragedy.

They were themselves such high points that, outside their own achieve-ments, they cannot be said to have advanced the European tradition. In the long run, Matisse's influence is likely to prove the more fruitful. By using pure colour, and stripping away the accretions of centuries, the dead crust of finicking realism, he brought back in a new guise the great

Mediterranean qualities – above all, simplification. Picasso, in his many-faceted art, was the one who most completely expressed his age, its doubts, its questioning of everything, its violence, destruction, fragmentation, terror, its mourning, grief, and anger – but all this in images as monumental as any in the world, with a primitive boldness and savagery drawn from far beyond the European Tradition, for he ranged over and ransacked all civilisations. He as it were integrated disintegration, devouring, tearing apart, and remaking, like an impatient and furious god. But his powers were so spectacular, so almost superhuman, that either they disheartened, or were the cause, in others, of mere silliness.

And since everything in turn was being questioned, it was inevitable that, sooner or later, the question should be asked: What exactly is the role of representation in art, and is it really necessary? And so the radical break was made, cutting clean across the long tradition.

The beginning of the break – the crack, so to speak – appeared before the First World War; gradually it spread until the whole world of tradition fell apart, and chaos took its place.

The questioning and the chaos were largely caused by the scale and degree of the disasters afflicting humanity in the first half of the twentieth century. Artists felt guilty if they did not reflect this situation, but, among painters who did so, only Picasso was of great enough stature to reflect it adequately, so that his response was on the level of Greek tragedy. In general, art did not know how to behave. It was ashamed to be private, and when it was not, it became rather ridiculous and embarrassing.

To add to this confusion, with the passing of time, the achievements of the great French painters of the late nineteenth and early twentieth century could now be seen for what they were, and critics, dealers and official bodies feared to make the same mistake – of non-recognition, of 'missing the boat' – again; they supposed that everything new and disturbing must of necessity be 'good' and 'advanced'; and thus began the break-neck pursuit of Fashion in art.

So now there were two kinds of popular art: one for the philistines, to be seen in the old-established annual exhibitions, and a certain quiet kind of gallery and shop; the other, with a new look, for the 'intelligentsia', to be found alternating, or even rubbing shoulders, with the now generally accepted French Renaissance works in the smart dealers' galleries and officially sponsored, expensively mounted exhibitions all over the world.

It is not worth wasting many words on this wretched and chaotic state of

affairs. In the third quarter of the twentieth century, amidst the ruins and confusion, here and there the question began to be asked: What has become of that once Great Tradition? And, marvellously enough, it was found that, in spite of suffering an almost mortal blow, the Tradition had not in fact died. It can now be seen to have survived, though only in the work of a mere handful of artists.

To recapitulate very briefly:

In antique and Renaissance art, craftsmanship, handed on from master to pupil, developed from primitive to supreme technical ability. In both periods, when the stage of virtuosity was reached, decadence set in.

Until these periods of decline, the artist's instinct was sound. He used the craft he had mastered to express an idea, to create an image, in the language proper to his medium. Often he was required to produce illustrational works – the need for which has now passed away – but it was the degree of his personal form-creating gift which determined his artistic stature. Phidias and Giotto and Michelangelo were illustrators, but great by virtue of their formal qualities.

In periods of decadence, technique – or craftsmanship – was used, not to create form, but to imitate appearance, and for other irrelevant purposes. At intervals, some genius would arise who revived the failing spark of the Great Tradition, until in the second half of the nineteenth century, in the French Renaissance, it blazed up in splendour – for the third time.

Then, in the twentieth century, came the break – the most dramatic break that had ever yet occurred – the collapse of tradition, with the advent of non-representational, or non-figurative art.

Between the last great age and the present age a huge chasm had opened. It was the void left by the vanishing of belief.

In antique art there was a belief in a natural order, and, in harmony with this, a dignified acceptance of death.

In Christian art there was a belief in a divine order, a fear of Judgment and Hell, but nevertheless a belief in God and the possibility of mercy.

In the humanist art of recent times there was an infinitely optimistic belief in Man and his destiny.

But in the art of today (though of course there are always exceptions), in the art of today as a whole, there is no belief in anything beyond the evidence of the senses and of scientific instruments – unless, perhaps, in chance.

This has produced, among a great variety of effects, the cult of the fragment, and a tendency to look askance at 'composition'.

But having reached this nadir, we must look for signs of hope and renewal.

POSTSCRIPT, AFTER VISITING EGYPT

It might seem unlikely that the achievements of a civilization so distant from ours both in time and place could suggest any solutions to our present problems. For certainly 'there were giants in the earth in those days', and their remaining works, even incomplete and partly ruined, far surpass anything done since. And yet they are not all gigantic. The two opposed extremes: heroic monumentality and the modesty of genre, are both seen at their own extreme limits in the art of ancient Egypt – in the colossal statues and huge temples, and the finely carved reliefs (often painted) of scenes of daily life, suggesting swarming anonymity, and including little creatures such as frogs and butterflies. In intention, the second served the first – the recording of genre scenes served the glory of Pharaoh and of the gods – or at the very least of the great nobles.

What made the art of those people great was, that they used it in the service of something they felt and believed to be greater. Except in the case of the Pharaohs themselves, who caused their statues and public monuments to be made, vanity did not come into it. The painted reliefs in the tombs were not even meant to be seen by later mortals, though no doubt a certain pride was taken in producing work of sustained fine quality; the arts themselves were learned as crafts, handed down probably through many generations from father to son, in a tradition that maintained its character for thousands of years, through all variations – not constantly seeking for something new, like the Western world.

And probably the vitality of the artistic tradition was precisely co-existent with the sincerity of religious belief.

It is customary to think of the life and art of ancient Egypt as being orientated towards death; but is it not rather that they loved life so much – the life on this earth, that they knew – that they could not bear to face the idea that it would ever come to a complete end? Theirs is not the only religion that has (wishfully?) prolonged human existence into a clearly imagined after-life; but the Egyptian nature seems to have had a

tendency towards extremes, so that all their lives they kept death in mind, and the rulers at least largely devoted the transient present to securing, as they believed, an eternal future – in two ways: firstly, that they should never be forgotten on earth, but that prodigious monuments should keep their memory alive for ever in the minds of men; and secondly, that by the observance of religious rites and honouring the gods, as well as making every possible provision for the requirements of life beyond the grave, their souls should survive for all eternity. They have indeed been remarkably successful in the first aim; as to the second, we are not in a position to know.

But in the light of history we can see that such beliefs were bound, eventually, to weaken – to come to seem naïve; and this not so much because of Christianity as of Greece. For compared with that of Egypt, the civilization of Greece was young and rising, and the ancient Greeks were a modern, humanist people – daring and original thinkers, fearlessly facing 'Necessity' and whatever seemed to them true. They invented democracy, with the freedom of the individual, and, for better or worse, it was they who set the modern world rolling.

However, let us not blame the Greeks for the trough into which modern art has sunk, and where it now lies thrashing about. Sophisticated and realistic as the Greeks were, they were not irreligious. As for the passing away of existence, which the Egyptians could not or would not look in the face, this very transience of life – or rather, its continual transformations – was one of the foundations on which Goethe – pagan as he was often called – built his own life and work. The whole structure of Faust is based on the impossibility of any blissful moment being other than fleeting. And in his Vier Jahreszeiten he has two couplets (35 and 36) which may be roughly translated:

Why am I fleeting, O Zeus? So Beauty asked.
Because, said the God, I made only the fleeting beautiful.

And Love, and Youth, and the Dew and the Flowers understood;
All went weeping away from Jupiter's throne.

Yet Goethe shared with the ancient Greeks a kind of noble optimism in the face of tragedy, (cf. Aeschylus, in the Agamemnon, 'But may the Good prevail') – and a reverent attitude towards whatever Power created and rules us.

And is it not possible that we in the West, without necessarily accepting any one doctrinal system, could yet regain this fundamentally religious attitude? Could we not, without retrogressing to the particular religion of the ancient Egyptians, draw some salutary lessons from what they accomplished in art, as we have done in the past from Greece?

Of course, as scientists know, one finds what one is looking for; and in Egypt, apart from my simple hunger to see the country and the great works themselves, I was looking for a kind of confirmation of a belief at which I had already arrived – namely that it is possible, without any false primitivism, and without denying or ignoring, but rather incorporating, many elements which, in the past 800 years, great artists have built into our own tradition – possible still to develop an art – a new movement – which should acknowledge the dignity, the beauty, the mystery, of 'ordinary' life, or 'ordinary' people – an art which should replace the endless snapshots that are, by the very nature of photography, accidental and superficial, by something considered and monumental, both in painting and sculpture.

It is more urgent, we know, that everyone should have a decent home, and work, and a fair living. But in the meantime, why should not as many families as possible – for instance, all those who find it necessary to own a car and a television set – own a portrait-group, of parents and children, a fair-sized painting or sculpture, showing them in the normal circumstances of their lives, but capturing something of those moments when life seems most desirable, when something profound and permanent appears to shine through the continual change – something universal but particular, to which one would like to give duration – which can only be done, and even then incompletely, through art? Let them keep their thousands of snapshots – in albums or boxes; but against their walls there should be works of true art.

The portrait-groups that Reynolds painted were of and for high society; but today there ought to be a school of work more in the spirit of Chardin. And if this could come about it would also take back the now rootless and drifting artist into the social structure – he would once more be wanted, and have his place. There would be a demand for his services – *as a trained craftsman knowing his job* – not as a lost soul looking for *himself*, or striving for *self*-expression. And gradually the more gifted ones would be sought out and offered a higher price for their work. And also, as the generations succeeded one another, the finest examples would

find their way into museums, instead of being produced *for* them, as they are now.

As for the commemoration of public figures, a gift for monumental sculpture is exceedingly rare, and anyone possessing it will find his own way; yet lessons in this line could sill be learnt from the ancient Egyptians, who reached the highest level ever attained in this branch of art, and remain, as far as can at present be imagined, unapproachably supreme.

But I am thinking of a more attainable aim: the creation of a school of genre portrait-groups, raised, in a more modest and private way, to a monumental level – yet unpretentious and faithful – 'My father in his habit, as he lived'. And for a renaissance of this kind one can certainly find guide-lines in the art of ancient Egypt – in the tomb-paintings, and in such a marvellous small sculpture as 'The Dwarf Seneb with his wife and children' – which would give scope for variety and invention as infinite as life itself.

Ah, what a dream! But why not? Yes – 'May the Good prevail'.

REFERENCES

CHAPTER 1 THE GREAT TRADITION
p.11, line 17
Art New Annual, XXVI, 1957. 'An
Anthology of Max J. Friedländer', from
Die Altniederländische Malerei, 1924.
The quotation is from the first piece,
'The Personality of Jan Van Eyck'.

CHAPTER 2 GIACOMETTI
p.20, line 16
'Giacometti', *Portfolio & Art News
Annual* No. 3, 1960, p.79.

CHAPTER 5 FRANK AUERBACH
p.56, line 31
'The Bomberg Papers', 'X', Vol. 1,
No. 3, June 1960, p.186.
p.71, line 23
Sickert in a conversation with the author.

CHAPTER 6 FRANCIS BACON
p.76, line 32
The closing sentences of Goethe's auto-
biography, *Truth & Poetry from my own
life*, translated by John Oxenford, Bohn's
Standard Library, 1848.

CHAPTER 7 BALTHUS
p.97, line 18
Balthus, Drawings & Watercolours,
Thames & Hudson, 1983.
p.101, line 17 & p.105, line 11
Jean Leymarie, *Balthus*, Editions d'Art
Albert Skira SA, Geneva, 1979.
p.104, line 26 & p.111, line 28
John Russell, *Balthus*, Arts Council,
1968.
p.109, line 2
Jean Clair, *Balthus*, Centre Georges
Pompidou 1983–4, p.105. First pub-
lished in the *Nouvelle Revue Francaise*,
Paris, No.163, July 1966, pp.148–152.

CHAPTER 8 LUCIAN FREUD
p.140, line 36
Lucian Freud, exhibition catalogue,
Hayward Gallery, 1974.

CHAPTER 10 EVERT LUNDQUIST
p.158, line 23
Stevie Smith, *Novel on Yellow Paper*,
reprinted by permission of James Mac-
Gibbon.

CHAPTER 11 RAYMOND MASON
p.169, line 2
Laurence Sterne, *A Sentimental Jour-
ney*, 1768.
p.181, line 36
From the translation by Patricia South-
gate in the catalogue of the 1971 exhibi-
tion at the Pierre Matisse Gallery, New
York. His original text in French
appeared in the catalogue of the exhibi-
tion at the Claude Bernard Gallery,
Paris.

CHAPTER 12 EUAN UGLOW
p.197, line 33
James Elroy Flecker, *Hassan*, Heine-
mann, 1923.
p.198, line 18
Thomas Mann, radio broadcast, 1952.

CHAPTER 13 DEVELOPMENT OF THE
THEME OF THE GREAT TRADITION
p.203, line 7
Bertrand Russell, *History of Western
Philosophy*, p.490. George Allen &
Unwin, 1948.

INDEX

Page numbers in *italic* refer to the illustrations

Abdy, Lady, 104
academies, 205, 207
Acropolis museum, Athens, 119
Aeschylus, 95, 216
African art, 200
Aitchison, Craigie, 22–34; 'Candlestick
 Still-life', 30; 'Crucifixion IV', *25*;
 'Garden at Tulliallan', 30; 'Landscape
 with Telegraph Poles', 23; landscapes,
 23, 26, 30–2; 'Mr Georgeous
 Macaulay', 29–30, *31*, 33; nudes, 26,
 27–9, 32; 'Poppies in Tulliallan
 Garden', 30; religious pictures, 23–7;
 still-lifes, 26, 30; techniques, 22–3;
 use of colour, 23, 32; 'Walls and Fields
 at Tulliallan', 30–2; 'Woman standing
 in front of black background', *33*;
 'Yellow Picture', 23
Alberti, Leon Battista, 193
Amsterdam, 152
Anavi, Madame, 118, 119
Andrews, Michael, 23, 35–53, 137; 'All
 Night Long', 43, 44, 47–8; 'August for
 the People', 35–8, *36*, 41, 51; 'The
 Colony Room', 43, 44, 46; day
 pictures, 42, 43–4, 46; 'Deer Park',
 43, 44, 46–7, 48; 'Digswell Man'
 ('Man in a Landscape'), 43, 44–6;
 'Family in the Garden', 43–4, *45*, 48,
 52; 'Girl on a Balcony', 42; influences
 on, 41–2, 47; 'Late Evening on a
 Summer Day', 42, 43, 46; 'Lights',
 49–50; 'Liony Piony', 42–3; 'Lorenza
 Mazzetti in Italy', 38–40, *39*; 'A man
 who suddenly fell over', 37, 38; 'Notes'
 in 'X', 35, 38, 44; party pictures, 42,
 43, 46–9; 'The Pier and the Road', 51;
 'The Pier Pavilion', 51; 'Portrait of
 Timothy Behrens', 46; 'A Shadow', 52;
 'The Spa', 51–2; 'Sunbathers', 41,
 43; techniques, 50–1
Anthony of Padua, St, 172
Arezzo, 98
Argenti, Filippo, 74
Artaud, Antonin, 105
Arts Council, 17, 41, 46
Auden, W. H., 37

Auerbach, Frank, 55–72; black and
 white paintings, 65, 68; drawings, 61;
 'E.O.W. on her Blue Eiderdown', 66,
 68; friendship with Kossoff, 56,
 144–5; 'Gaumont Cinema, Camden
 Town', 69; 'Head of E.O.W.', *54*, 55;
 influences on, 56; Kossoff's portrait
 of, 144, 149; Mornington Crescent
 pictures, 70; nudes, 61, 62, 65, 67;
 'The Origin of the Great Bear', 72;
 'Oxford Street Building Site II', 59,
 60; portraits, 55; Primrose Hill
 pictures, 55, 59, 62, 69–70, 72;
 'Primrose Hill, winter', *63*;
 'Rebuilding the Empire Cinema,
 Leicester Square', 68; 'Shell Building
 Site', 68; 'Sitting Room', 69, 70;
 'Smithfield Meat Market', 68; 'Spring
 Sunshine', 69–70; techniques, 59–62;
 townscapes, 68, 70; use of colour,
 59–61, 64–7; 'View from Primrose
 Hill', 68–70; 'Winter Sunshine',
 69–70

Bacon, Francis, 46, 73–96, 137, 163;
 'Bull-fight', 89; Crucifixions, 74, 81,
 89, 92, 93, 94; 'Figure Writing
 Reflected in a Mirror', 90, *91*; Freud's
 portrait of, 130, 132; influence of, 37,
 135, 142–3; influences on, 73, 79–80;
 'Lying Figure in a Mirror', 80; nudes,
 79; '"Oresteia" Triptych', 93, 94, 95;
 'Painting', 81; 'Portrait of Isabel
 Rawsthorne Standing in a Street in
 Soho', *78*, 89; 'Red Pope', 80;
 Retrospective Exhibitions, 79, 83,
 88–96; screaming Popes, 38, 74;
 'Seated Figure', 90; self-portraits, 83;
 'Sleeping Figure', 90; 'Studies for a
 Crucifixion', 92; 'Studies of the
 Human Body', 90; 'Study of George
 Dyer', 80, 82; 'Study of Red Pope,
 2nd Version', 80; 'Three Figures and a
 Portrait', 90; 'Three Studies for a
 Crucifixion', 81; 'Three Studies for
 Figures at the Base of a Crucifixion',
 81, 88; 'Three Studies of the Male

Bacon, Francis – *cont.*
Back', 90; 'Triptych – Studies from the Human Body', 93; 'Triptych Inspired by T. S. Eliot's Poem "Sweeney Agonistes"', 82, 93; 'Triptych with two Figures Lying on a Bed, with Attendants', 93; triptychs, 74, 81, 83, *84–5, 86–7*, 90, 93–5; 'Two Studies for a Portrait of George Dyer', 93; use of colour, 90–3

Balthus, 97–121, 129; 'The Angel's Message to the Knight of Strättlingen', 97; 'Les Beaux Jours' ('The Golden Days'), 110, *112*, 113; 'Buste de Femme', 110; 'Le Cerisier', 109; 'La Chambre' ('The Room'), 106, 111, 113–14, 120; 'La Chambre Turque', 119; 'Le Chapeau Bernois', 108; 'La Coiffure', 115; 'Cour de Ferme à Chassy', 116; 'La Dormeuse', 115; 'L'Enfant Gourmand', 108; 'Les Enfants', 106; 'Etude pour une Composition', 119; 'La Fenêtre', 104; 'Le Fruit d'Or', 116; 'Golden Afternoon', 116; 'Le Gotteron', 109; 'Le Goûter', 108–9, 110; 'Grand Paysage à l'Arbre', 116, *117*; 'Grand Paysage avec Vache', 116; influence of, 168; influences on, 98–9; 'Japonaise à la Table Rouge', 119; 'Japonaise au Miroir Noir', 119; 'Jeune Fille à la Chemise Blanche', 115; 'Jeune Fille à la Fenêtre', 116–18; 'Jeune fille en Vert et Rouge' ('Le Chandelier'), 108–9, 110; 'Jeune Fille Lisant', 115; 'La Jupe Blanche', 106; 'Katia Lisant', 120; 'Lady Abdy', 104; landscapes, 109, 114–15, 116; 'Larchant', 109; 'La Leçon de Guitare', 104; 'Léna aux Bras Croisés', 115; 'La Montagne', 104–6, 108, 114; 'Nature Morte', 106, 108–9; 'Nature Morte à la Lampe', 116; 'Nu Assoupi', 120; 'Nu de Profil', 120; 'Partie de Cartes' pictures, 110; 'Le Passage du Commerce-Saint-André', 106, *107*, 111–13, 114, 175; 'La Patience', 110, 115; 'Paysage aux Boeufs', 109; 'Le Peintre et son Modèle', 120–1; 'La Phalène', 118; portraits, 103–4, 106; 'The Quays', 175; Retrospective Exhibition, 97–8, 119; 'Le Rêve', 115, 116; 'La Rue' ('The Street'), 98–9, *100*, 101–3, 105,
111, 114, 175; 'Le Salon', 109–10; 'La Sortie du Bain', 119; 'La Tasse de Café', 116; 'The Three Sisters', 115; 'La Tireuse de Cartes', 116; 'La Toilette de Cathy', 103, 106; *Wuthering Heights* drawings, 97, 103, 106

Balzac, Honoré de, 178, 181
Baroque, 152, 157, 196
Barye, Antoine Louis, 178
Baudelaire, Charles, 89, 98
Bayeux Tapestry, 69
Behrens, Timothy, 46
Belcher, Muriel, 46
Bérard, Christian, 128
Berenson, Bernhard, 211
Berlin, 56, 122
Bernini, Giovanni Lorenzo, 40, 178
Bible, 152
Birmingham, 168, 169
Boccioni, Umberto, 79
Bomberg, David, 56, 57, 144
Bonnard, Pierre, 41–3, 69, 99, 101
Books of Hours, 158
Borromini, Francesco, 16, 18, 181
Botticelli, Sandro, 94, 108, 188; 'Pallas and the Centaur', 104; 'Primavera', 102, 105
Brancusi, Constantin, 178
Breughel, Pieter, 154
British Museum, 161
Brontë, Emily, *Wuthering Heights*, 97, 103, 106
Brunelleschi, Filippo, 193
Byzantine mosaics, 16

Camberwell School of Art, 185, 194
Camden Town school, 62
Carandente, Giovanni, 97
Caravaggio, 106, 108
Carpeaux, Jean Baptiste, 178
Carreras Factory, 68
Cézanne, Paul, 17, 21, 22, 56–7, 137, 178, 196; 'Bathers', 211; importance of, 208–11; influence of, 14–15, 27, 35, 40, 79, 134, 189, 191, 194; use of colour, 209–10
Chardin, Jean Baptiste Siméon, 15, 194, 201, 202, 216
Chassy, 114–15, 116–18
Chekhov, Anton, 43–4, 52
Chinese art, 23, 35, 124, 127–8, 145, 200

Christ, 24
Christianity, 12, 74, 200, 213, 215
Cimabue, Giovanni, 16, 20, 75
Clair, Jean, 108–9
Clark, Kenneth, 27, 164, 193, 202
classical art, 199–200
Coldstream, Sir William, 27, 35, 185, 187
Colony Room, 43
Constable, John, 157
Contemporary Art Society, 26
Corot, Jean Baptiste Camille, 197, 204
Correggio, 139
Courbet, Gustave, 104, 106, 110–11, 156, 201, 204
Cranach, Lucas, 127
Cubism, 116

Dante, 74, 179
Daumier, Honoré, 204
David, Jacques Louis, 106, 201
Deakin, John, 135, 136, 140
Degas, Edgar, 57, 79, 81, 178, 208
Delacroix, Ferdinand Victor Eugène, 70, 74, 201, 204, 209
della Robbia family, 177
Derain, André, 29, 101, 103, 106, 128, 129
Diamond, Harry, 140
Digswell, 44–6
d'Offay Gallery, London, 123
Donatello, 171, 178, 183
Drottningholm, 155
Dyer, George, 80, 82, 93

Egypt, ancient, 10, 16, 20, 127, 202, 214–17
Einigen, chapel of, 97
Eliot, T. S., 75, 82, 93
Ensor, James, 37
Existentialism, 20
Expressionism, 97, 150, 208
Eyck, Jan van, 'Jan Arnolfini and his Wife', 137

Flemish art, 11, 102, 189
Florence, 42, 75, 81, 82, 129–34, 189, 197
foreshortening, 200–1
France, 89, 102, 130, 159, 184, 204–8, 212
Frazer, Sir James, 114
Freud, Lucien, 46, 122–43; 'Baby on a Green Sofa', 134; 'Father and Daughter', 129, 132–3, 135, 142; 'Francis Bacon', 130, 132; 'Girl Holding a Towel', 138, 139; 'Girl in a Dark Jacket', 128; 'Girl in a Fur Coat', 138; 'Girl with Kitten', 127–8; 'Girl with Leaves', 128; 'Girl with Roses', 126, 127, 130, 141–2; 'Girl with a White Dog', 129–30, 132–3; 'Head of a Woman', 130; 'Hospital Ward', 123; 'Ill in Paris', 128; influences on, 141–3; 'Interior in Paddington', 125, 129, 130, 132–3; 'Interior with Plant, Reflection Listening', 138; 'John Deakin', 135, 136, 138, 140; 'John Minton', 130, 131, 132; 'Large Interior, W9', 140; 'Large Interior in Paddington', 139, 143; 'Lemon Sprig', 125; 'A Man and his Daughter', 135, 138; 'Man at Night', 128; 'Man in a Head-scarf', 133; 'Man with a Feather', 123, 129; 'Michael Andrews and June', 137–8; 'Mother and Baby', 142; 'Naked Child Laughing', 134; 'Naked Girls', 140; 'Naked Portrait', 140; 'The Painter's Room', 125; 'Portrait on a Brown Blanket', 140; 'Portrait of Cedric Morris', 123; portraits, 125, 130–8; 'Pregnant Girl', 134; 'Reflection with Two Children', 135–7, 138; 'The Refugees', 123, 125, 140; Retrospective Exhibition, 122, 132; 'Self-portrait', 132, 133; 'Sleeping Head', 134; 'Still-life with Aloe', 142; 'Still-life with Apricots and Shell', 142; 'Still-life with Green Lemon', 125; 'Still-life with Sea-urchin', 142; 'Unripe Tangerine', 125; use of colour, 134; 'The Village Boys', 123, 129; 'A Woman Painter', 133; 'Woman Smiling', 134; 'Woman with a Daffodil', 125; 'Woman with a Tulip', 125; 'A Writer', 130
Friedländer, Max, 11, 66, 189–91, 207
Futurists, 79

Gainsborough, Thomas, 41, 157, 201
Gauguin, Paul, 34, 208
genre painting, 202
Géricault, Theodore, 201
Germany, 97, 124, 127
Giacometti, Alberto, 10, 14–21, 22, 74, 75, 101, 137, 175, 178, 179; drawings,

Giacometti, Alberto – *cont*.
 14–15; influence of, 27, 35, 73, 138,
 168, 187; influences, 18; paintings,
 18–20; sculpture, 16, 17–18, 20;
 'Still-life with Pitcher', 15
Giorgione, 42
Giotto, 20, 37, 56, 118, 119, 213
Goethe, Johann Wolfgang von, 181,
 215–16; *Egmont*, 76–7
Gombrich, E. H., 147
Gothic, 20, 24, 28, 183, 201
Goya, Francisco José de, 201
Grand, Paul-Marie, 20
Grand Palais, Paris, 77
Greece, 125–7, 139; ancient Greece,
 10–12, 20, 34, 95, 119, 120, 152, 159,
 161, 193, 201–2, 203, 215–16
Grien, Hans Baldung, 127
Gris, Juan, 18–19
Grosz, George, 122–3
Grünewald, Matthias, Crucifixions, 75

Hals, Franz, 70, 135, 164, 201
Hayward Gallery, London, 122, 140
Heine, Heinrich, 199
Henry VIII, King, 128
Hess, F. S., 65
Hiroshima, 77
Hogarth, William, 182
Holbein, Hans, 127, 128, 132
Holland, 70, 102, 124, 205
Homer, 96, 159
Hugo, Victor, 'Les Contemplations', 169
humanism, 203, 213

ICA, 119
Impressionism, 41–2, 67, 68, 70, 81, 98,
 102, 139, 150, 154, 156, 157, 189, 194,
 208
Indian art, 200
Ingres, Jean Auguste Dominique, 132,
 201; 'Raphael's House', 197
Italy, 16, 22, 23, 24, 38–40, 95, 102,
 124, 127, 129, 152, 184, 197, 201

Japanese art, 26, 51, 119, 120, 124, 200
Jews, 144, 152

Kleist, Heinrich von, 183
Kokoschka, Oskar, 133–4, 137, 189
Kossoff, Leon, 55, 56–7, 144–54;
 'Building Site, Mornington Crescent',
 149; 'Children's Swimming Pool', 154;
'City Landscape', 152; 'City
 Landscape, Early Morning', 145, 154;
 friendship with Auerbach, 56, 144–5;
 landscapes, 151; 'Mother Asleep',
 149–50; nudes, 151; pictures of
 building sites, 145; 'Portrait of Frank
 Auerbach', 144, 149; portraits,
 149–51; 'Rachel Seated in an
 Armchair', 152–4; 'Railway, Bethnal
 Green', 149; 'Railway Bridge,
 Mornington Crescent', 149; 'Recent
 Work' exhibition, 154; 'Riverside'
 landscapes, 147–9; 'St Paul's building
 site', *146*, 149, 152; 'Seated Woman I',
 148; techniques, 147; 'Two Seated
 Figures', 150–2; use of colour, 150;
 'Willesden Junction, Early Morning',
 150; 'A Woman Ill in Bed Surrounded
 by Family', 152, *153*
Kossoff, Philip, 151

La Tour, Georges de, 106, 108, 194
Le Nain, 106
Leiris, Michael, 74
Leonardo da Vinci, 40, 145
Leymarie, Jean, 101, 105, 108
Limoges enamels, 209
Lorenzo Monaco, 'Coronation of the
 Virgin', 129
Lubéron mountain, 176
Lundquist, Evert, 155–67; 'At the Edge
 of the Forest', 163; 'From the
 Garden', 163; 'Girl Asleep', 161; 'The
 Glass', 163; 'Harvesting Woman', 164,
 167; 'Street Sweeper', 164, *166*, 167;
 'The Torch', 163, *165*; 'The Tree',
 162, 163
Luxembourg Gardens, Paris, 42

Macaulay, Georgeous, 29–30, *31*, 32, 34
Mahler, Alma, 137
Mailer, Norman, *Deer Park*, 46
Manet, Edouard, 208
Manhattan, 52
Mann, Thomas, 75, 198; 'The
 Wardrobe', 28, 34
Maples, 59
Marlborough Gallery, London, 151,
 152–4
Masaccio, 15; 'Tribute Money', 46
Mason, Raymond, 168–83; 'The
 Barcelona Tram', 169–72, *170*, 181;
 'Big Midi Landscape', 176; 'Boul'

Mich', 177; 'Boulevard Saint
Germain', 173–5; 'Carrefour de
l'Odéon', 175; 'The Crowd', 177,
178–81, 183; 'Le Départ des Fruits et
Légumes du Coeur de Paris, le 28
février 1969', *180*, 181–3; drawings,
169; 'Elements of the Crowd', 178;
'Les Épouvantées', 175; 'The Idyll',
175; illustrations for 'Les
Contemplations', 169; influences on,
168; landscape reliefs, 176–7;
'Landscape with Storm-cloud', 176;
'London', *174*; 'Man in the Street',
172, 173; 'Mois de Mai à Paris',
176–7; 'Place de l'Opéra', 173; 'Place
Saint-Germain-des-Prés', 172–3;
'Procession of Clouds', 176; 'Le
Roucas', 176; 'Small Crowds', 178;
'The Street', 177, 178; techniques,
169, 177
Matisse, Henri, 14, 34, 83, 116, 161,
178, 211–12
Mazzetti, Lorenza, 38–40, *39*
Mediterranean art, 12–13, 199–204, 206
Metropolitan Museum, New York, 83
Michelangelo, 14, 37, 43, 56, 79–80, 83,
89–90, 94, 95, 160, 178, 179, 201, 210,
213; 'The Last Judgement', 79
Midi, 176
Minton, John, 130, *131*, 132
Miro, Joan, 106, 129
Mitsou, 97
Modern Movement, 207
Monet, Claude, 57, 81, 89, 154, 207, 209
Monroe, Marilyn, 47
Montaigne, Michel Eyquem de, 114
Monte Calvello, 120
Moraes, Henrietta, 81
Morocco, 101
Morris, Cedric, 122–3
Morvan, 114
Mouffle d'Angerville, *Vie privée de Louis
XV*, 46
Mozart, Wolfgang Amadeus, 77
Munch, Edvard, 38, 156
music, 204

Naples, 34
Napoleon I, Emperor, 77
National Gallery of Modern Art,
Edinburgh, 23
National Gallery of Victoria, Melbourne,
42, 47

New Burlington Galleries, London, 141
Nijinsky, 43
North Africa, 89
Northern art, 12–13, 199–206
Norwich, 35, 41, 43

Odyssey, 83
Old Testament, 152
Oudry, 'White Duck', 130

Paolozzi, Eduardo, 40
Paris, 16, 98–9, 102, 128, 156, 168, 173,
175, 181–2
Parrhasius, 11
perspective, 16, 19
Phidias, 202, 213
Picasso, Pablo, 14, 77, 83, 89, 99, 103,
106, 115, 168, 178, 211–12
Piero della Francesca, 40, 98, 99, 101,
106, 115, 193–6; 'Madonna del Parto',
114
Pirandello, Luigi, 89
Pompeii, 34, 160, 172
Pompidou Centre, Paris, 97–8
Poussin, Nicolas, 105, 106, 154, 194,
197, 201, 210
Prévert, Jacques, 58
Primrose Hill, 55, 59, 62, 68, 69–70, 72
Proust, Marcel, 97, 110
Provence, 209

Racine, Jean, 175
Raphael, Sistine Madonna, 137
Rawsthorne, Isabel, *78*, 89
religion, 202–3, 214–15
Rembrandt, 55, 57, 65, 68, 83, 108, 144,
152, 156, 161, 164, 201, 205, 206;
'Jewish Bride', 137
Renaissance, 15, 24, 40–1, 46, 61, 69,
79–81, 95, 97, 102, 105–6, 119, 124,
137, 152, 160, 173, 178, 183–4,
196–7, 201–5
Renoir, Pierre Auguste, 129, 178, 208
Reynolds, Sir Joshua, 216
Rilke, Rainer Maria, 97, 98, 99
Rimbaud, Arthur, *Illuminations*, 47, 49
Rodin, Auguste, 178; Balzac monument,
178, 181; 'Head of Iris', 178; 'La Porte
de l'Enfer', 179
Roman art, 11, 20, 119, 120, 152,
169–71, 201–2
romantic art, 199–200
Rome, 38–40, 42, 160

Rothko, Mark, 23
Royal College of Art, 56, 144, 168
Rubens, Peter Paul, 135, 139, 147, 154, 157, 201
Russell, Bertrand, 203
Russell, John, 47–8, 104, 111, 140–1, 143

St Mark's, Venice, 123
St Martin's School of Art, 56, 144
St Pancras, 59
Scarborough, 51
Schiller, Johann Christoph Friedrich von, 151
science, 58–9, 204
Scotland, 22, 23, 26
Second World War, 88, 111
Seedo, 149
Seurat, Georges, 101, 194, 208
Shakespeare, William, 167
Sickert, Walter Richard, 62, 70, 71, 76, 94
Signorelli, Luca, 108
Sistine Chapel, Vatican, 79, 80, 90, 201
Slade School, 22, 23, 27, 28, 35, 38, 41, 48, 168, 185, 189, 194
Smith, Stevie, *Novel on Yellow Paper*, 158–9, 161
Sotheby's, 118, 119
Soutine, Chaim, 151
Spain, 102
Spencer, Stanley, 143
Stein, Gertrude, 103
Sterne, Laurence, 169
Stockholm, 156
Surrealism, 51, 73, 99, 125, 175
Sweden, 155, 160
Switzerland, 103
Sylvester, David, 17, 18, 80

Tangier, 89
Tate Gallery, 37, 46
Thun, Lake, 97
Tiepolo, Giambattista, 201
The Times, 171
Tintoretto, 70, 89
Tischbein, 181

Titian, 57, 70, 79, 80, 81, 89, 109–10, 113, 119, 157, 161, 193, 203; 'Bacchus and Ariadne', 71, 72; 'Diana and Actaeon', 110; 'Rape of Lucrece', 72; 'Sacred and Profane Love', 110
Together, 40
Toulouse Lautrec, Henri de, 156
Tulliallan, 26
Turner, Joseph Mallord William, 147, 157, 160, 201

Uglow, Euan, 23, 184–98; influences on, 187, 194; 'Large Oval Still Life', *190*; 'The Massacre of the Innocents (after Poussin)', *195*; 'Nude, from twelve regular vertical positions from the eye', *186*, 188; 'Nude with a White Skirt', 189; 'Passionate Perspective', 192; techniques, 185–9, 191
United States of America, 89

Van Gogh, Vincent, 81, 89, 90, 150, 156, 184, 208, 210; 'The Potato-eaters', 150; 'Sorrow', 192
Vasari, Giorgio, 197
Velasquez, Diego de Silva y, 57, 73, 79, 81, 106, 113, 157, 164, 197, 201; 'Boar Hunt', 47
Venice, 42, 81, 111, 123, 157
Venus Pudica, 26
Verdi, Giuseppe, 167
Vermeer, Jan, 57, 106, 194, 198, 201, 202

Waldberg, Patrick, 176
Watteau, Antoine, 201
Watteville, Antoinette de, 103
Whitechapel Gallery, London, 154
Wilkie, David, 70, 71, 72
Wood, Christopher, 122, 141, 143; 'The Blue Necklace', 141–2; 'Zebra and Parachute', 141

Yeats, W. B., 'The Second Coming', 74

Zeuxis, 11